STEVEN SPIELBERG

THE ICONIC FILMMAKER AND HIS WORK

IAN NATHAN

Quarto

First published in 2024 by White Lion Publishing
an imprint of The Quarto Group.
One Triptych Place, London, SE1 9SH
United Kingdom
T (0)20 7700 6700
www.Quarto.com

A catalogue record for this book is available from the British Library.

ISBN 978-0-71129-523-0
Ebook ISBN 978-0-71129-524-7

Designed by Sue Pressley and Paul Turner, Stonecastle Graphics
Edited by Nick Freeth
Publisher Jessica Axe
Editorial Director Jennifer Barr
Art Director Paileen Currie
Senior Production Manager Rohana Yusof

Printed in China

10 9 8 7 6 5 4 3 2 1

MIX
Paper | Supporting
responsible forestry
FSC
www.fsc.org FSC® C016973

STEVEN SPIELBERG

THE ICONIC FILMMAKER AND HIS WORK

IAN NATHAN

UNOFFICIAL AND UNAUTHORISED

WHITE
LION
PUBLISHING

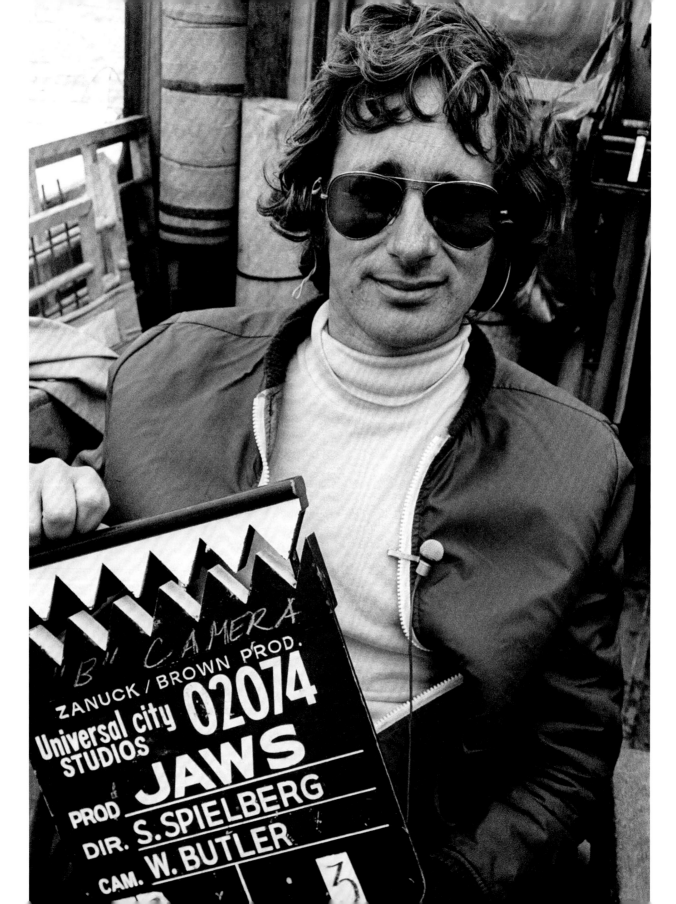

"B" CAMERA

ZANUCK / BROWN PROD.

Universal city STUDIOS 02074

PROD. JAWS

DIR. S. SPIELBERG

CAM. W. BUTLER

CONTENTS

Opposite: Steven Spielberg and the film that changed everything. *Jaws* was the baptism by water (and malfunctioning sharks) that taught him to rely on his own extraordinary instinct for visual storytelling.

THE OPENING...

'I'm going to make movies. I'm going to direct and produce movies.'[1]
Steven Spielberg, eighth grade

It starts with a call. The urgent rattling of a Bakelite phone in its nest. That's a bit fanciful, but you catch my drift. This is the movies.

'How about Spielberg?' My publisher throws off the question as if it were the easiest thing in the world. We are discussing future books, potential subjects, iconic directors.

I'll be honest, I didn't expect the most iconic director of them all. My brain plays a montage, it's a flashback to my own childhood – all those images flickering on the cinema screen of my mind. How about Spielberg? The thought is terrifying. And thrilling.

Let's stop and consider this for a moment. Let's just get this straight. Steven Spielberg is the most famous director who has ever lived. He is the medium's defining artist. Indeed, the embodiment of the Hollywood ideal: the commercial potential of film married to its creative possibilities. Art and commerce.

Spielberg sits above the simple calculus of modern times – a phenomenon, a mirage, a goofy guy with a knack of telling stories with light that speaks to millions upon millions by making the extraordinary ordinary. Or the other way around. His leading characters, even Indiana Jones, even Abraham Lincoln,

even those played by Tom Cruise, are marked by their vulnerability, their mistakes, their yearning.

It's the human touch.

The task in deciphering such a monumental career was to bring Spielberg back to the engaging level of his heroes (and by *The Fabelmans*, in 2022, he has become his own hero). To cut through the deification – the holy brand! – to find the artist, filmmaker, and man beneath, driven by a many-headed gift: the scope of David Lean and John Ford mixed with the thrill of Alfred Hitchcock, the detail of Stanley Kubrick, the emotional core of Walt Disney, and the naturalism of François Truffaut.

There are so many parts to the story: the suburban background that supplied the films with a biographical streak; the collaborations (with George Lucas and the Movie Brats in general, with composer John Williams, editor Michael Kahn, stars Richard Dreyfuss, Harrison Ford, and Tom Hanks, and mogul and mentor Sid Sheinberg). The myths that bloomed from the making of these films – Hollywood folklore. The nightmare shoot and stubborn shark behind *Jaws*. The strange ambitions of *Close Encounters of the Third Kind*. Dive bombing with *1941*. Inventing *Indiana Jones*. Reinventing the blockbuster

Right: Steven Spielberg in his early twenties, a TV director with a rare contract at Universal. It's a start, but his talent is irrepressible, and he craves the dream of a feature film.

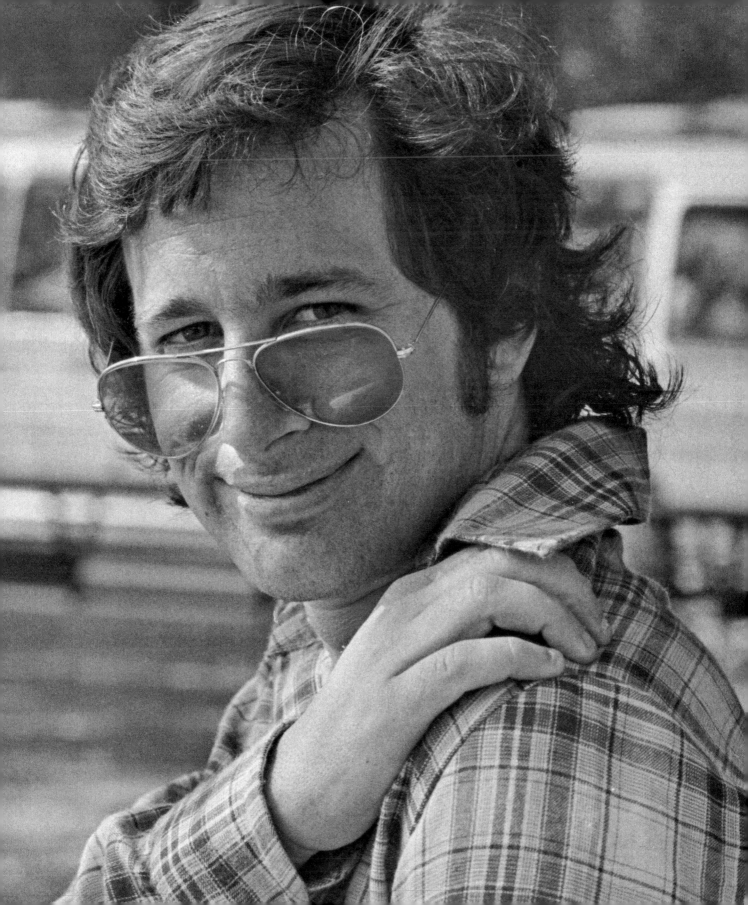

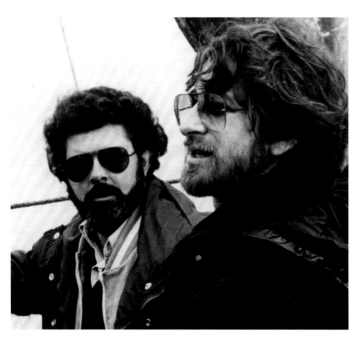 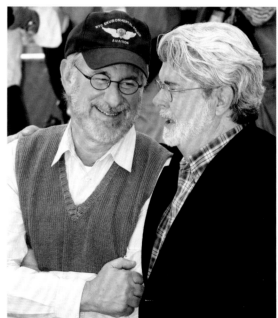

with *Jurassic Park*. Venturing into history's darkest shadows with *Schindler's List*. Transforming a genre with *Saving Private Ryan*. The muscular, unpredictable, confrontational Spielberg of *Minority Report*, *Munich*, and *Lincoln*.

And there is the man himself, a reticent celebrity, shrewd powerbroker, and uncompromising artist driven by highly personal impulses. And so often assailed by doubts. If there is an abiding emotional thread that ties all thirty-four feature films (including TV spectacular *Duel*, with its cinema release in Europe), it is anxiety.

So much that is thought of Spielberg is tangibly wrong. The feelgood director, bestowing bliss like Santa Claus. The great sentimentalist. Have you watched his films? He so much darker than he is given credit for. Often, it is that darkness that speaks to us.

Spielberg presents an enigmatic front, as if this Hollywood game was effortless, yet his life and work, as well as his understanding of the medium and the world at large, are deeply interwoven. Long before *The Fabelmans*, there were hints of autobiography in Elliott from *E.T. the Extra-Terrestrial*; Indy, of course, overriding chaos with a shrug; such lost boys as Jim in *Empire of the Sun* and Frank Abagnale Jr in *Catch Me If You Can*, inventing his own life; and in those real-world crusaders Oskar Schindler, Abraham Lincoln, and Ben Bradlee, the *Washington Post* editor portrayed with such intellectual glee by Tom Hanks in *The Post*.

There is Spielberg's complex relationship with his Jewish faith, ever-present but only fully embraced when he came to make *Schindler's List*. And there is his family. How his films, even late in his career – lionized, untouchable – went in search of approval from his parents. He wanted that acknowledgment from his peers too. That fateful Oscar was so long in coming. His filmmaking has always been about finding connection.

Above left: George Lucas and Steven Spielberg on the set of *Raiders of the Lost Ark* in 1981 – just two buddies who changed the landscape of cinema forever.

Above right: Spielberg and Lucas at the Cannes premiere of *Indiana Jones and the Kingdom of the Crystal Skull*. Still just two buddies playing in the biggest sandbox they could find.

Opposite: Spielberg in 2024, attending the Golden Globes, his boyishness undiminished, the world still eagerly awaiting what comes next.

He is oddly self-critical – the first to cite a weakness in the films. Getting ahead of the critics. He claims to have never made a film as good as *The Godfather*, but it is easy to argue him down. They are set in different places and alternative genres, but films as varied as *E.T.* and *Schindler's List*, *Jaws* and *Lincoln*, have a greatness that is often obscured by popularity. How can anything this popular be that good? Academia treats him with kid gloves.

Defining, appreciating, contextualizing, and understanding the films of Spielberg is a tall order. Their simplicity is deceptive. You have to cut through the glow, the adoration, the simple joy that comes with their embrace, and get to the thrust of the filmmaking. Sourcing the inspirations; how the blood of old Hollywood runs in his veins. Exploring and cataloguing the iconic sequences: the Mother Ship landing at the crescendo of *Close Encounters*, the bikes soaring into the air in *E.T. the Extra-Terrestrial*, the boulder rumbling after a foolhardy archaeologist in *Raiders of the Lost Ark*, the liquidation of the ghetto in *Schindler's List*, the D-Day landing in *Saving Private Ryan*… the list is very long. In essence, the genius of Spielberg lies in his iconic shots. His filmmaking choices.

The perilous challenge put before me, like one of those booby-trapped tombs in the *Indiana Jones* films, was to see Spielberg with fresh eyes.

So I said yes and plunged…

THE NATURAL

The early films, the TV episodes, *Duel* (1971), *The Sugarland Express* (1974)

Where to begin? What is the great opening to this nonpareil career of Steven Spielberg? How exactly do you become the most famous director who has ever lived? The record-breaking box office is only half the story. This is not about the ringing up of hits, but tectonic shifts in culture, a reshaping of the world around a name – Spielberg. It is about emotional epochs in our lives. An intensely personal experience shared with millions. Arguably, only the Beatles have had a commensurate effect. So pristine, so vibrant, so perfectly catchy on the surface. Suffused with complexity, meaning, and ambiguity beneath. Equally possessed of that constant rediscovery of where their talent might take them.

Where does it come from - the Spielberg touch?

The given answer is to earn a photography merit badge for the Flaming Arrow Patrol of Troop 294 in Scottsdale, Arizona in 1958. Spielberg was so much better at the creative rather than physical badges. 'I wanted to be a boy scout,'[1] he insisted, as if this could explain it all. As if this would make him a real boy.

The badge required that he tell a story in still photos. The only thing was – and here is fate playing its part – his camera was broken. But there was the family's Super 8, which had naturally fallen under Steven's jurisdiction. His parents had noticed how their eldest was eager to reshape reality. These were *shots*. The family car pulling to a stop at a resort, the camera no higher than the hubcap, repeated until Steven was satisfied.

He put the plan to the Flaming Arrow eldership. 'Can we change the rules, so I can use a movie camera?'

'Go ahead,'[2] replied the scoutmaster, oblivious to the fact he was the figurative butterfly of Ian Malcolm's chaos-theorizing from *Jurassic Park*, and that this flutter of filigree wings would lead one day to *Spielberg*.

The result was *Gunfight*, a Western in nine resplendent, inventive, if derivative minutes, in which his friends (the Sollenberger brothers) rob a stagecoach outside a Pinnacle Patio steakhouse in up-and-coming Scottsdale (handily, a scarlet stagecoach was permanently parked out front). The director's three younger sisters play 'damsels in distress.'[3] The young Spielberg included cutaways to his mother's jewellery as the intended spoils.

Opposite: The iconic pose – Steven Spielberg on the set of *Raiders of the Lost Ark* in 1981, baseball cap in place, beard, his attention rapt by the magic of the moment.

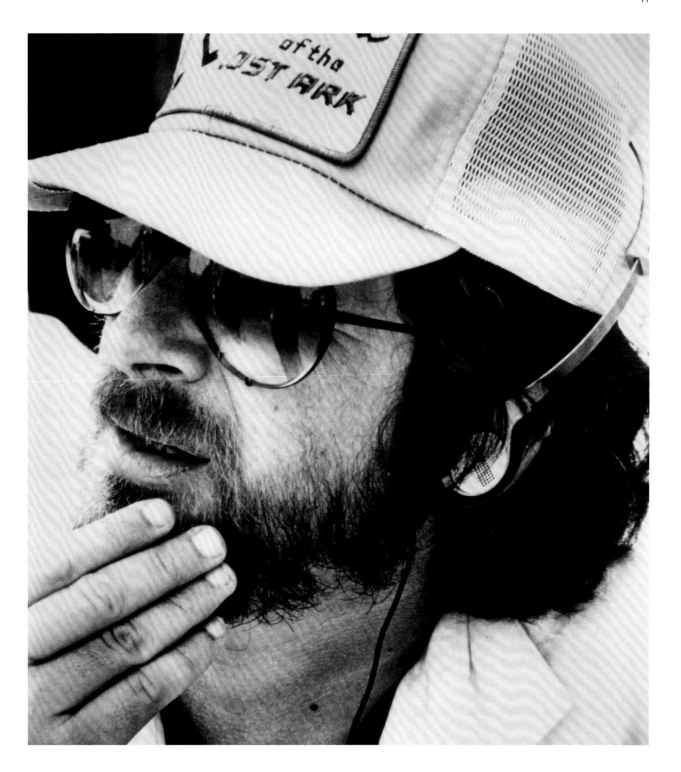

He showed it to the troop that weekend, listening as they screamed and applauded. It was the response that changed him – the electricity that ran through the audience.

'I just got the bug,'[4] he recalled with deafening understatement. He also got his badge.

Of course, there is a film at the other end of his career, and the other end of this book, portraying and mythologizing these humble beginnings. In *The Fabelmans*, lavished in the dream-glow of filmmaking, we get a recreation of a recreation.

Spielberg's very first film is a remake. It is 1957, he is eleven, and shaken to the core by his first trip to the temple of the cinema. He watched Cecil B. DeMille's *The Greatest Show on Earth*, a circus epic, squeezed between his parents. It's the train crash that haunts him. He wants to understand how to cast such a spell. Using that wind-up 8mm camera, he stages collisions with his Lionel train set, setting his eye at track level to gain the perspective

of the locomotive. In the film to come, sixty-five years hence, the toy train is lit in tribute to DeMille, the engine's piercing headlamp racing toward camera.

'That was the first time I realized the power of film,'[5] recalled Spielberg. He could run the footage over and over, projected onto the wall of his closet, landing the same thrill without fear of his father's wrath for damaging the precious trains. His mother declared it a triumph. His first review.

'Everything about me is in my films,'[6] he understood, given to self-analysis and criticism. His is a life written in films.

It's not that these films are about childhood (there are fewer of those than you think). He made films *using* his childhood – that primal storehouse that shapes all adult lives. The metronomic of wonder and fear. His marvellous career has been driven by preternatural emotional memory, an instinct amplified by anxiety, and charged by memory. Biographer

Above left: A three-year-old Steven Spielberg (left) alongside his mother Leah and baby sister Anne in a family photo taken in 1949.

Above right: That seminal boyhood – a young Steven, now recognizable, in the early 1950s.

Opposite left and right: History repeating – Spielberg fictionalizes his own life in *The Fabelmans* with Paul Dano, Mateo Zoryan, and Michelle Williams. The scene in question is the momentous occasion of his first visit to the cinema, when he saw Cecil B. DeMille's circus epic *The Greatest Show on Earth* – an experience he would spend his entire career trying to recapture.

Molly Haskell calls him 'Proust with a Steadicam.'[7] He is a tuning fork for feeling. It's the key to his universality.

Everyone on Earth has experienced childhood.

The very beginning is 18 December 1946, when Spielberg was born in Cincinnati, Ohio, the Midwestern boomtown where Arnold and Leah Spielberg had grown up. His parents were second-generation Jewish immigrants, trailing fateful family legends of fleeing the pogroms of rural Kamieniec Podolski and worldly Odessa in the Ukraine. Steven would overhear pensive tales from his grandparents and the ageing Jewish community in the Cincinnati district of Avondale. Talk of the Holocaust and Hitler – recent history.

Storytelling was never far away. Leah's father, his grandfather, was a frustrated artist, singing and dancing around the piano, refusing to be reconstructed by

fast-moving Cincinnati. Beneath a fulsome black beard, he went by his Yiddish name, Fievel, a name consciously endowed upon the mouse-shaped immigrant of *An American Tail*, the animated film produced by Spielberg in 1986.

There was Great Uncle Boris too, the family eccentric, reprised in a thunderclap of Falstaffian oratory by Judd Hirsch for *The Fabelmans*. Uncle Boris had been a lion tamer, a vaudevillian, a Shakespearean actor. He could be one of the chatterbox senators in *Lincoln*.

Spielberg's earliest memory is recollected like a special effect. He is taken to synagogue, that other temple, for the first time. He sees nothing but the fierce red light pulsating in front of the replica Ark, tiled in gold and blue, as elders sway back and forth. A different light held a greater hold on his developing psyche. He joked that he was raised by three parents: mother, father, and

"Everything about me is in my films."

Steven Spielberg

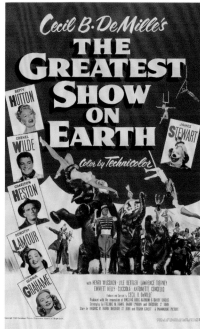

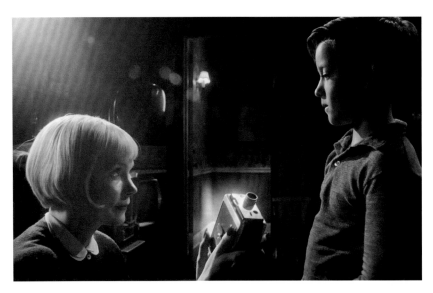

Above left: Life and art combined in *The Fabelmans* – Mitzi Fabelman née Leah Spielberg (Michelle Williams), her eldest child Sammy Fabelman né Steven Spielberg, and the sacred family 8mm camera.

Below: A teenaged Sammy Fabelman/Steven Spielberg (Gabriel LaBelle) gains the full force of the wisdom of Uncle Boris (the great Judd Hirsch).

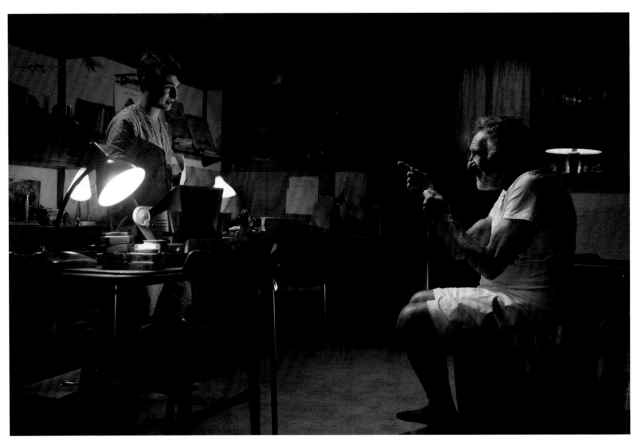

 THE LAST TRAIN WRECK (SHORT)
1957 Director

 THE LAST GUN (SHORT)
1959 Actor/Director/Editor/Producer

FIGHTER SQUAD (SHORT)
1961 Director/Editor/Producer/Writer

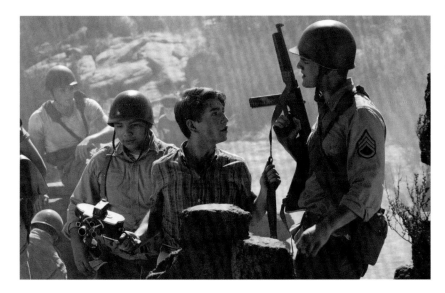

Left: Portrait of the artist as a young man – Sammy/Steven (LaBelle) corrals his friends as he makes his war film *Escape to Nowhere* in 1961.

television set. It arrived in 1949, Arnold always so keen to have the latest gadget. The son leans in close and listens to the static, bathed in the phosphorescent glow, certain he can discern messages.

The family are uprooted by his father's ambitions – training to be a computer programmer, landing at a job at RCA. His mother played piano, her cherished ambitions to be a concert pianist quashed by obligation. Science and art, pragmatism and dreaming. They landed first in Haddon Township, New Jersey.

Leah had a secular spirit, and the family's orthodoxy wavered. Her mischievous son began his Bar Mitzvah by pelting guests with oranges from the roof of the synagogue. He would grouch at Christmastime about being in the only house on the suburban street without decoration – were the glittering baubles of *Close Encounters of the Third Kind* making up for the shameful gloom of their windows?

Skinny, geeky, awkward Steven, nibbling his fingernails, is a contradiction: the fretful boy who plays wicked, inventive pranks on his sisters like early set pieces. A favourite: locking them in a closet, then thrusting in a plastic skull, lit from within by a flashlight. They are a rehearsal for Indiana Jones and his screaming companions. 'His badness was so original,'[8] shrugged his mother.

They move to Scottsdale, Arizona, the place he grew up: American suburbia, framed by Camelback Mountain and the uncaring desert. He was the boy-scout filmmaker. Into adolescence, he was rarely seen without a camera clutched in his hand: an expanding repertoire from the Super 8 to a Bolex to 16mm. He thought visually.

This wasn't a fad, it was as deep-rooted as a calling, close to an obsession. His father would attempt to rein him in, pointing out the high cost of buying and developing film, a prototype for the producers to come – all the questioning executives. Steven experimented with form: documentaries, war films, science fiction, more Westerns, a film noir – complete with exotic angles. He fixed a cart to the family cocker spaniel, Thunder, and had it tow a camera around town. In one film, his mother dies from a heart attack after his sister is abducted. For *Senior Sneak Day*, he corralled the crowds of senior year hitting the beach – another vivid enterprise retold in *The Fabelmans*, and maybe in *Jaws* too.

Here were emotional headwaters that would flow through a career. His Jewish identity locked away to fit in at high school, but bullied by the jocks all the same. They called him 'Spielbug.'[9] At close quarters, he watched his parents' marriage disintegrate.

In his first UFO fable, *Firelight*, catastrophe comes to suburbia, heralded by a flashing red light. Foregrounded in the story, a marriage runs aground, with the husband eager to stray. Spielberg blamed Arnold for the collapse of the marriage – away working, providing, avoiding the chaos of Leah's bohemian habits. The original absentee father. It was an act of denial. He secretly knew that Leah was the unfaithful party, falling in love and eventually marrying Arnold's best friend Bernie. Wounded mothers, failing fathers, lost boys.

 ESCAPE TO NOWHERE (SHORT)
1961 Director/Editor (uncredited)/Producer/Writer

FIRELIGHT
1964 Cinematographer/Composer/Director/Editor/Producer/Writer

In the wake of the divorce, his life flickers into montage. Bristling when it was decided he should live with his father in Los Angeles, splitting his time between humble California State College (minus a film department) and an opportunity to intern at Universal Studios, wrangled through family connections. Arnold despaired – why didn't he follow him into computer programming? There was a future in that. His headstrong son abandoned ship (and college), moving in with a friend in West L.A. He watched every film he could, still does. Bold but never pushy, he roamed the Universal backlot in his sports coat, witnessing the pros at work. This was his film school. John Cassavetes directing *Faces*. Charlton Heston leading *The War Lord*. Slipping onto the set of Hitchcock's *Torn Curtain*, before being sharply removed with no more than a glimpse of the great man's great head. And yes, he did indeed hustle five testy minutes in John Ford's presence (David Lynch in *The Fabelmans*).

How different his world was from the crowd at Nicholas Canyon Beach. Spilling out of the rival film schools at USC and UCLA, they were full of vim and theory, plotting revolution. Spielberg became enrolled in the Movie Brats after seeking out George Lucas, bowled over by his student film *THX 1138* (later to be expanded into an austere dystopian feature). Lucas was Francis Ford Coppola's filmmaking partner, but he and Spielberg had more in common. The two geeks in the corner of the party, swerving

Above left: Dreaming of the Oscars, perchance? A dapper and unmistakable Steven Spielberg photographed for his High School Yearbook in 1963.

Right: John Cassavetes directing *Husbands* in 1970 – in his early days interning at Universal, Spielberg had snuck onto the set of Cassavetes' *Faces* on the studio backlot.

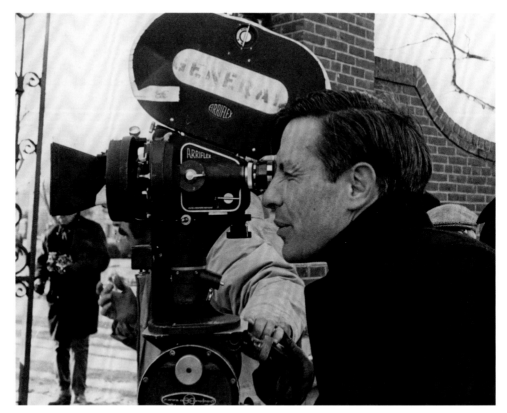

Visit the future where love
is the ultimate crime.

THX 1138

Warner Bros. presents THX 1138 · An American Zoetrope Production · Starring
Robert Duvall and Donald Pleasence · with Don Pedro Colley, Maggie McOmie
and Ian Wolfe · Technicolor® · Techniscope® · Executive Producer, Francis Ford
Coppola · Screenplay by George Lucas and Walter Murch · Story by George Lucas
Produced by Lawrence Sturhahn · Directed by George Lucas · Music by Lalo Schifrin

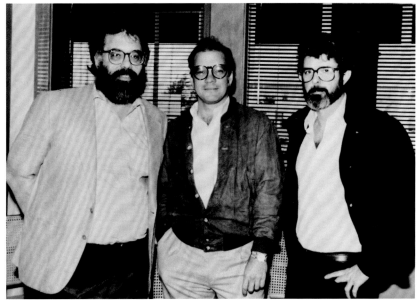

the coke and girls. It was a heady time.
A new generation was about to – briefly
– tip the balance in favour of the artist.
They would gather at the beach house of
actresses Jennifer Salt and Margot Kidder,
the legendary, motley, auteur Brats: Lucas,
Spielberg, Coppola, Martin Scorsese, John
Milius, Paul Schrader et al. It is an over-
told story, that seventies thing. Especially,
the central cliché of Spielberg never quite
conforming to their unconformity. He
drew deep on that collaborative air.

The mix is vital: bouncing off his
fellow Brats, all the intellectual possibility
of film, and the production-line discipline
of shooting television at Universal just
around the corner.

First came *Amblin'*, the short film
that gave its name to Spielberg's vaunted
production company. He needed a calling
card. Something that made him 'look
like a professional moviemaker.'[10] To
impress the powers in the Black Tower
that loomed over the Universal lot like
a mother ship. Independent producer

Denis C. Hoffman had offered $20,000
on the condition there was no dialogue,
it used his Cinefx Studio, and offered a
platform for the band, October Country,
whom he happened to manage. The
acoustic airs hover suspiciously close to
Simon & Garfunkel's *Scarborough Fair*. But
then, Spielberg is undeniably under the
influence of *The Graduate*.

Light and windblown as cactus
blossom, *Amblin'* centres on two
hitchhikers on a desert highway, a guy
and a girl (Richard Levin and Pamela
McMyler) – hippy kids who bond, flirt,
jape, thumb a few lifts, sleep beneath
the moon, and fall for one another
before reaching the beckoning surf of
the Pacific. All the while maintaining
the mystery of what is inside his guitar
case. And achieved without a single line
of dialogue. Shot in 1968, it was a labour
of love with an emphasis on labour: the
crew of unpaid volunteers struggling
through the fierce heat of Pearblossom
on the desert fringes of Los Angeles.

Above left: A viewing of the
student version of George
Lucas' dystopian thriller
THX 1138 captured
Spielberg's imagination
so much, he sought out its
director, and a remarkable
friendship was born.

Above right: Generation
Film - three of the fabled
Movie Brats, Francis Ford
Coppola, Paul Schrader, and
Lucas, pictured in 1985.

AMBLIN' (SHORT)
1968 Director/Editor (uncredited)/Writer

He edited night and day, condensing three hours of footage into a strange little marvel, twenty-six minutes long.

Spielberg has subsequently frowned upon *Amblin'*, seeing it as a 'piece of driftwood,'[11] horrified by its political ambivalence while Vietnam and Kent State were shaking the headlines. Yet the film is enchanting, and a rare sighting of a theme treated with even more ambivalence in the films to come – sexual attraction. In any case, the handwriting is legible. Scenes of the couple transformed into moonlit silhouettes. Shots reflected in a car's wing mirror. Desert roads. Car bumpers. Jokes constructed from the crosscurrent of close-ups and mid-shots.

With the boy frolicking in the surf fully clothed, the girl takes her chance to open his guitar case (his fateful Ark) and discover his true identity: a suit and tie, wing-tipped shoes, toothpaste, mouthwash, and a copy of Arthur C. Clarke's *The City and the Stars*. He is a secret square. Was this a self-portrait? Levin resembles the young director to an uncanny degree. Biographer Molly Haskell registers the title of Clarke's novel as a delightful pun 'that might suggest a guidebook to L.A. and homes of celebrities.'[12]

In the late sixties, former lawyer Sidney J. Sheinberg was vice president of Universal Television, and saw enough in *Amblin'* to offer Spielberg a seven-year contract. It was the warmth that struck the trim, pin-striped studio man. Sheinberg was to become his great mentor, his fairy godfather (a surrogate for the failed Arnold): savvy, straight-talking, ready to cheerlead on behalf of precocious talent. 'He gave birth to my career and made Universal my home,'[13] extolled his young charge.

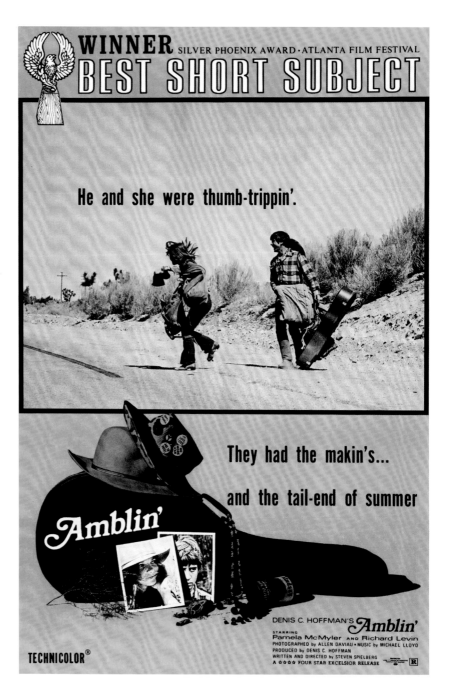

Above: The release poster for *Amblin'*. Steven Spielberg's 1968 short was impressive enough to land him a studio deal at Universal Television.

NIGHT GALLERY (TV SERIES, 1 EPISODE)
1969 Director

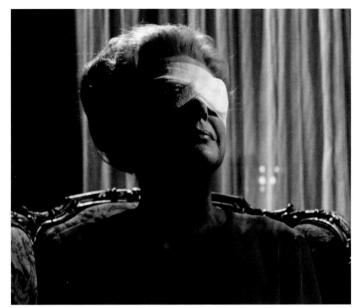 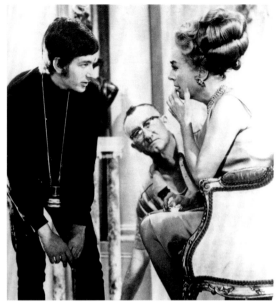

Above left and right:
Spielberg's very first professional assignment was directing an episode of the anthology series *Night Gallery*, starring the formidable Joan Crawford as a blind woman who will temporarily gain new eyes (a motif repeated in *Minority Report*), only to pull away her bandages during a blackout.

Spielberg was the youngest director to land a studio deal. Sheinberg laid it all out. He comes to work in television, starting with a few shows, maybe branch out into feature films. 'I mean, it was all very vague,' said Spielberg. 'But it *sounded* great.'[14]

He began on $275 a week.

The child who once worshipped television was now that voice within the set. His first assignment was *Eyes*, part of the supernatural anthology *Night Gallery*, written by *The Twilight Zone's* Rod Serling. What's more, it was legendary diva Joan Crawford playing the blind woman who bribes her way to a new pair of surgically implanted eyes. Enough for a few hours of regained sight. Only when she finally removes the bandages (an image replayed in *Minority Report* and *War Horse*), New York City is smothered in a blackout.

'She took pity on me,' recalled Spielberg, fondly, 'this little kid with acne all over his face.'[15] He looked frighteningly young face-to-face with venerable

Hollywood. On the lot they called him 'Sheinberg's folly.'[16] The crew thought he was some kind of joke. The resulting episode had the producer slamming his 'arty-farty'[17] shots.

There were attempts to get a feature film off the ground, but the sweatshop of television was unrelenting. The serial Spielberg of *Marcus Welby, M.D.*, *The Psychiatrist*, *The Name of the Game*, and *Columbo* debut *Murder by the Book*. A fascinating compendium of the formulaic punctuated with cunning master shots and jazzy angles. A trail of breadcrumbs that leads to *Duel*.

In a single glance, he knew the beat-up '55 Peterbilt 281 to be his star: 'It had a face, a huge protruding snout, eyes.'[18] Sanded down to its rusted bones, smeared in oil, it was a monstrous, living thing. Spielberg would splatter the windshield with dead bugs. It was author Richard Matheson's idea that we never see the driver, beyond his boots and tattooed arm. Spielberg loved that – the idea of *unseen* evil.

1970 MARCUS WELBY, M.D. (TV SERIES, I EPISODE)
Director

1971 NIGHT GALLERY (TV SERIES, I EPISODE)
Director

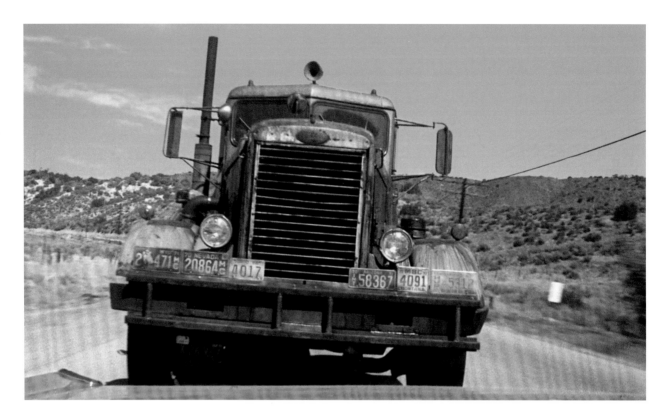

Above: The psychopathic pantechnicon – the unrelenting foe of *Duel* in all its rusted, bug-splattered, oil-smeared glory. The idea was to make it feel like a living thing.

Right: The release poster for *Duel* from 1971. While made for television, the film was deemed good enough for a cinema release in Europe, adding a touch of confusion as to what stands as Steven Spielberg's first feature film.

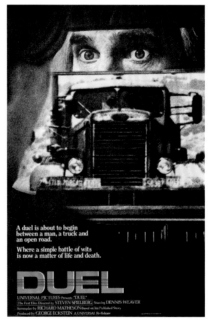

This was almost a Hitchcock movie. 'Like *Psycho* or *The Birds* on wheels,'[19] he enthused. Watch his career in reverse and it's *Jaws* on wheels.

Duel is the flare launched over Hollywood. The honking, snorting, propulsive blast of genre that heralds the talent to come. Without discernible motive, for seventy-three gripping minutes, a red Plymouth Valiant is tormented by this battered ten-wheel tanker intent on the driver's death. The hero is so run-of-the-mill he is even named David Mann (Dennis Weaver).

Matheson had based his short story on a real experience of a tail-gating truck. He had initially tried to sell it as a screenplay, but found no takers. 'There's not enough there,'[20] he was told. Spielberg was assigned the film by Universal Television

THE NAME OF THE GAME (TV SERIES, 1 EPISODE)
1971 Director

THE PSYCHIATRIST (TV SERIES, 2 EPISODES)
1971 Director

after the story had run in *Playboy*. It was an ABC Movie of the Week, but so astronomical were its ratings, the decision was taken to expand it by eighteen (unnecessary) minutes for a cinema release in Europe.

Weaver was the network's suggestion (over Dustin Hoffman among others). Spielberg was delighted. He had loved him as the twitchy hotel clerk in Orson Welles' *Touch of Evil*. 'The anxiety, panic, and paranoia of *Touch of Evil*, ' he relished, 'that's where I wanted him to get to.'[21] Eager European critics saw a film about class warfare. Their American counterparts saw a Western, or a slasher movie.

Spielberg demanded to shoot on location. No plates, no wobbly process shots, just thirteen days on Canyon Road, north of Los Angeles. A serpentine strip of mountain highway threading six canyons, the landscape is a scuffed parchment of desert beneath chipped enamel skies. The challenge was variety. How do you create visual texture within one long chase?

It is like a dam breaking. Spielberg surges with creativity, that Hitchcock dictum running on a loop in his head: 'Don't ever let the audience off the hook.'[22] Multiple cameras catch every conceivable angle of car and heavy-breathing truck. Hubcap-level shots lap up the differential between tarmac and tyre. He didn't storyboard so much as map it out. The Art Department drew up an aerial chart of the route the film takes, every hairpin bend, every stunt, a giant mural that covered the walls of his hotel room.

He sharpens the film to two perspectives: Plymouth and Peterbilt. Mirrors, windshields, pedals, speedometers, the grill of the tanker, Weaver's stricken face. He grabs superb, human moments; hints of a fragmenting

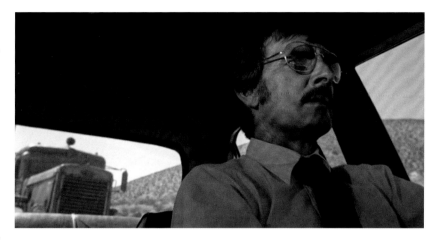

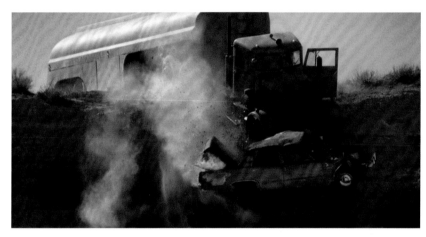

marriage in Mann's fraught call home to his wife (Jacqueline Scott). The three-and-a-half-week edit won an Emmy. It is a magnificent exercise in distilled suspense. A one-off. If he made it again, with everything he has learned, it would be a lesser film. Back then he was hungry.

There were more contractual obligations. More television films. *Something Evil*, adept enough, is Spielberg's only bona fide horror movie. The plot has a familiar ring: failing father Darren McGavin uproots his family to a haunted farmhouse in Pennsylvania. Trick shots ensue.

Top: Dennis Weaver as the everyman hero/victim of *Duel* named David Mann. There are echoes of the determined character in Roy Scheider's Brody in *Jaws*.

Above: The end of the road – as the truck plunges to its death off a cliff, Steven Spielberg mixed in a synthesized dinosaur roar, something he would do again for the death of the shark in *Jaws*.

1971 COLUMBO (TV SERIES, 1 EPISODE)
Director

1971 OWEN MARSHALL, COUNSELOR AT LAW (TV SERIES, 1 EPISODE)
Director

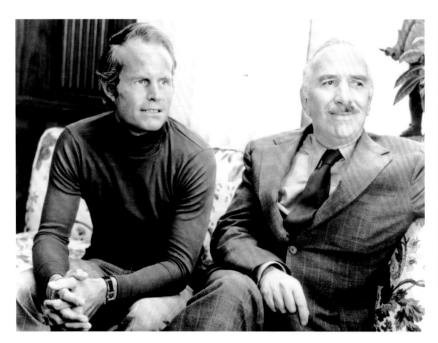

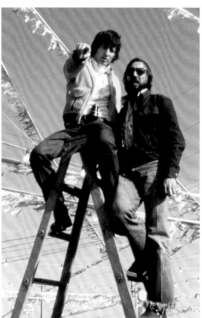

Above left: The canny producing team of Richard D. Zanuck and David Brown, who took a chance on Steven Spielberg with *The Sugarland Express* and stuck with him for *Jaws*.

Above right: In his element – the young Spielberg points out the shot to cinematographer Vilmos Zsigmond, in a partnership that would bear even greater fruit on *Close Encounters of the Third Kind*.

Right: Spielberg and leading lady Goldie Hawn on the 1973 set of *The Sugarland Express*, ostensibly his first feature, which tends to be forgotten with all that came afterwards.

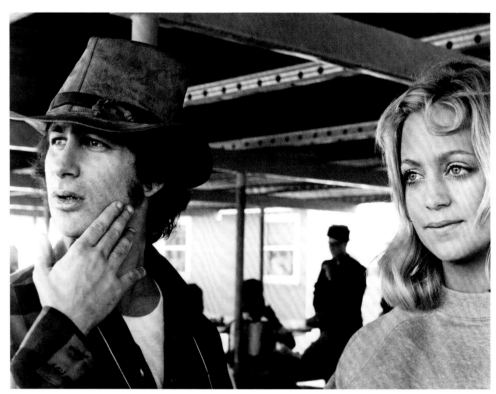

DUEL (TV MOVIE)
1971 Director

SOMETHING EVIL (TV MOVIE)
1972 Actor/Director

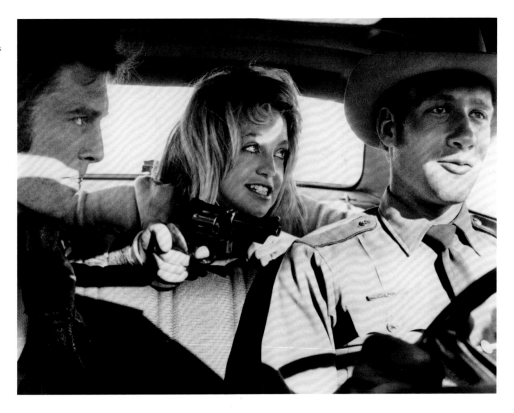

Right: Lovers on the lam – William Atherton and Hawn take patrolman Michael Sacks hostage as they race to save their child from care in *The Sugarland Express*. As based on a real-life story.

So this is how it officially begins. Spielberg's film career. With a road movie in the seventies mould that went unnoticed, though the reviews were decent. *The New Yorker's* Pauline Kael declared him 'a new generation's Howard Hawks.'[23] Produced by Richard D. Zanuck and David Brown – a pair of seasoned Hollywood players who had a feeling about this kid – *The Sugarland Express* was based on a newspaper article about a Texan couple who abscond from prison to rescue their child from foster care. Taking a patrolman hostage in his car, they are pursued for six hundred miles across Texas by a procession of wailing patrol cars. Recalling the couple-on-the-lam dynamics of *Bonnie and Clyde* and *Badlands*, they become a media sensation, mythologized into outlaws. Zanuck was

behind the canny casting of Goldie Hawn – America's latest sweetheart – as the all-but bipolar Lou Jean, with William Atherton as feckless, doomed numbskull Clovis. They are not exactly everyman-and-woman, this runaway couple.

Written by Movie Brat pals Hal Barwood and Matthew Robbins, and backed by Universal for $3 million, it is a giddy but compassionate tale of mother love, driven by Hawn's wild energy, a comedy that darkens into something more poignant.

Spielberg conjures up visual wonders. Lightweight Panaflex cameras allowed him to swirl around the fleeing vehicle in 360 degrees. Along endless highways, the horizon pancake-flat, his chosen cinematographer Vilmos Zsigmond shot in natural light. As dusk settles, the phalanx of police lights glittering into

the distance foretells of *Close Encounters* to come. In one unforgettable moment, Clovis watches a *Road Runner* cartoon (chosen by Spielberg) on a distant drive-in screen. We see it reflected onto the windshield and his troubled face, just as Wylie Coyote plunges from a cliff.

Making a humbling $7.5 million, *The Sugarland Express* disappeared quietly into history (from where, of course, it has been reborn). Spielberg was already preparing his second film.

SAVAGE (TV MOVIE
1973 Director/Editor (uncredited)

THE SUGARLAND EXPRESS
1974 Director/Writer

THE BIG FISH

The unstoppable *Jaws* (1975)

The day the shark arrived – in fact, there were three mechanical great whites, each as ineffectual as the next – coincided with the first time that Steven Spielberg attempted to shoot on open water. Two chilling portents of things to come. The shot was comparatively simple (a distinction that would grow in dread as the Sisyphean shoot wore on), in which peppy ichthyologist Hooper (Richard Dreyfuss), burdened police chief Brody (Roy Scheider), and local newspaperman Meadows (screenwriter Carl Gottlieb doing double duty) pull up to a wrecked boat belonging to Amity fisherman Ben Gardner (a brief cameo from Massachusetts fisherman Craig Kingsbury, who will be immortalized as a corpse). Time and again, the swells off Martha's Vineyard pulled the boats out of alignment, frustrating the endeavours of cinematographer Bill Butler to line up a shot, and finally resulted in Gottlieb going headfirst into the cold spring water, the sound man's equipment getting soaked, and the day's shooting being abandoned.

At Gottlieb's suggestion, Spielberg would redo the scene as a night shoot with only Brody and Hooper patrolling the waters to much spookier effect, the yellow searchlight sweeping the soupy water like a prelude to the UFO drama which Spielberg was yearning to make. Only twenty-seven, the director would find his film within the crisis of its making.

'I wanted to do *Jaws* for hostile reasons,' Spielberg once said. He had felt attacked by the book, terrified by the possibilities. 'It somehow appealed to my baser instincts… I didn't have any fun making it. But I had a great time planning it.'[1]

This is a story of instinct. That of an apex predator. That of a Hollywood studio. And that of a director, who defied the elements. No one could have foreseen the profound effect it would have not only in film but culture, becoming this Jungian wolf whistle. *Bah-dum*. It's a holy text for a generation of filmmakers: Steven Soderbergh, David Fincher, M. Night Shyamalan, J.J. Abrams, Eli Roth; Ridley Scott's *Alien* is essentially *Jaws* in space.

When Spielberg volunteered to direct *Jaws*, he was turned down. He had picked up the novel in galley form in the office of Richard D. Zanuck and David Brown, who had produced *The Sugarland Express* through their shingle at Universal, and snuck it home to read over the weekend.

Right: Shark sighting – Spielberg's legendary dolly zoom into Brody (Roy Scheider), warping the world around the horror-struck police chief.

JAWS
1975 Director/ Actor (uncredited)

Or maybe he had permission. Myth pecks at the truth like a seagull. Dapper Brown, based in New York, had an ear to the literary scene. He knew where the hot material might lie. He had the inside track to land *Jaws* before the competition. Though it still took a cool $175,000 to buy the rights.

With its almost goofy, monosyllabic title, *Jaws* was the first novel by Peter Benchley, a former journalist at *Newsweek*, who had spent childhood summers shark-fishing off Nantucket. With a shimmer of Robert Redford to his square-jawed mien (he can be spotted cameoing as the roving TV reporter), Benchley had done the research, grounding himself in the science. And the history. In 1916, a great white had made forays into the shallows of New Jersey, dining on locals. For all his research, Benchley was playing to the crowd – the book was a fantasy, a monster movie under its soapy, modernist skin.

The plot is one of the easiest recalled in film history. At the height of summer season on the fictional island of Amity, a ferry ride from the Massachusetts coast, a great white has come to feed. Though the town elders remain in denial. New to the job, a veteran of New York's precincts, Scheider's police chief, Martin Brody, doesn't know which way to turn. Until the body count swells, and the beaches are finally shut. Together with Dreyfuss's shark expert Martin Hooper and cantankerous old salt Quint (Robert Shaw), Brody takes to the waters to hunt down their cartilaginous serial killer. Or serve as shark bait.

Zanuck and Brown's instinct was for an old Hollywood engineer, good with the machinery of filmmaking – the story presented significant technical demands, not least shooting on water. Maybe Richard Fleischer, who had

proved his worth with *20,000 Leagues Under the Sea*. An unnamed prospect spent a boozy lunch with Zanuck and Brown referring to the shark as 'the whale'[2] – *Moby Dick* allusions aside, the producers were not impressed.

When they returned to the idea of 'the kid'[3] directing their big fish, Spielberg had second thoughts. Was it too commercial? Too much like a horror film? After *Duel*, he fretted, 'who wants to be known

as the truck-and-shark director?'[4] The question was what kind of director did he want to be? His peers were being lauded as revolutionaries. 'I wanted to be Antonioni, Bob Rafelson. Hal Ashby, Marty Scorsese,'[5] he recalled. He wanted to make films, not movies.

How do you make a 'distinguished' film as well as a movie out of such commercial material? It became the essential tension of the first half of his

career. He would thrive in that no-man's-land, never being entirely sure where he belonged. The artist with the common touch. Hollywood's blockbusting auteur. Throughout the making of *Jaws*, he would be plagued by the idea he was caught up in a pricy exercise in exploitation.

Career stratagems were never far from Spielberg's mind. With *The Sugarland Express* still to be released, he had set up deals across town, both a sign of his ambition and a canny mitigation against the potential failure of his first film. Talked out of a period romance called *Lucky Lady* (which had a timbre of *Indiana Jones* about it, and Paul Newman ready to commit), and with his prize UFO project at Columbia needing serious rewrites, Zanuck persuaded him of his obligation to *Jaws*.

The dog-eared legend has Spielberg giving birth to the studio blockbuster,

Above: Few directors can muster a crowd scene like Spielberg, who takes his camera into the water and the heart of the panic as shark fever spreads.

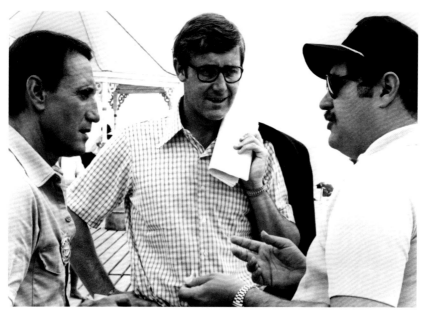

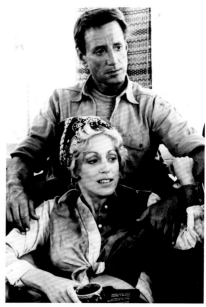

for good or ill. Buy into the theory of Peter Biskind's celebrated history of seventies Hollywood, *Easy Riders, Raging Bulls*, as many do, and the success of *Jaws* put an end to the decade's procession of artistically cogent, ground-breaking films being made by Spielberg's auteur-dubbed peers. Which overlooks the fact that *Jaws* itself is as ground-breaking as any seventies darling. Moreover, Spielberg wasn't the only one who sensed the potential in the book. In a sense, he was a director for hire. Here were two producers dealing in high concept – an 'IP' (intellectual property) in modern terms; before Spielberg himself became the IP – and the studio had set a strict release date of Memorial Day 1975 to ride the book's surge to the top of the best-seller charts. An urgency that may have been the root of their problems.

They were of one accord, producers and director, ambition overriding common filmmaking sense: they would shoot out at sea, finding some relatively sheltered spot on the unforgiving Atlantic coast, ride the tides and ride their luck. Something that had never been done before. The idea of a tank appalled Spielberg. To fake their limitless ocean with process shots. 'We underestimate the intelligence of the audience,'[6] he said, craving the documentary verisimilitude he had seen in *The French Connection* and *Midnight Cowboy* for his monster movie.

More pressing was the script. Benchley's three drafts had, at least, excised distracting subplots featuring an affair between Hooper and Brody's wife (the excellent Lorraine Gary) and links between the mayoral office and the mafia. The budget of $3.5 million was based on the uncredited four-week rewrite by playwright Howard Sackler, an island dweller and experienced diver. But it was left to Gottlieb, hired eleven days before production, to remedy the script's shortcomings *during* the shoot. This included cutting much of his own part. Gottlieb would also provide the world

Above left: One star and two writers – *Jaws* star Roy Scheider (left) listens to *Jaws* screenwriter Carl Gottlieb (right), as Jaws novelist Peter Benchley (centre) looks on.

Above right: Out-of-towners – Chief Brody (Scheider) and his wife Ellen (Lorraine Gary) share a quiet moment away from the madness of Amity.

with *The Jaws Log*, his seminal account of the making of the film.

Then there was the question of how do you train a great white shark to act. That idea had genuinely been discussed, until it became clear great whites don't take to being told what to do. Ahead of production, second unit shots of a great white were captured off the coast of Australia for the sequence of Hooper being trapped in the shark cage. Per Zanuck's instructions, a diminutive four-foot-eleven diver was employed to make the shark look bigger. But that was a real shark looking for a real meal.

So they happened upon the solution, which was to torment them through the long weeks of production. They would make a mechanical shark. Encourage Robert A. Mattey out of retirement, the man who had built the giant squid puppet for *20,000 Leagues Under the Sea* (they'd all loved that), and have a polyurethane coated *Carcharodon carcharias* to do their bidding. Mattey did sketches, made models. He figured out a pneumatic control system, whereby they could operate their full-sized great white via tubes of compressed air (anything electric would short out in the water).

Each christened Bruce, after the director's lawyer, there was one full twelve-ton model for front-on or overhead shots; and there were two relatively more agile half-models of the shark for the left and right sides. They resembled Damien Hirst's famous sculpture of a bisected tiger shark.

Below: Open wide – a weary Spielberg aims a close-up at the notorious mechanical shark, known to history as Bruce, after his actually rather likeable lawyer Bruce Ramer.

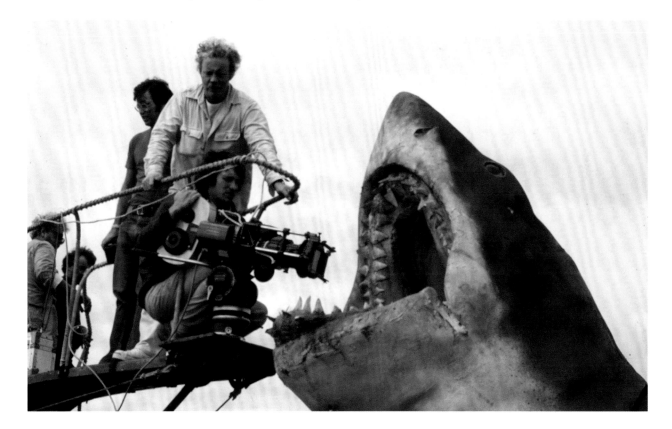

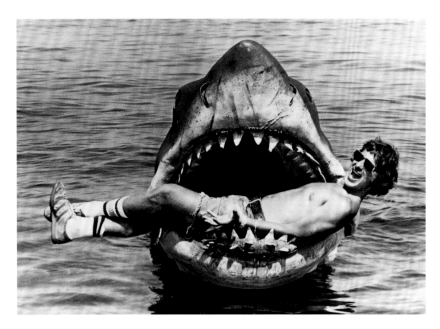

Though it is more often said that Hirst's shark reminds people of *Jaws*.

Bruce and his half-brothers were constructed in a warehouse in the San Fernando Valley. Spielberg took his Movie Brat buddies Brian De Palma, George Lucas, Hal Barwood, and Matthew Robbins to the workshop – dubbed 'Shark City'[7] – to gauge the progress. Maybe John Milius was there too. De Palma stuck his head into its open mouth, and for a joke Spielberg clamped it shut, and then couldn't get it to open again. Or maybe it was Lucas with his head in the shark. Myths.

These gargantuan puppets were designed to be attached to a crane arm which was attached to an underwater platform that ran along tracks, with a tangle of tubes running to the operating barge like something out of a Terry Gilliam movie. Divers would be on hand to do running repairs, and there were many repairs. The salt water ate the skin and rusted the frame, with barnacles gathering on its belly.

The human cast, which now seems so indelible, so fixed in our minds, was born out of Spielberg's edict on no movie stars. The audience mustn't 'be used'[8] to the characters, he said. So Charlton Heston was resisted for the role of Brody, despite publicly proclaiming his readiness to play the part. Spielberg had met Scheider at a party, and appreciated what Gottlieb calls the 'icy competence'[9] the actor gave to resilient cops in *The French Connection* and *The Seven-Ups*. Ironically, Lee Marvin, Spielberg's ideal Quint, was away fishing. Then the leathery Sterling Hayden from *Dr. Strangelove* had tax issues, so couldn't leave his boathouse in Paris. So Brown suggested the British character actor Shaw, most recently the duped villain in his and Zanuck's Oscar-winner *The Sting*. Spielberg liked him best as the stony assassin in *From Russia With Love*.

Hooper was interesting. Hooper was the part that bore the closest resemblance to the director: the fast-talking realist, the geek, the scientist,

with a brusque, defensive humour. They had tried Timothy Bottoms and Jeff Bridges, when George Lucas suggested the unconventional talents of Dreyfuss, having directed him in *American Graffiti*.

They arrived to disrupt the seasonal flow of life in Martha's Vineyard on 2 May 1974, which offered the perfect Amity, with its clapboard houses and allegedly negotiable waters in the Nantucket Sound. The first weeks, devoted to the conflict between Brody and Murray Hamilton's mayor, determined to keep the beaches open for the lucrative Fourth of July, were achieved with good pace and artistic control. Belying his age and inexperience – he was younger than most of the crew – Spielberg corralled the production, pushed his shots, orchestrated his panic.

Then they went to sea. Defying the classic three acts, the film is essentially constructed around two: the first on land, the second on the water. One crowded, the other reduced to three men in a boat.

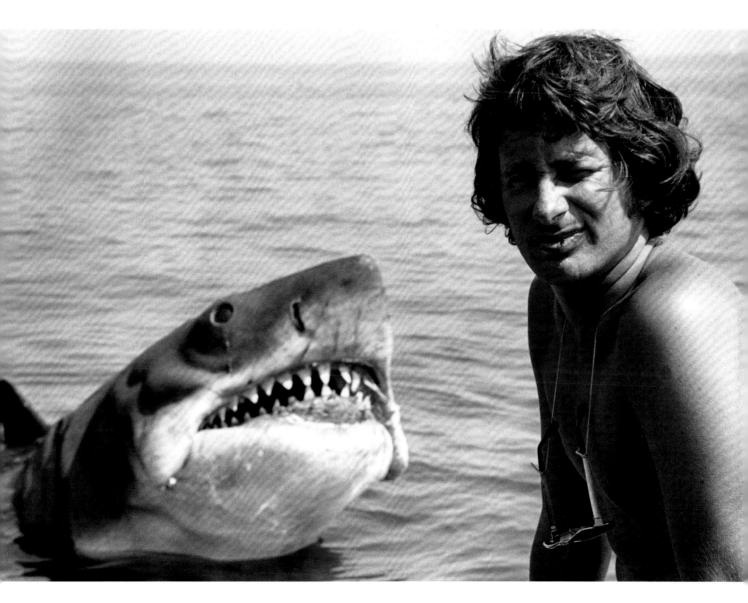

Which is when the production ran over schedule. And over-over schedule.

The call would come in, 'The shark *is* working!'[10] And there would be a mad scramble to get the director, clad in his wetsuit, out to the *Orca*, Quint's ramshackle vessel, a boat as weather-beaten as its captain. But the machinery would gum up again. Even when it worked, the shark looked as if it had palsy, rising to the surface boss-eyed. They would have to wait, and wait, as the light was squandered. There was both too much time, and never enough. The classic filmmaking joke to the power of ten: hurry up and wait.

Spielberg bewailed the limits imposed upon him. The time it took to anchor

Above: As much as the model great white drove Spielberg to distraction, viewed through an ironic lens, if the shark had worked any better the film would have been far worse.

the boats. The sailboats that ambled across the horizon. The limited number of compositions. 'I found myself out of shots really on the third day at sea,'[11] he recalled. He had tried to quit at least twice, but when Universal CEO and mentor Sid Sheinberg visited the set to witness their struggles and plead with the director to abandon ship and reconvene in a studio tank, Spielberg stood firm. He wanted the reality. It was like a mantra.

'Reality is costing us a lot of money,' Sheinberg warned him.

'I understand that, but I really believe in this movie,'[12] he replied.

With the shark refusing to play, he was shooting anything he could, inventing the shots, keeping the camera on the actors, catching details. Things he wondered if he would ever use; the very things that would give the film such texture.

For the scene where Bruce finally gets his close-up, flopping onto the stern of the *Orca*, tipping it *Titanic*-like into the ocean, with Quint sliding inexorably into the titular maw, Spielberg had envisioned the shark bursting from the water and slamming through the boat's flimsy bulwarks. Only Mattey admitted he had saved budget on the internal motor, and there wasn't the power for the shark to do any more than flop like a drunk. It looked like a joke. Yet fifty years later we treasure its strangeness.

On 17 September 1974, summer's end, shooting finally drew to a close with the shark blown to chewy pieces. The crew yearned for the sanity of the mainland, and the island was sick to death of them. Spielberg wasn't even there. The one man who been present for every take, never allowing his doubts to surface, primed the shot with the camera team, checked the lens, then fled the scene, certain the crew planned to toss him overboard in an act of exhausted merriment – he was right, and they made do with having the remaining department heads walk the celebratory plank. Spielberg wanted no part of the wrap party, 'no sentimental hugging,'[13]

Above: A night-mayor on Amity Island – posed in a fin-shaped triangle, Mayor Vaughn (Murray Hamilton) refuses to listen to reason from ichthyologist Hooper (Richard Dreyfuss) and Chief Brody (Roy Scheider).

Opposite: Life's a beach – Brody patrols the water's edge, while Spielberg catches three shades of blue from sky to sea.

sensed Gottlieb. A ritual was born, a lucky habit and an act of self-preservation against the japes of stir-crazy grips – always leave the night before.

Tally it up and *Jaws* was a catastrophe. A 55-day shoot had run to 159 days, so 104 days behind schedule. The budget had doubled to $7 million (later estimates suggest $10 million, but that could be more myths). Careers have drowned for less.

That night in a Boston hotel bar, awaiting the morning flight to Los Angeles, Spielberg and Dreyfuss screamed at one another, delirious with relief: 'Motherfucker, it's over! It's over!'[14] Later, the director sat bolt upright in bed, struggling to breathe, anxiety worming through his system until he doubled over and vomited. For months afterwards, he

would claim to be plagued by dreams that he was still filming.

Jump cut. To the Medallion Theatre in Dallas on 26 March 1975, where despite a warm evening they had a full house for their first preview. The cinema had just played *The Towering Inferno*, the kind of pre-packaged, harum-scarum, star-littered disaster fodder Spielberg was about to render obsolete. At the point where the Kintner kid disappears in a fountain of red, a man ran for the lobby and threw up on the carpet. He then went into the bathroom, tidied himself up, and returned to his seat. They screamed with laughter at Scheider's beloved ad-lib, 'You're gonna need a bigger boat.'[15] Moments and lines that slipped out of the film to become fixed in our collective memory. Spielberg

can still recall the rain of popcorn, each grain picked out against the screen. A second preview in Long Beach, California ended with a standing ovation.

Universal planned for an unprecedented mass-market release, a paradigm-shifting 400 screens, while the director sought one last shot. It was in editor Verna Fields' pool, covered in a sheet of tarpaulin and given a murky consistency with the help of a half-gallon of milk and flecks of tin foil, that Ben Gardner's bloated head lunged out of the gouged hull like a jack-in-the-box. One of the great cinematic scares. Totting up his manipulations, Spielberg's 'four-scream movie' was now a 'five-scream'[16] movie.

Another jump cut. To 20 June 1975, when barely fourteen days after its release

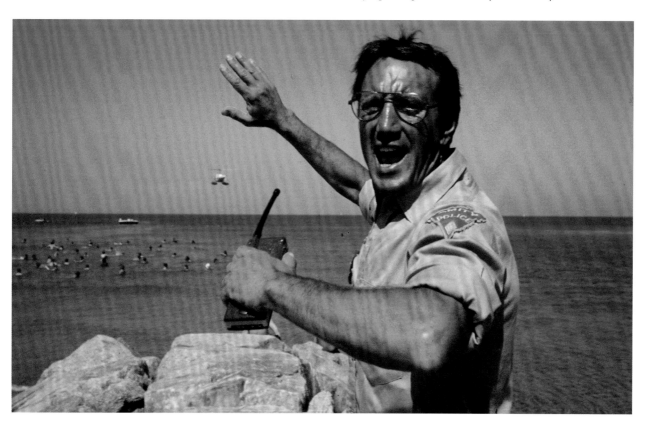

Jaws turned a profit. By 5 September, just under a year since the shoot had drawn its last breath, it was the most successful film of all time.

So the question is what went right? What sent the critics reeling, and then to their typewriters eager to express their reaction to the film's calculated effect? 'Perhaps the most perfectly constructed horror movie of our time,'[17] raved *The Hollywood Reporter.*

Jaws was the movie all those disasters added up to. Plain sailing would have made it something else, maybe just a decent horror movie, maybe not even that. Would we even have Spielberg without it? The success of *Jaws* granted him a freedom that shaped a monumental career.

We treasure *Jaws* both for its success – as a defining and revolutionary thriller – and for its mythology. No Spielberg film has ever been as pondered, debated, and had its cinematic guts split open to spill onto the wharf of public conjecture, to see what went into it. The seventies director who redefined convention – which is not the same as saying he has ever been conventional – Spielberg's daring is an expression of his artistic drive. An instinctual transcendence. How else would you tell this story? How else would you summon the salty authority to convince audiences? The more his talent was tested, the more inventive he became, filmmaking itself the inspiration. It is an art governed less by what he wants to say than by what he wants *us* to feel.

The two most important collaborators on *Jaws* came during post. Actually, this isn't entirely fair. The editor, Verna Fields, known as Mother Cutter, had been present on the island, shuttered away in her room, making sense out of the footage or cycling to set. She was older, wiser, unsure about this bottom-feeding disaster

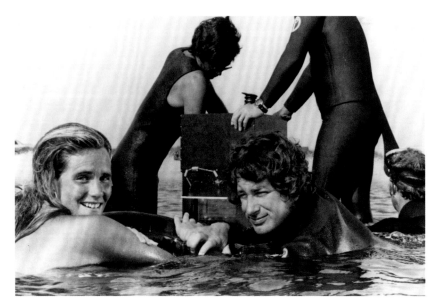

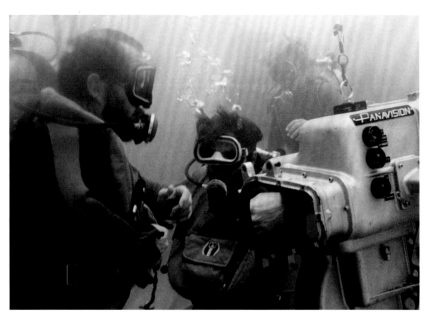

Top: Scream queen – Susan Backlinie (who plays the first victim Chrissie) poses beside a pensive Spielberg as they shoot in the shallows.

Above: Capturing below-the-line scenes of Richard Dreyfuss's Hooper for the shark-cage sequence, filmed in the MGM tank.

Above: In the days before video playback, the only way to show Roy Scheider (left) an image was for Spielberg to go through the actual frames of celluloid, while editor Verna Fields (right) holds up the precious film.

movie, but certain there was something in the footage. She was the one who made sense of the miasma of uncatalogued shots from the *Orca*, grabbing the seconds of useable footage. The *New Yorker's* Pauline Kael loved her 'tricky' editing rhythms: 'Even when you're convulsed with laughter, you're still apprehensive.'[18]

A crucial component of Spielberg's gift was established – latent comedy. The way terror gives way to sudden stabs of humour. Is this why it all feels so honest? Life is funny.

The other great collaborator was composer John Williams. After *The Sugarland Express* and *Jaws*, Fields was only a two-time thing (snide myths have Spielberg resentful about how much credit she was given), whereas Williams was a career move. The joke is that when the composer played the director his shark theme, a minor second interval formed of two basso notes, Spielberg was unimpressed. This was 'instinctual, relentless, unstoppable,'[19] conjectured Williams.

'I expected to hear something weird and melodic,' recalled Spielberg, '... I thought he was putting me on.'[20] Play it again, John. And again. He realized that Williams had 'found a signature for the entire movie.'[21] It is the most recognizable theme in history, this aural imprint of the encroaching shark. Dread as a vibration. Across the board, Williams caught a breeze of genre-parody in his pirate jigs, the soaring themes for the *Orca*, the mustering fugues as the shark cage is constructed, to send Hooper to the deep.

Jaws is a masterpiece, and masterpiece it is, because we forget it is a horror movie. It's like an act of hypnotism; Spielberg makes us believers. In this dyspeptic, we-had-it-coming book, he found a tableau for his innate talent to tell

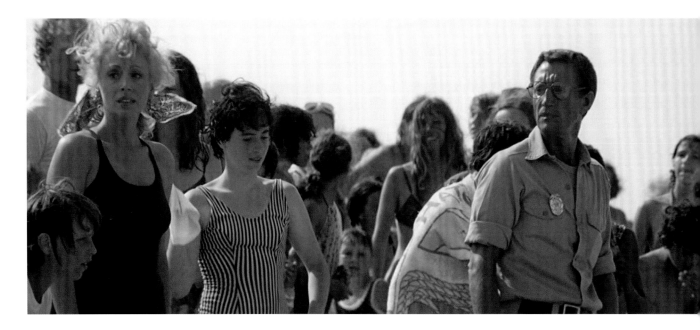

a story in images. His outrageous verve with a set-up. That far-fetched realism. In the face of the direst of circumstances, indeed quite because of them, he demonstrated a natural shorthand, a capacity to occupy our emotions and needle our imaginations.

For all that the script was being assembled in an ad-hoc frenzy, pages delivered overnight by Gottlieb, stationed in the same island house (known as the 'Log Cabin'[22]) as Spielberg, the dramatic architecture is stunningly precise. Notice the book on sharks that broody Brody can't tear his eyes away from – a joke at the film's own expense (as are the kids with a fake fin of a fake fin). This is the first glimpse we get of any shark: a taste, placidly on page, from which to assemble a monster in our minds. All mouth, all teeth, with those doll's eyes. And here is a photograph of a great white tearing into an oxygen canister, laying down track for the final confrontation: 'Smile you sonofabitch.'[23]

From the start, Spielberg tunes the film to an anxious key. Susan Backlinie's screams as the skinny-dipping mermaid Chrissie, the first victim, is swept absurdly back and forth in the grip of the unseen attacker. The next day, with her remains washed up on the beach, there comes the shrill cry of gulls and the shriek of a police whistle.

Jaws is more than a film about a shark. The shark is the threat, against which a town is found wanting. It's a film about human frailty. Spielberg's fantasies are anchored by gilded moments. What we come to think of as the Spielberg touch – the caress of the real across the rules of genre. The delicacy of those character moments, such as a troubled Brody at the dinner table touched by the sight of his young son (local find Jay Mello), spontaneously aping his movements.

The filmmaking is so deft.

The rich, blanketing blue of the sky over Amity was inspired by the

Opposite: The fear factor – wife and husband, Eileen (Lorraine Gary) and Brody (Roy Scheider) hear the cries from the direction of the boating bond, where their son is in the water.

Below: The handsome novelist Peter Benchley, paying the production a flying visit, was roped in to cameo as a roving television reporter, which happened to be his former vocation.

paintings of Andrew Wyeth. The town, through Brody's creased New York eyes, looks sickly, and is soon overcrowded, paradise transformed into a honking, squabbling, worrying morass of shark food. With its fishing tackle shops and marching bands, the place is as perversely all-American as Lumberton in *Blue Velvet*, another town where it's what's beneath the surface that matters.

Those beach scenes come with a lifelike bustle more free-wheeling Robert Altman than clockwork Hitchcock. Spielberg shoots the throng from the idle perspective of a sunbather. All the happy campers, clumped in holiday snap poses, drowsy with sun-baked leisure. He will be one of the masters of the crowd shot, finding meaning in multiplicity in so

many films: *Close Encounters of the Third Kind*, the Indy movies, *Empire of the Sun*, *Schindler's List*, *West Side Story*. Slashes of yellow, in doomed Alex Kintner's lilo or his tremulous mother's hat, encode the land. Blue encodes the water. The sea glitters, but never looks inviting.

There are moments of cinematic virtuosity. And across the years to come, through hit upon hit, Spielberg's flare is often forgotten amid the overall effect his films have upon us. That reverse-zoom dolly, borrowed from Hitchcock's *Vertigo*, travelling up the beach and into Brody's face, the lens zooming out as the camera dollies in, remains an unforgettable evocation of horror. Or putting the camera in a water-tight box and sending it bobbing among the swimmers, the

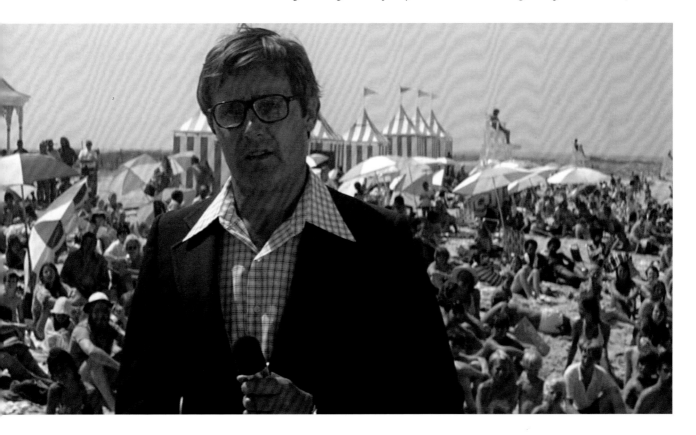

shot half-above and half-below the water. Clock how Spielberg frames his characters in trios, all these testy triangles like a shark's fin.

Even on the boat, amid days when they returned with nothing, the necessity of switching to handheld cameras (with operator Michael Chapman, the film's unsung hero, absorbing the pitch and yaw beneath his feet) gifts the film a *vérité* intensity, as if we are there too, cramped, waiting for the creature to show up.

Spielberg once declared that what had drawn him to the book was 'the last 120 pages when they go on a hunt, a sea hunt for the great white shark, and that extended drama.'[24] These three men who were against each other, united to fight the enemy. That was where he would stay truest to Benchley's novel. And express the optimism that had cynics berate him as populist and uncool.

'They would evolve into likeability,'[25] declared Spielberg. Even that sourpuss Quint. Besieged on that boat by their production travails and the antipathy of the elements, the actors gained a priceless commodity – rehearsal time, a chance

to interact and develop what was on the page into living, breathing dimensions on screen. Their frustrations evoked an emotional undercurrent on screen: Shaw and Dreyfuss's marked disdain for one another could have been a blurring of actor, character, petrol fumes, and salty air. As Scheider stared gloomily toward the horizon, Dreyfuss would endure Shaw's jibes, then sneakily drain his whiskey into the currents. The actors were given room to improvise as they never have again on a Spielberg film.

Kael saw it as a post-Vietnam disaster movie, in which genre conventions are upended. 'It belongs to the pulpiest sci-fi monster-movie tradition, yet it stands some of the old conventions on their head.'[26]

Old Hollywood masculinity is mocked. They are a hardtack crew, uptight in that seventies way. Spielberg liked this uncertainty in his characters. They sway into human foibles, they can look tough, but we get them. Brody was to have 'all the problems, all the faults of a human being,'[27] said Spielberg, including the director's own fear of the water.

Quint's basso-profundo proclamations are as drunkenly two-note as the score, but there is a tease in Shaw's icy-blue eyes. Brainiac Hooper is full of fake brio, and Dreyfuss gives him a neurotic cartoon snigger. 'It reminds you that a boy is making the film,'[28] says Antonia Quirke in her peerless blow-by-blow *BFI Modern Classic*. Dreyfuss was launched as Spielberg's alter-ego and chief conspirator, planning in advance the scene where Hooper caricatures Quint crushing his beer can, by crumpling his Styrofoam coffee cup. It's nearly a satire.

Out of the flow of the entire film, Quint is finally granted depth beneath the Ahab posturing. Around another dinner table, we get the fabled *USS Indianapolis* scene: Shaw's mesmerising, sepulchral, Hemingway-taut monologue (shot over two nights) based on the true story of the torpedoed vessel that had delivered the bomb for Hiroshima, and the victims being picked off by tiger sharks. 'At first light, Chief, the sharks come cruisn','[29] he growls in another spellbinding *Jawsian* contradiction, telling us the gothic anecdote rather the showing it to us.

Right: Quint was the last of three heroes to be cast, after Lee Marvin and Sterling Hayden proved unavailable or unwilling, but the icy-blue eyes of British actor Robert Shaw feel indelible now.

Below: They're going on a shark hunt - the three heroes Quint (Shaw), Brody (Scheider), and Hooper (Dreyfuss) head out to sea as the film's second half switches into an adventure mode.

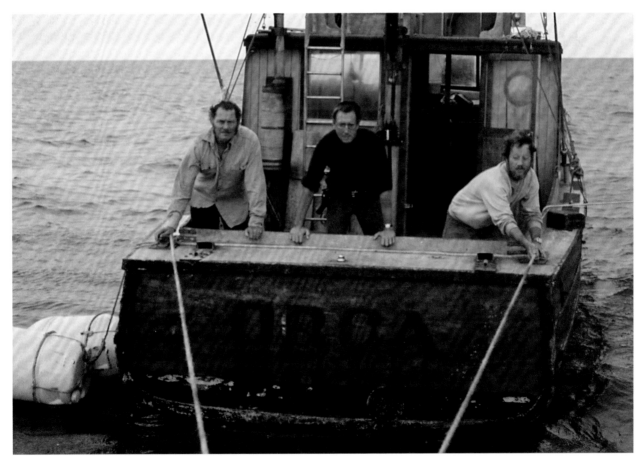

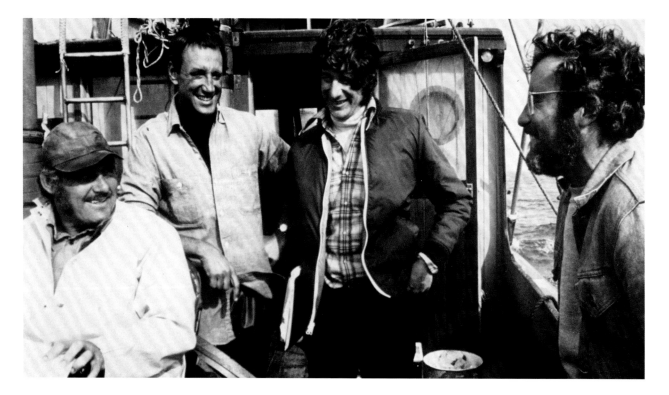

Who wrote the damn thing is another myth: let's stick with it being conceived by Sackler, embellished to nine pages by John Milius as a favour, and trimmed to consumable length by Shaw.

Ever since that fateful summer, argument and counter-argument have pulled the *Jaws* conversation in different directions. A film so popular, so era-defining, *so good* was bound to be thrown onto the autopsy table. There are those that hold to its purity being a godsend. That it is precisely what it says it is: an exercise in stirring primal fears about a great white having its fill of tourists, and the sturdy men who hunt it down, three Beowulfs in a boat. Derek Malcolm, pondering its virtues in *The Guardian*, saw it as 'such a cracking piece of entertainment that you don't have to make excuses for it.'[30] This splendidly

shrewd cinematic equation – calculated to break us into submission. 'It means nothing at all,'[31] insisted film historian David Thomson.

And there are those certain that will not do, claiming that *Jaws* is as richly veined in thematic potential as its ancestor *Moby Dick*, a symbol upon which anything can be projected.

Benchley's novel, for a beach read, was drawing from a classical mode: mankind against the ocean, humanity cowering before implacable nature. Here was Melville's aforementioned *Moby Dick*, of course; but also Coleridge's *The Rime of the Ancient Mariner*, Hemingway's *The Old Man and the Sea*, even Homer's *Odyssey*. Spielberg mentioned Ibsen's *An Enemy of the People*, the late play about a environmental cover-up and the local self-serving townspeople.

" ... such a cracking piece of entertainment that you don't have to make excuses for it."

Derek Malcolm

Opposite: All smiles – amid the intense stresses of shooting the open-water sequences, Robert Shaw, Roy Scheider, Spielberg, and Richard Dreyfuss share a rare moment of contentment on the deck of the *Orca*.

Right: View from the top – Spielberg makes his case to producers David Brown (left) and Richard D. Zanuck (right).

Below: Spielberg stares into the jaws of his dilemma – the scale model great white was mounted on a crane attached to a moving platform somewhere below the water, and painfully camera-shy.

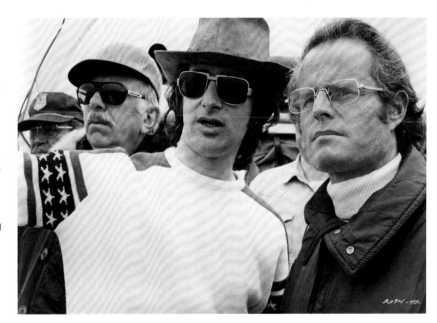

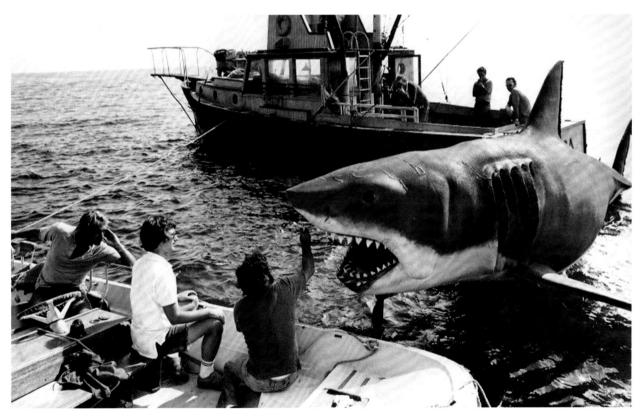

So is *Jaws* political? Does Hamilton's oleaginous mayor look like Nixon? Does the sheepish coroner resemble Kissinger? Castro decided it was a Marxist picture, with the blinkered mayor oiling the capitalist wheels. 'I'm not really that preoccupied with being the spokesman for the paranoid seventies,' claimed Spielberg in 1978, 'because I'm not really

that paranoid.' [32] But there is a shiver of something, a disturbance on the water, a neurosis in the air. The shark is the first in a trilogy of homeland invasions.

The Freudians naturally had a field day. The ever-hungry shark is a phallic symbol, raping poor Chrissie. Or a *vagina dentata* rising from the deep to consume the trite machismo of Quint.

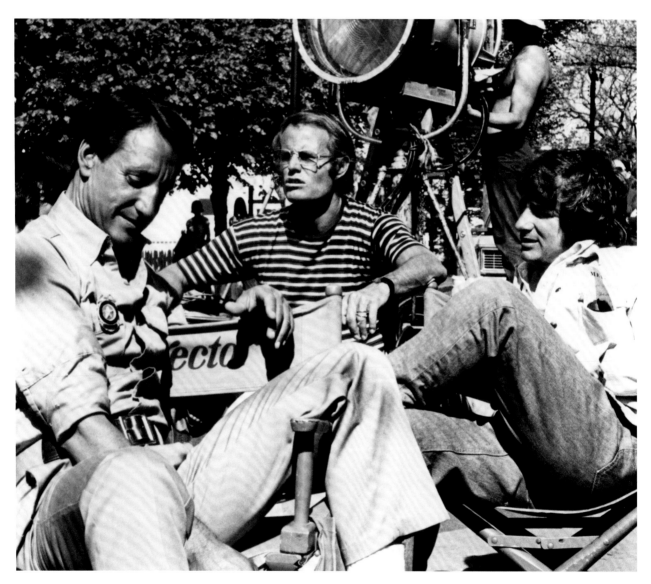

Below: Steady as she goes – star Roy Scheider, producer Richard D. Zanuck, and Steven Spielberg bask in the simple pleasures of shooting on land. The early scenes filmed on Martha's Vineyard were deceptively efficient.

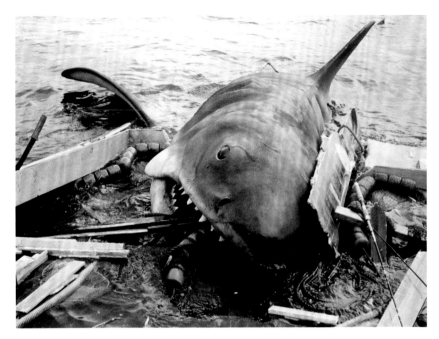

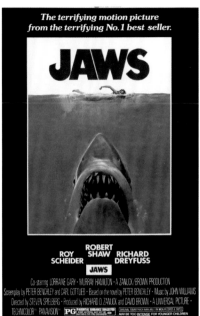

The terrifying motion picture from the terrifying No.1 best seller.

JAWS

ROY SCHEIDER ROBERT SHAW RICHARD DREYFUSS

JAWS

Co-starring LORRAINE GARY · MURRAY HAMILTON · A ZANUCK/BROWN PRODUCTION
Screenplay by PETER BENCHLEY and CARL GOTTLIEB · Based on the novel by PETER BENCHLEY · Music by JOHN WILLIAMS
Directed by STEVEN SPIELBERG · Produced by RICHARD D. ZANUCK and DAVID BROWN · A UNIVERSAL PICTURE ·
TECHNICOLOR® PANAVISION® PG PARENTAL GUIDANCE SUGGESTED ORIGINAL SOUNDTRACK AVAILABLE IN MCA RECORDS & TAPES
····MAY BE TOO INTENSE FOR YOUNGER CHILDREN

Above left: When finally breaking cover and sinking the *Orca*, the shark was laughably underpowered. Yet fifty years later there is something otherworldly about the confrontation - as if we know it to be a model, but simply don't care.

Above right: The iconic poster for *Jaws*, arguably the most famous movie poster of all time, was the creation of artist Roger Kastel, and first appeared on the paperback version of the novel. The original has been missing for nearly fifty years.

Pushed to interpret the film's monumental success – emptying the beaches and filling the cinemas, so said the myth – Spielberg kept it simple: it was a film not about a shark per se, but about fear, particularly fear of the water. The thing we *can't* see.

The defining stroke of genius lies in *not* seeing the shark. The dailies had revealed something to both the studio and Spielberg – despite everything the film looked good, as long as you didn't see Bruce gurning in the water. A strategy emerged, though Spielberg had insisted to Zanuck that he would hold back the star's entrance for an hour. So attuned to the audience's impulses, he began to imply, to suggest, to *project* the idea of a shark through underwater POV shots snaking through the kelp; with the bright yellow barrels, harpooned into its skin, and the remains of a jetty, swivelling toward the bumbling fisherman; and through the swaying throb of Williams's music.

To paraphrase Stephen King, terror is 'the knock at the door'[33], the thing you don't see, only imagine. Its lesser sibling, horror, is what happens once the door is opened. Once the shark shows its face. Arguments have even been made on behalf of poor old Bruce: as Chuck Bowen wrote in *Slant*, 'The shark, effectively built up as an object of myth and obsession for the first half of the film, would be a crushing disappointment if it looked "real."'[34]

The idea of the film being made today, liberated by CGI, doesn't bear thinking about.

SHOCK AND AWE

Close Encounters of the Third Kind (1977), *1941* (1979), *Raiders of the Lost Ark* (1981)

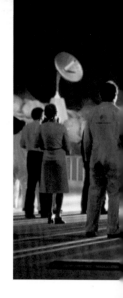

Having reshaped an industry, Steven Spielberg had an appointment to keep. *Close Encounters of the Third Kind* was the film he had been meaning to make all along. And now he had the commercial clout to do it. His first official venture into science fiction, his grand UFO film, was to be framed in a piercing yet personal light. As best friend and future collaborator George Lucas set his compass by the gee-whiz, serial science fiction of pre-war America with *Star Wars* (the *other* sensation accused of crashing the sophisticates' ball of the seventies), Spielberg went in search of a Kubrickian veracity and grandeur, only instilled with a warmth unknown to the great Stanley. *Jaws* had remixed genre with vivid, off-centre characters, but it is *Close Encounters* that sets out the Spielbergian manifesto.

This was the film he had yearned to make since boyhood, and his first film to be filled with yearning. Taking the most clichéd subject of all, the existence of extra-terrestrial life, Spielberg explored what it is to be human. At the same time, like Kubrick with *2001: A Space Odyssey*, and indeed like Lucas, he wanted to redefine what was possible on a cinema screen. *Close Encounters* reached for the heavens, while bestowing belief on Earth. Blockbusting realism. And its voyage to the screen challenged him in ways even a malfunctioning shark never could. Compared to *Jaws*, he would later confess, making *Close Encounters* was 'twice as bad – and twice as expensive as well.'[1]

It was a remake. Of a kind. Of *Firelight*, the homemade epic completed when Spielberg was sixteen, which depicted aliens invading American suburbia through the eyes of a broken family (that persistent theme). But the true source lies in the night his father, an amateur astronomer, drove a bleary-eyed six-year-old across the New Jersey night to watch the Perseid meteor shower among wide-eyed locals. 'That's probably the first time I became aware of the sky,'[2] recalled Spielberg. A memory replayed in the film when Roy Neary (Richard Dreyfuss) stirs his confused family to follow him back to the Indiana roadside where he witnessed UFOs, with views across the patchwork quilt of American farmland as quaint as the train set in their living room, a facsimile of the one Spielberg had grown up in.

CLOSE ENCOUNTERS OF THE THIRD KIND
1977 Director/Writer

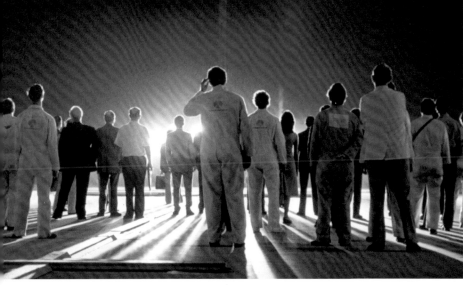

Left: The light fantastic – *Close Encounters of the Third Kind* inverted the classic invasion tropes of the genre for a heavenly meeting with an alien visitor.

Below: The landing site and lower portion of the Mother Ship were built inside a vast aircraft hangar in Mobile, Alabama. Their construction consumed enough electricity to power an entire city block.

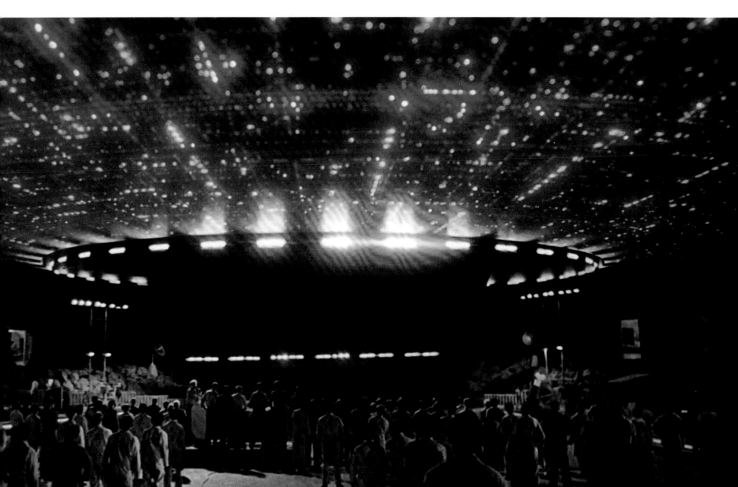

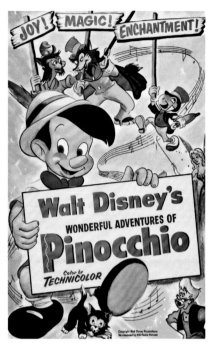
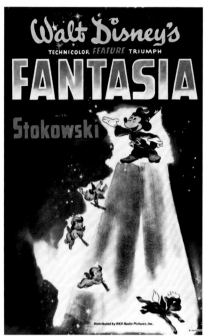

Right: The Disney classics have had a profound influence on Spielberg's entire career: *Pinocchio* and *Fantasia* provided the mood and the ending for *Close Encounters of the Third Kind.*

Movies played their part. He was haunted by two Disney memories, one magical, one more ominous. Jiminy Cricket singing 'When You Wish Upon a Star' in *Pinocchio* gave him a feeling. 'I pretty much hung my story on the mood the song created.'[3] While the 'Night on Bald Mountain' sequence from *Fantasia* provided him with 'the symbolic end zone of the movie.'[4]

In 1970, Spielberg wrote a short story, *Experiences*, about teens sneaking off in their cars to make out, only to witness strange lights in the sky. *Experiences* evolved into a screenplay called *Watch the Skies* – the final warning from the Howard Hawks-produced chiller *The Thing from Another World*. Infused with the paranoia of Watergate America, a science-fiction fable became a political thriller – *The X-Files* long before *The X-Files* – following a government coverup of UFO sightings.

Enter Paul Schrader. The lauded, complicated screenwriter of *Taxi Driver* had been introduced to Spielberg by husband-and-wife producers Michael and Julia Phillips. He was a fellow Movie Brat, part of the scene with Lucas, Scorsese, Coppola, and the others, and ran on dark currents that flowed out of a strict Calvinist childhood. In his hands, *Watch the Skies* became variously *Pilgrim* and *Kingdom Come*, for it was Schrader who introduced the religious aspect. The idea of Neary having an alien vision implanted in his head by a scorching beam of Damascene light. In the film, this translates into Devils Tower in Wyoming, the designated landing site for the Mother Ship, as conspicuous a hunk of American rock as John Ford's Monument Valley. It was Schrader who happened upon the 1972 book, *The UFO Experience: A Scientific Inquiry*, by astronomer and ufologist Dr J. Allen Hynek, a sceptic-turned-

believer who would serve as an advisor to the film. You can see him moving through the crowd as the lost pilots exit the Mother Ship, an academic Van Dyke, a pipe slotted into his mouth. It was Hynek who formulated the 'Close Encounter Scale.'[5]

A *close encounter of the first kind* is a visual sighting of a UFO.

A *close encounter of the second kind* is physical evidence of a UFO.

A *close encounter of the third kind* is contact with extra-terrestrial life.

Schrader and Spielberg would part ways. The writer never understood the director's Capra-like insistence on centring the story on an everyman, claiming they fell out 'along strictly ideological lines.'[6] There were sour comments later about being denied a credit.

In Schrader's stead came Walter Hill and David Giler (who would later work on *Alien*) and then Hal Barwood and Matthew Robbins, who made the significant

suggestion of the visitors kidnapping a child. Increasingly, Spielberg claimed ownership of the screenplay. Despite the contribution of all these writers in the scope of *Close Encounters*, he would insist that the final credit read 'Written and directed by Steven Spielberg.'

Michael Phillips saw a filmmaker who was 'still maturing as a person.'[7] As always, he was given to qualms. What if *Jaws* was a freak event that could never happen again? The unsinkable one-off? And he was launching into a hugely demanding film with no real idea of what the 200 special-effect shots, being invented by Kubrick's man Douglas Trumbull, would eventually look like on screen. Spielberg took to calling it 'science speculation.'[8]

UFOs are skimming the Earth like fireflies, leaving calling cards both physical and psychic. Their light has infected Neary (Dreyfuss) with Schrader's Pauline delirium. Who are they? What do they want? Why him? His family thinks he's going mad. Single mother Jillian Guiler (Melinda Dillon) wants her infant son back, stolen from her remote house in Muncie, Indiana, beneath a whirlpool of roiling clouds. Two everyday souls – the father a dreamer, the mother more pragmatic – drawn ineluctably, through the barricades of a military cover-up, to the most incredible event in history. Hitchcock's dictum, the ordinary thrust into extraordinary circumstances, taken to unprecedented altitudes of story.

What is still so radical is Spielberg's inversion of the red-baiting, B-movie fifties, jangling with the certainty that flying saucers are the harbingers of death rays – the doctrine of H.G. Wells.

Below left: Ufologist Dr J. Allen Hynek served as scientific advisor to the film, as well as taking a cameo. He formulated the 'Close Encounter Scale.'

Below right: Father of the Mother Ship – legendary visual effects supervisor Douglas Trumbull was chosen for his ground-breaking work on *2001: A Space Odyssey*.

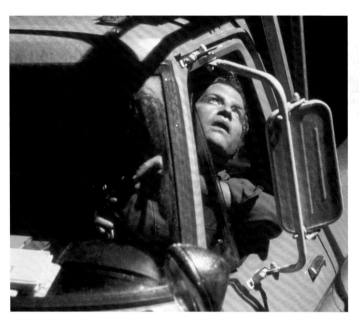

Close Encounters still feints toward the Nixonian paranoia of early drafts, with the government fairy tale of a toxic spill. Gassed cattle lining the roadsides. Neary ripping off his gas mask in an act of faith. Lights materializing into an angry chopper. But the revelatory tone is not peril but connection: hand signals, musical codes, and alien angels descending from starships amid Manhattans of beneficent light.

John Williams' score is, if anything, more integral to the narrative than in *Jaws*. Only now Spielberg was right. Williams pressed for a seven-note sequence for the interplanetary jingle to harmony 'When You Wish Upon a Star', but Spielberg held him back to a more assertive five. After 300 failed attempts, the notation has become as universal a herald for aliens as the two-note signature of *Jaws* is a foghorn for sharks.

Neary and Jillian's quests run in parallel to the witness accounts being accrued by the wry double act of François

Truffaut and Bob Balaban, scientists traversing the globe in the blink of a cut: India, the Gobi – opening the film in the Sonoran Desert in Mexico where a squadron of dusty fighter planes that disappeared over the Bermuda Triangle are returned, unaged and unoccupied. Documentary-sharp slivers of scientific fervour. Evidence contrasted with belief. The sensation of a film rising in pitch. The aliens are coming to America.

The casting of fellow director Truffaut, recalled *The Guardian's* Peter Bradshaw, 'was a left-field masterstroke.'[9] Behavioural expert Claude Lacombe is halfway to an alien, with the French New Wave darling wryly bemused to find himself on the strange planet of a Hollywood blockbuster. How opposite he is to Neary, the agitated American nobody-hero, Spielberg's alter-ego, scrabbling his way to enlightenment.

Never shy of expressing his feelings, Dreyfuss had grown tired of hearing about this UFO film day in, day out

Above left: The chosen one – Richard Dreyfuss as ordinary guy Neary in classic Spielbergian staring-up-in-awe pose.

Above right: Devils Tower – Neary gets his answer via the television set, a screen-within-the-screen shot that Spielberg would utilize again in *Munich*.

Opposite: The searchers – Neary and Jillian (Melinda Dillon) embody the film's essential mood of yearning.

during the interminable making of *Jaws*. Spielberg had been set on Jack Nicholson as his everyman electrician. The character is as roughhewn, and at times as manic and amusing, as the heroes of *Jaws*. Committed elsewhere, Nicholson asked Spielberg to delay production for an untenable two years. Dustin Hoffman, Gene Hackman, and Al Pacino were mentioned as alternatives, movie stars who could rustle up the lifelike over the godlike. In the end, laughed Spielberg, though slightly too young, Dreyfuss

talked him round: 'He had listened to about 155 days-worth of *Close Encounters*. He contributed ideas, and finally he said, "Look turkey, cast me in this thing."'[10]

Spielberg moved in ways so contradictory to the prevailing wisdom. Truffaut was in awe of how he gave such 'plausibility to the extraordinary', and scenes of everyday suburbia 'a slightly fantastic aspect.'[11]

There are threads of selfishness, the collateral damage of obsession, as Neary's rattled wife (the excellent Teri Garr)

wonders what has become of her husband. Spielberg is so good at marriage. Later in life, a father, he wondered if he could portray such eagerness to abandon a family.

How often his films run to the drive of unswerving men. Neary's all-consuming need to meet the Mother Ship, Indy's implacable quest for fortune and glory, the earthbound zeal in Schindler's urgency to save his workers, and Lincoln's ironclad determination to pass his bill. Behind them all, a director consumed by what he does.

Left: Home invasion – in a flood of orange light, the unseen aliens 'attack' the remote house of single mother Jillian Guiler (Melinda Dillon) and her curious son Barry (four-year-old Carey Guffey).

Below Referencing both Dorothy's arrival in Oz and Ethan Edwards heading out in *The Searchers*, Spielberg considered Barry opening the door to the alien light his greatest shot.

Neary's unheroic urges are a mirror for Barry (Cary Guffey), Jillian's four-year-old son, enchanted away by these Pied Pipers from outer space, who will turn out to be ancient children (indeed played by dance-school kids in prosthetic suits). Gazing upwards in the stalls, light falling on our dazed faces, we too submit to a state of childlike wonder and the innocent hope that there is something out there to save us from our lonely vigil in the cosmos.

Plucked from a school in Douglasville, Georgia, the best of 200 kids, Guffey's saucer-like eyes hint at the visitors to come. That smile is genuine – he thought filmmaking was a game. Guffey had never even seen a movie. Spielberg dressed as the Easter Bunny and had the makeup man in a gorilla mask to catch the surprise.

Barry's kidnap is Spielberg at his primal best. A mother's terror counterpointed by a child's giddy delight as the director builds to a phantasmagorical frenzy, a house possessed by cosmic poltergeists. Appliances dance like *The Sorcerer's Apprentice*. Light presses through every aperture like water on a sinking boat. The boy swings open the door to greet a molten orange sky as startling as the first glimpse of Oz. In 1991, this is the shot that Spielberg chose above all others to epitomize his work.

'That beautiful but awful light, just like fire coming through the doorway,' he recalled. 'And he's very small, and it's a very large door, and there's a lot of promise or danger outside that door.'[12]

Cinematographer Vilmos Zsigmond, playing a virtuoso's hand, recalled a young Spielberg almost drunk on the possibilities of cinema. He would watch one or two films a night during production, imprinting his findings into more and more storyboards. *The Searchers*, *It's a Wonderful Life*, *Bambi*, *The Birds*, *North By Northwest*, *The Day the Earth Stood Still*: it was a search for the transcendent. The schedule swelled like a tide. His head filled with visions like Neary.

Doubt swirled among the crew and fretful studio having to trust that Spielberg could draw this mystical film from his imagination. The budget leapt like an electron from one astronomical state to the next: $2.7 million, $4.1 million, $5.5 million, $7 million, $9 million, to land at a then staggering $19 million. All of it up on the screen. A mismanaged Columbia was already deep

in debt, with the bank asking questions about a film likely to ruin them.

This was the Movie Brat religion – to find greatness on the edge of chaos. The difference with Spielberg was that he converted the masses, even as his ambitions ran beyond the physical means of Hollywood. To create the box canyon in the lee of Devils Tower in which the spindly E.T.s will touch down, mere sets would not do. Production designer Joe Alves was instructed by Spielberg to 'scour America for a place that only my imagination told me existed.'[13] He found

it in a former aircraft hangar in Mobile, Alabama, where the soundstage could stretch to the size of a football field, and so high it developed weather patterns in the rafters. Built for $700,000, including acres of concrete and enough electricity to run a city block, it was a cursed, secretive place, consuming half of the schedule with endless delays as Trumbull would come by and demand more lights to match his models. Temperatures soared to 140 degrees. Spielberg would stare into the dark recesses beyond, thinking 'this set is my shark.'[14]

"That beautiful but awful light ... and there's a lot of promise or danger outside that door."

Joseph McBride, *Steven Spielberg: A Biography*

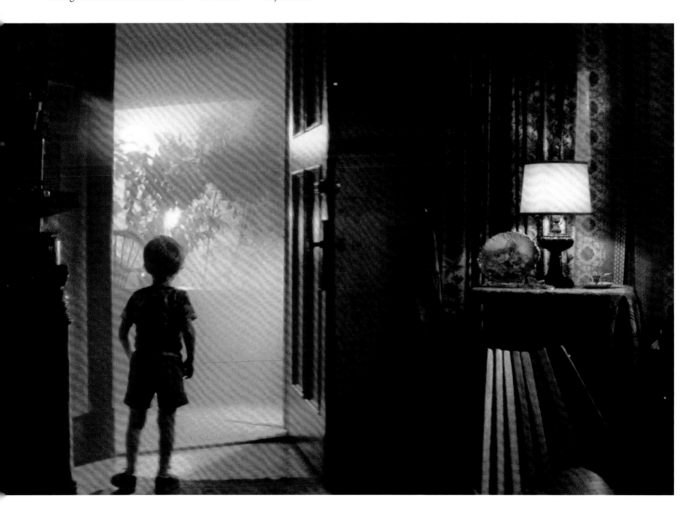

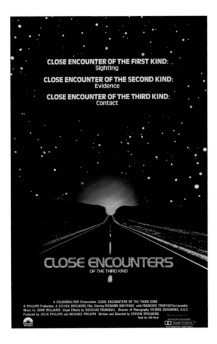

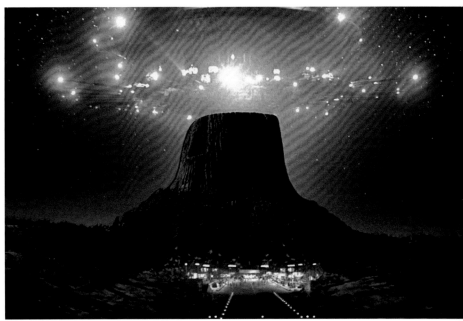

Opening on 15 November 1977, *Close Encounters* swept aside doubts and debts to make $306 million around the world. 'It's one of the great movie-going experiences,'[15] declared the *Chicago Sun-Times*. This was 'sensation as an end in itself,'[16] exclaimed the *New York Times*, forgetting how the light show is kept in abeyance by a study in human longing until the miraculous 43-minute landing sequence forged a new classicism.

Withholding the aliens was as much part of the design as it had been with the shark. The sightings of ships, pearlescent ice cream cones and Tinker Bell baubles that skitter across the darkness, are like the yellow barrels cresting the surface. However, *Close Encounters* is more consciously poetic. We think of it as a triumph of special effects, but in truth it is an ecstasy of light.

The Mother Ship is Spielberg absolving himself of an underpowered shark. The original concept was for a giant

Kubrickian monolith to smother the stars, out of which a heavenly beam would fall – all those radiant shafts were dubbed 'god lights.'[17] Looking out at a vast oil refinery during his daily commute to set in Maharashtra, India – this riddle of pipes and lights like sequins – Spielberg changed tack. He called for 'a city in the sky'[18] from Trumbull. Six feet in diameter, sculpted from plexiglass and steel, and lit by infinitesimal quartz bulbs and neon, the model gyrates to Williams' score with a Kubrickian grace, guided by a director certain that to hold his audience in a state of rapture was the prime objective of his chosen medium. 'The power of renewal and repeated surprise was clearly a vital part of Spielberg's being,'[19] realized critic David Thomson.

Enclosed in the dark of the mountain setting, light as dense as liquid streams out from the Mother Ship like a blessing, or a movie screen, into which a man escapes forever.

Above left: The mysterious release poster explaining the three stages of extra-terrestrial encounter. This brilliant marketing campaign made a boon of what we didn't see.

Above right: The mother of all spaceships – for the finale Steven Spielberg imagined a rising scale of spectacle, reaching a crescendo with the main event: a ship the size of Manhattan.

Opposite above: Cartographer-cum-interpreter David Laughlin (Bob Balaban) and behavioural specialist Claude Lacombe (François Truffaut) follow the extra-terrestrials' trail like prototypes of Indiana Jones.

Opposite below: After numerous failed experiments, the extra-terrestrials were entirely played by six-year-old girls, as they moved with more grace than boys.

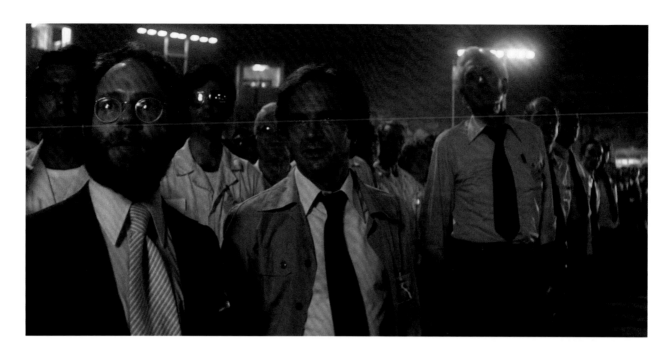

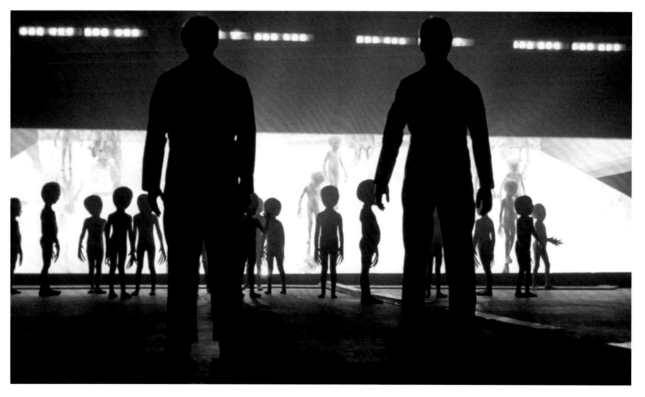

Success can make anyone a little crazy. Success on this scale gives the world *1941*. Spielberg's first war film, first period piece, and last outright comedy is the picture that spoils the picture. What a parade it would have made: *Jaws* and *Close Encounters of the Third Kind* into *Raiders of the Lost Ark* and *E.T. the Extra-Terrestrial*, the quartet that fixed our view of Spielberg (our unquenchable nostalgia for a nostalgic aesthetic). Four films, almost back to back, that became culture totems equal to *The Wizard of Oz*, *Casablanca*, or The Godfather. Four films enfolded into the rituals of life.

But *1941* interrupts the flow like a drunk at a wedding. To be kind, it might be a necessary exorcism. To rid himself of the urge to match the raucous, countercultural sprit of his peers, and the times. Campus comedy *National*

Above: Dark side of the Moon - Steven Spielberg went through torment trying to reach his vision for *Close Encounters of the Third Kind*, claiming it was ultimately a harder shoot than *Jaws*…

Right: … The young director was dreaming up things he had no idea he could pull off. Often he couldn't even describe what he imagined. He was Neary – in the grip of fantastical visions.

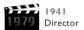
1941
Director

Lampoon's Animal House had been a big hit. And here was John Belushi doing the same wacko-lummox routines as a rogue pilot. To quiet the devil inside too. As a kid, Spielberg tormented his sisters with pranks; years later, paging Richard Nixon across the Universal commissary to see all the executives craning their necks. Now the millionaire Puck wanted to channel Preston Sturges, *Mad Magazine*, *Catch-22*, *Dr. Strangelove*, and the silent gods. And for good measure, transform his beloved Chuck Jones cartoons into flesh and blood. Jones was actually consulted at the design stage.

It was also a chance to get that fall from grace out of his system.

'*1941* was capriciously and lavishly over-budget and over-schedule, and it was all my fault.'[20] Spielberg tended to view his first true failure as a fit of the 'overs': overwritten, over-scored, and over-directed.

Somehow it is based on real events, the deluge of paranoia caused by a lone Japanese submarine firing twenty shells at the Californian coast on 22 February 1942, turned into a treacherously high-concept comedy by hotshots Bob Gale and Robert Zemeckis (later to prove more adept directing farce with *Back to the Future* and *Who Framed Roger Rabbit*). Set across one night and a tumult of storylines, their script, *The Night the Japs Attacked*, was passed to Spielberg by John Milius while they were out skeet shooting.

Spielberg shot and shot for a staggering 247 days on soundstages at Warner Brothers and on location in Malibu, Long Beach, and the Mojave, free from all restraint, the boy wonder, but untethered from a guiding vision like a barrage balloon floating out to sea. It was insecurity driving him, he said, not hubris. Each production had become a wrestling match with scale, but here it

Above left: The bump in the road – Dan Aykroyd and John Belushi keep it cool on the chaotic set of *1941*.

Above right: The madcap *1941* convinced Spielberg that he was never funny if he tried to be funny. So he never made a comedy again, and became all the funnier because of it.

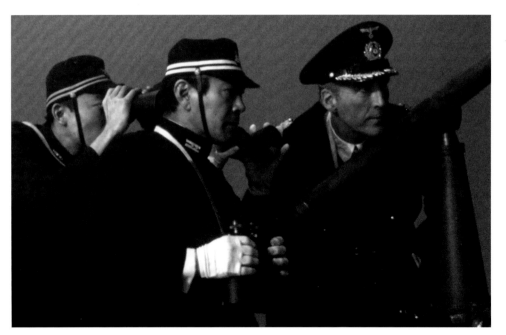

was about 'reaching for laughs'[21] that never came.

A co-production between Universal and Columbia, costing an eventual $26 million, brilliant barnstorming moments metastasize into carnivals of destruction crying out for a punchline. A fighter strafes Hollywood Boulevard, a Ferris wheel cartwheels into the Pacific, an entire house was built to be pushed off a cliff: *1941* is *all* set pieces. The models were exquisite: scale versions of Ocean Pier Amusement Park, Hollywood Boulevard, the La Brea Tar Pits. But Spielberg's technical mastery falls on barren ground.

There is a profusion of characters, but nowhere to hang our sympathy. The august Toshirô Mifune plays a stern Japanese submarine commander, Christopher Lee hams it up as Spielberg's first panto Nazi, while Murray Hamilton returns as a local coot; there's also Warren Oates, Slim Pickens, Dan

Aykroyd, Treat Williams, and Robert Stack. Salty character actors mingling with hipster comics. Spielberg had sent the script to John Wayne, with the unflappable General Stilwell in mind, but who still blubs over *Dumbo*. Wayne got straight on the phone to talk him out of making this damn fool movie.

'Is there anything honourable to destroy in Los Angeles?' growls Mifune from the belly of the submarine.

'Hollywood!'[22] cries his delighted subordinate.

There you have it. The point. *1941* is an excessive in-joke about Hollywood excess, and the madness of L.A. and America at large, past and present, which Spielberg even turns on himself. The opening gag, clanging with misplaced irony, has Susan Backlinie back to take a midnight dip as she did in *Jaws*. We even get a sorry *bar-dum*. Only now she is lifted from the water clinging to the periscope of a Japanese sub. And that

is the same desert gas stop in Aqua Dunce from *Duel*. In its way, *1941* explores similar themes to *Jaws* and *Close Encounters*: group hysteria, latent paranoia, America going nuts in the face of the unknown. But without the oxygen of anything human it is just nuts.

Not quite the turkey of repute, *1941* did poorly at the box office, but at $90 million turned a profit. Spielberg was as ready as he could be for the critical punches – the previews had been awful. It was another deluge. 'A movie that will live in infamy,'[23] squawked the *Los Angeles Herald-Examiner*. An 'oil spill,'[24] slammed the *Los Angeles Times*.

'I'm comically courageous when comedy isn't the home plate,'[25] reflected Spielberg. In other words, he could only be funny when taking things seriously.

1941's mania did, at least, serve as the perfect dress rehearsal for what came next. The chance to be madcap with great precision.

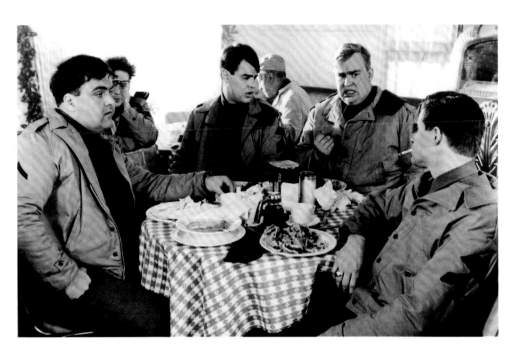

Left: Among the sprawling cast of *1941* were many stars to come, including Mickey Rourke (second from the left), Dan Aykroyd, John Candy, and Treat Williams.

Below: The part of the imperturbable (and real-life) General Joseph W. Stilwell went to Robert Stack (left) when John Wayne refused to have anything to do with the film.

The silhouette is instantly recognizable. Even back in that misty time when no one yet knew him by name, the hat, the broad shoulders, and the outline of a bullwhip spoke of a iconography that fell back through the ages of chipped machismo: Bogart, Wayne, Stewart, Flynn, Fairbanks Jr. Our response to meeting Indiana Jones was one of familiarity. He had the handsome face of Han Solo, but smeared in stubble, and broodingly intense. It's myth now: how Harrison Ford replaced Tom Selleck, whose heavy *Magnum P.I.* schedule lost him the role of a lifetime. His loss is our gain. Ford has something far beyond good looks: a crack in the veneer; a testy, parchment-dry, why-me humour, the school teacher out of his depth. We knew Indy to be a pastiche, not to be taken seriously, but he was no joke.

Blame George. *Raiders of the Lost Ark* was his idea. Lucas and Spielberg were on a beach in Hawaii, sandcastling away a vacation as *Star Wars* opened and *Close Encounters* entered post, when Spielberg idly espoused how he would love to make a Bond movie in the Connery mould.

'I've got something you might like as much as Bond,'[26] responded Lucas, waves lapping at bare feet, history in the making. To demythologize a perfect moment, Spielberg would recall talk of a 'series of *Raiders* films'[27] over a previous dinner.

Indiana Jones was born when Lucas' mind wandered from writing *Star Wars*. Researching snappy Saturday-afternoon 1930s serials, he pictured an adventurer-archaeologist who unearths supernatural artefacts. He called him Indiana Smith. This was *Zorro* spun with *Flash Gordon* and *Tarzan*, and a spy catcher called *Don Winslow*. *Star Wars* with cobwebs. *The Treasure of the Sierra Madre* with special effects.

'We'll keep it in the thirties, but we'll update it and make it modern,'[28] Lucas assured his friend.

Back in California, Lucas had another idea for Spielberg – about plundering the vaults of the studios with a revolutionary deal. How they would dismantle standard practice by only offering prospective studios a share of the profits once the

negative cost (the budget) had been recovered, no upfront distribution fees, no overhead charges. After some compromise, Paramount agreed, and would be richly rewarded. Spielberg was taking full control of his career. Moreover, he was now financially motivated to bring his film in on time and on budget (which he would do at seventy-three days and $20 million).

RAIDERS OF THE LOST ARK
1981 Director

The script evolved. Philip Kaufman delivered a first draft, taking Lucas' perquisites (the hat, the whip, the artefact, and the hero's name – purloined from his Alaskan Malamute and now surnamed Jones) and adding the Ark of the Covenant as the MacGuffin combined with Hitler's obsession with the occult. At this stage, they were all going to be called *Raiders* of *This* or *That*. After Kaufman came Lawrence Kasdan, with a knack for the snap and sizzle of forties dialogue, and a spiky brunette love interest named Marion (Karen Allen chosen over Debra Winger).

The plot was settled: in 1936, American authorities hire Indiana Jones, professor, archaeologist, obtainer of rare antiquities, to beat the Nazis to the Ark, the fabled Hebrew chest for transporting the Ten Commandments and hence some kind of receiver for the power of God, last seen centuries ago in deepest Egypt. Indy does his darnedest, but it takes Jehovah to melt the Nazis. God turns out to be far less benign than aliens.

Then the brainstorming really began.

Released on 12 June 1981, causing a joyous hullabaloo from Pasadena to Poughkeepsie, Raiders was the hit it needed to be, making a mighty $390 million – proof that Spielberg was indeed in possession of a godly gift for lighting cultural fires. 'Deliriously funny, ingenious, and stylish,'[29] enthused the *New York Times*. But there were those who wondered why Spielberg, after 1941, was so insistent on squandering his talent.

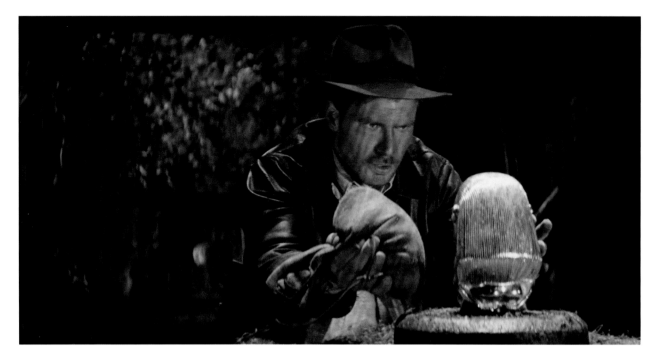

Pauline Kael wrote it off as 'impersonal.'[30] Then hadn't *Jaws* been calculated? Even Spielberg viewed himself as a gun for hire, albeit hired by his best friend. And this is exactly what happens when best friends get together to plot and play to their hearts' content. A sandpit spectacle constructed from sheer verve. Shot by shot, moment by moment, iconic image by iconic image, *Raiders* is the Spielberg recalled better than any other.

After that opening close-up of our hero, the tail end of the previous adventure continues as he negotiates a Peruvian tomb, rigged with a comic-book anthology of traps: tarantulas, spikes, pits, darts, the prize of a magnificent golden idol triggering a deep, grumbling mechanism, and a stone boulder that comes tumbling after the hero.

'This boulder is the size of a house,'[31] demanded Spielberg. It was twelve feet in diameter and 300 lbs of fibreglass rock.

Start as you mean to go on.

Lucas and Spielberg were film archaeologists delving for the magic of yesteryear Hollywood, delivering a self-reflexive commentary on the very idea of matinée excitement. The bursts of action are choreographed with the musical rigour of that trio of angelic clowns, Chaplin, Lloyd, and more than any other, Keaton, a hair's breadth from calamity. More than the caricature Nazis, Indy's enemy is Fate, or God, or the machinations of directors. He is trapped forever inside a film, forever pursued by a giant boulder. But it is Fate that will save him and his hat (the soul of the man) again and again. Here is Spielberg's living cartoon.

Point of fact: the Flying Wing sequence. The Flying Wing being the full-sized model of the screwy aircraft with which the Nazis are hoping to fast track the Ark into Hitler's hands, a plan Indy and Marion are going to disrupt by

blowing it up. It's a perfectly composed gag about chaos (*1941* inverted). The German beefcake (Pat Roach), a boxing career left behind in Düsseldorf or Bonn, preferring a fist fight to raising the alarm. The spinning propellors portending inexorable death as Indy is plonked on his tush by a punch, the butt of the slapstick routine, spitting out blood and dignity, with Marion trapped in the cockpit as flames lick at a petrol spill. This is slide-rule chaos, inches from absurdity. The list of such marvels is long: the bar fight in Marion's joint, the market chase, the Well of Souls, the truck chase … *Raiders* is not a film of special effects, though there are many, it is a symphony of physical filmmaking, thrills built like spring-loaded contraptions and stacked like tumbling dominos, cause and effect.

Shooting between Hawaii, Arizona, La Rochelle, Tunisia, and Elstree

Opposite: The original tomb raider - Indiana Jones (Harrison Ford) makes the switch for the golden idol in the immortal opening sequence to *Raiders of the Lost Ark*. It is Indy's curse never to keep hold of his prize.

Below: Duel in the sun - Indy is confronted with a scimitar-spinning Arab warrior (Terry Richards), moments before what is arguably the most famous improvisation in movie history.

Studios, Spielberg was doubling down on his speciality. This perfect equipoise between irony and belief, a postmodern sensibility that fools us every time. Ford's balancing act is equally as sublime: brooding and childish, brilliant and rash, the fuddy-duddy prof with 007 in his DNA. Spielberg constantly seeks the humanity in those bruised reactions and touching flaws ('Why does it have to be snakes?'[32]) The American Film Institute voted him the second greatest hero of all time in 2003, behind Atticus Finch, but one ahead of Bond. He is also Spielberg given a movie-star polish, boyish, geeky, unflagging, rebounding, a master of improvising fireworks out of a crisis.

'What now?' demands Marion as the Nazis make off with the Ark again.

'I don't know,' snaps Indy, the burden of movie heroism heavy on his shoulders.

'I'm making this up as I go along.'[33]

Dysentery running rife, Ford's worn complexion occasionally bears witness to more insistent issues than his character's predicaments. One scene, calcified in myth, has Ford, his stomach taking a lurch, persuading his director to cut short a planned duel with the Arabian knight spinning his scimitar – the storyboards show a fight between whip and blade careering between market stalls.

'I'd never unholstered my gun in the entire movie,' recalled Ford, 'so I said, "Let's just shoot the fucker," and we did. That's getting character into action.'[34]

Spielberg winces a little these days, but it's a gag that defines their whole enterprise. Aren't movies silly, it seems to say. A moment sold by the exuberant reaction of the extras, hooting wickedly like the audience to come.

French archaeologist-profiteer Belloq is a sly foe. Given a knowing (everything is knowing) English-actor-with-an-accent vibrato, Paul Freeman's villain is the dark side of Indy, and with his snappy suits and snake-oil charm (yet another snake to disturb Indy's equilibrium), he's also the dark side of Truffaut's Lacombe from *Close Encounters*. Allen's Marion is both a strength and relative weakness. She talks tough, a spitfire dame. There's a history with Indy, another relic to be dug up and cracked open. But she's Lauren Bacall without the smarts, often reduced to obstreperous shrieks of '*Indddyy!*' as her ordained hero-beau hustles a solution out of their next tight spot.

There are flaws. By the ending, Indy becomes a passenger in the story. Questions remain over whether the film has anything to say beyond its ode to escapism. This heady brew bubbling with John Williams' heady score. But compare its ingenuity and character to modern blockbusters. All those melting Nazi faces are the icing on the cake – a prankster's love of the dark stuff. This box of tricks that unleashes god lights direct from God. The very ending is perfectly unsettling. A riff on *Citizen Kane*, with the Ark buried again, this time in officialdom, still throbbing with intent. *Raiders* may have been a stopgap, a dalliance, a refresher course in the fun of it all, but the movie is immortal.

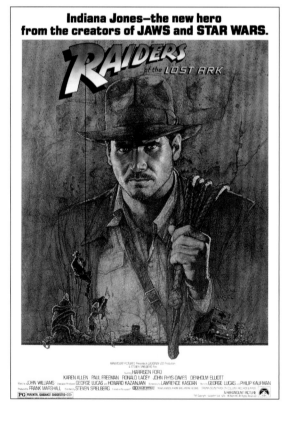

Above: Dame with a claim – Indiana Jones' erstwhile love Marion (Karen Allen) with the crucial headpiece to the Staff of Ra.

Left: In many ways, *Raiders of the Lost Ark* is the film that has come to define Steven Spielberg's reputation as the world's pre-eminent entertainer.

THE INNER CIRCLE

Steven Spielberg's key collaborators

SID SHEINBERG
Spielberg's great mentor, Universal CEO Sidney Jay Sheinberg not only took a chance on the young director, he was sounding board, advisor, inspiration (Sheinberg gambled on *E.T. the Extra-Terrestrial* and suggested *Schindler's List*), and palliative (he kept Spielberg afloat through the heavy weather of *Jaws*).

GEORGE LUCAS
Conspirators, collaborators, partners, Movie Brats, and best friends, Spielberg and George Lucas are Hollywood's most successful double act. Together, they created the *Indiana Jones* saga. Constant sounding boards for each other's projects, they offer a fascinating contrast: Spielberg's instinctual genius versus Lucas's industry-wide vision.

RICHARD DREYFUSS
Spielberg's first alter ego, Richard Dreyfuss brought the central concept of the geek-hero to barbed and brilliant life in *Jaws* and *Close Encounters of the Third Kind*. He returned for *Always*, but his edgy presence is missed in later films – his very unlikeliness as a leading man gave those films a vital energy.

KATHLEEN KENNEDY
One of the married duo of long-time producers, from *Raiders of the Lost Ark* onwards Kathleen Kennedy had a knack for organizing Spielberg's fountainhead of ideas. Soon enough, she was bringing ideas to him: both *The Color Purple* and *The BFG* began with Kennedy.

FRANK MARSHALL
The other great producer partner (and Kennedy's husband), Frank Marshall was Spielberg's man on the ground for decades. Introduced by *Jaws* editor Verna Fields, he too began on *Raiders*, intuiting straightaway that what the director needed was someone between him and the studio: 'He wanted a producer who could actually get the movie made for a price.'[1]

JOHN WILLLIAMS
Arguably, Spielberg's greatest collaboration is with composer John Williams. Commencing with *The Sugarland Express*, they have made twenty-nine films together, where music and image are inseparable. Or as Spielberg put it: 'I tell a story, and then John retells the story musically.'[2]

MICHAEL KAHN
Commencing with *Close Encounters*, Michael Kahn was Spielberg's chosen editor for decades. You can see why. Kahn brings such natural storytelling rhythms. He makes Spielberg's films effortless to watch. 'I'm a very good listener,' he said, asked for the secret of their partnership. 'So when Steven talks, I listen closely. I listen to what he says and then I listen to what I think he means and then I listen to myself.'[3]

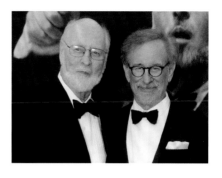

ALLEN DAVIAU
The first of the defining cinematographers was Allen Daviau. He had shot *Amblin'* for an undiscovered Spielberg, then returned for *E.T. the Extra-Terrestrial* to fuse the suburban and the fairy tale for a signature dreamlike aura. He became Spielberg's go-to guy for five films.

JANUSZ KAMIŃSKI
Polish cinematographer Janusz first collaborated with Spielberg on *Schindler's List* and they have been inseparable since. Meticulous to a fault, Kamiński expanded upon Daviau's washes of silver light with great versatility: historical epic, science fiction, musical, animated giants – anything was possible. Kamiński credits himself with helping to change Spielberg's ideas of 'traditional beauty.'[4]

TOM HANKS
With five films together, Tom Hanks has become Spielberg's everyman of choice. The director had known since producing *The Money Pit* that he wanted to make use of the actor's naturalism. Their double act as director and leading man began, of course, with *Saving Private Ryan*. ' I was just trying very hard to imagine what actor would not immediately want to use his teeth to pull out a pin on a hand grenade,' recalled Spielberg. 'And Tom Hanks just sprang to mind.'[5]

PHENOMENON

The miracle of *E.T. the Extra-Terrestrial* (1982)

Everything depended on Elliott. He was the prism through which the entire film would be refracted – a lost boy, ten years old, abandoned by an unseen father and neglected by a wounded mother, the middle child yearning for connection, Elliott is an alien in his own family. Notice how the name, Elliott, starts and ends in E.T. And watching a reel of the fatherless boy in the Sissy Spacek period drama *Raggedy Man*, Steven Spielberg knew this could be his unstarry star. Director Jack Fisk had heard about his struggles to cast the lead in his secretive new film and suggested he might have an answer.

Born in San Antonio, Texas, Henry Thomas filled the screen with gravity and defiance, with these moist, dark eyes, brimming with need, beneath a thatch of black hair. Kids were like that, Spielberg knew intuitively, because he could still remember. His film coursed with such memories. Hollywood had turned its child stars into a litany of Orphan Annies, all these precocious homunculi with vaudeville chops. Kids, *real* kids, were solemn creatures, but with firecracker impulses. If anything, Thomas' performance recalls Richard

Dreyfuss in *Close Encounters of the Third Kind*. Spielberg's kids are thrust into adulthood, while his adults search for the child they once were. 'Spielberg manages to combine escapism and inescapability, no mean feat,'[1] pointed out biographer Molly Haskell. Critics harped about the *Peter Pan* director, but his films are about the tragedy of growing up.

During the long production of *Close Encounters*, François Truffaut informed Spielberg, more than once, that he ought to be making a film about *'keeds.'*[2] Spielberg always gives the recollection an affectionate French accent. Truffaut had made one of the most gloriously unaffected and autobiographical *'keeds'* films in *The 400 Blows*.

'You are the child,'[3] he insisted to Spielberg.

A seed was lodged in the rich loam of the younger director's imagination, among those memories. Self-portrait was already present in Spielberg's work – in Hooper, Neary, and Indy – but this was the tale of *his* suburban childhood, *his* broken home, and *his* attempts to escape into his imagination. As he confessed in interview, his strange love story was born of 'a lot of suburban psychodrama.'[4]

Right: The signature image – in so many ways, Elliott (Henry Thomas) and E.T. flying past the Moon defines the Spielbergian touch: the fairy-tale light, the nod to Peter Pan, the silhouette, the everyday (a bike!) mixed with the magical, and a moment of absolute togetherness.

E.T. THE EXTRA-TERRESTRIAL
1982 Director/Producer

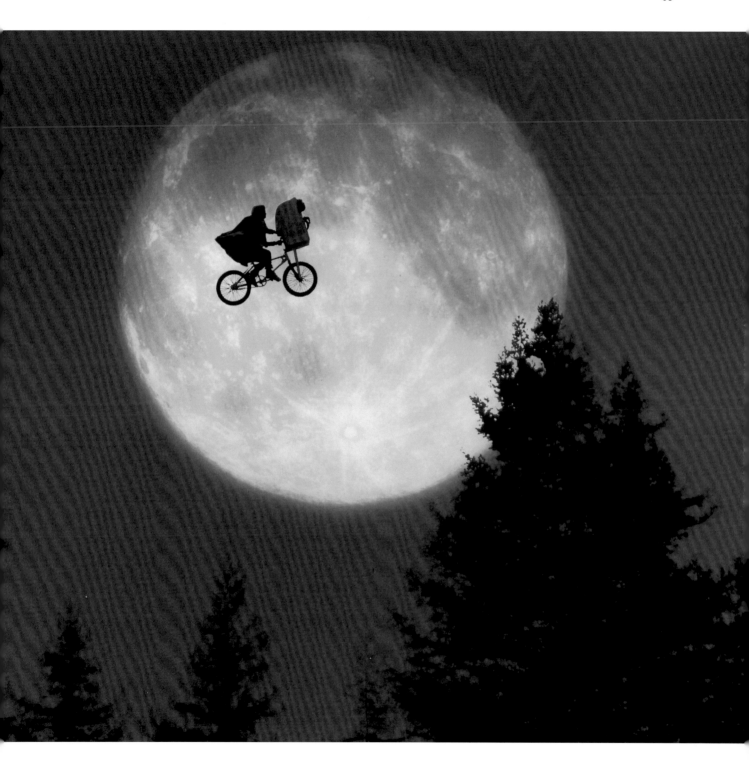

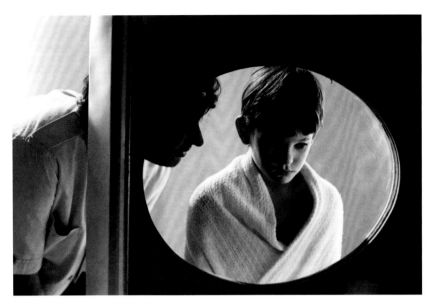

Left: This boy's life –
Steven Spielberg eases
Henry Thomas through
the emotional demands of
the scene. In every sense,
Elliott was a version of the
young Spielberg, and the
movie a science-fiction
spin on autobiography.

There had been gestures toward a straightish comedy called *Growing Up*, the story of a boy living through his parents' divorce, which would, forty years later, become *The Fabelmans*. In 1980, he couldn't help but add some Spielbergian growth formula. This would be an autobiographical fairy tale about an imaginary friend (*his* imaginary friend) made real. Once upon a time in an American suburb, not so different from the identikit drives and wide porches of sun-baked Saratoga where Spielberg spent his early teens, a lonely boy meets a castaway alien and they save one another.

Hiding his intentions from the avid media, his new film was codenamed *A Boy's Life*. It would eventually be called *E.T. the Extra-Terrestrial*.

He arranged a meeting. In he came, the boy, and the director worried he might be too serious. But as the nerves wore off, Thomas sprung to life. When Spielberg took him to meet his co-star, standing sentinel in the workshop with its wide head, squat body, and gentle blue eyes as big as grapefruits (Elliott will be determined he is a *he*; Gertie, Elliott's tiny sister, isn't so sure), his stoic face burst into demented laughter. Asked to improvise a scene of E.T. being taken away, Thomas recalled the death of a family dog and spilled raw tears, silencing the room. The kid was uncanny – he was like a tuning fork for emotion. Spielberg cast him on the spot.

There are striking performances across the decades. The defining naturalism of Roy Scheider in *Jaws*, Dreyfuss in *Close Encounters*, Harrison Ford's battered pride in the *Indiana Jones* films, then later, Ralph Fiennes in *Schindler's List*, Leonardo DiCaprio in *Catch Me if You Can*, and Daniel Day-Lewis standing tall in *Lincoln*. An art in itself, the casting is so precise.

Nevertheless, there are a quartet of performances in his sixth feature that ring so true that we barely stop to consider them performances at all. They just are. Fifteen-year-old Robert MacNaughton stars as Elliott's older brother, Michael, struggling to play man of the house, still buoyant with the encoded games of childhood. Watch his grin slip into fear, the uncertain adult stirring within, when Elliott lets him in on his secret. And the miracle of Drew Barrymore, then six, the granddaughter of the great John Barrymore, as irrepressible, hilarious Gertie, sassy as a prom queen in her pigtails. 'Give me a break,'[5] she groans at her wiseacre brothers' platitudes. She is the audience – laughing, crying, shrieking, *reacting*.

Then there is Dee Wallace as their mother; Mary to her kids. She is so crucial to the story, and Wallace, who had been in no more than werewolf indie *The Howling*, does so much with so little. Spielberg saw Mary as another child in the mix, a version of his own mother, Leah, harried and heartbroken, fragile as a vase. Wallace gives him the extraordinary scene of Mary, responding to primal instincts, wrenching her child away from his ailing companion, their screams like fingernails on a blackboard.

Why do people insist on calling *E.T.* feelgood?

Left: The power of heartache – Gertie (Drew Barrymore) and Mary (the marvellous Dee Wallace) watch on as E.T. declines, and noses run in every cinema in every land.

Below: The three lead performances from Thomas, Barrymore and Robert MacNaughton are so naturalistic we barely consider them performances at all. They simply are these kids.

Tired of the demands of four vast productions as demanding as the Labours of Hercules, Spielberg simply opted not to be Steven Spielberg. Expectation had been a constant companion since *Jaws* broke upon the shores of American culture. So to hell with it. By 8 September 1981, as production started in the unexceptional Los Angeles suburbs of Tujunga and Northridge, on the northernmost edge of the San Fernando Valley, he reflected that audiences were unlikely to be interested in his new film, but that was fine, this was one for him.

'I had nothing to prove to anybody except myself,' he insisted, sharply, 'and anybody who might have wondered if I ever had a heart beating beneath the one they assume that Industrial Light and Magic built for me.'[6]

A tale of science fiction held as softly as a child's hand, his little experiment would become one of the most beloved films in history. Proof that Spielberg's gift was an elemental expression of story, a form of emotional communion. Like Elliott and E.T., he felt our feelings.

In truth, he was a far more personal director than his maverick peers, who were so busy tearing up the rulebook that the ripping became the rule. Filmmaking was close to a way of being for the young Spielberg, he was a natural in every sense, immersed in a film at the expense of all else. He called it 'having an affair'[7] with his film. But he was a natural audience member too, waiting for the lights to dim. Art was never for art's sake. He needed our tears.

It had begun as a sequel to *Close Encounters*. Fearful an eager Columbia would carry on without his guiding light, marring his creation as *Jaws 2* had put a stain on his first hit, he proposed an anti-*Close Encounters*. Written by director-to-be John Sayles, with echoes of *Firelight*, *Night Skies* depicted a malevolent gang of aliens terrorizing a remote farmhouse. It was a good script at the wrong time. Spielberg wasn't in the right headspace for more terror, more derring-do, more of the same. *Night Skies* was shelved, though ideas would filter down into *Poltergeist* and *Gremlins*, which he produced. The alien bandits are led by the formidable Scar, the name given to the most malign Gremlin. He also gesticulated with a long, bony finger, and Sayles mentioned how the ending of his script left a good alien marooned on Earth.

During the gruelling production of *Raiders of the Lost Ark* in Tunisia, a homesick Spielberg began 'pouring out his heart'[8] to Melissa Mathison, Ford's then girlfriend and later wife. His loneliness took the form of a story. A gifted screenwriter, responsible for the wonderful (and influential) boy-and-his-horse epic *The Black Stallion*, Mathison was

Opposite: Inter-cosmic need – dressed for Halloween, Elliott (Henry Thomas) guides E.T. into the woods to try and make contact with his ship.

Below: E.T.'s glowing finger, with its healing gift, is the perfect symbol of the Spielbergian touch with its instinctive power to move the hearts of the audience.

indifferent to the science fiction as such, but loved how the central alien was so unexpectedly tender, and how it revolved around this friendship born of inter-cosmic need.

Writer and director formed an instant bond. 'Melissa is eighty percent heart and twenty percent logic,' recalled Spielberg. 'It took her sensitivity and my know-how to make *E.T.*'[9] Mathison's first draft arrived in two months (a rewrite by Matthew Robbins jettisoned Elliott's jealous best friend), and a delighted Spielberg imposed upon himself the limitations of his television films, with a budget set as low as $10 million, and to be shot in ten weeks, a true test of his talent.

'I can unequivocally say that my most enjoyable experience and the best result came out of the *E.T.* experience,'[10] he said.

In one of the great studio miscalculations, Columbia turned it down, wondering what happened to the scary stuff. Universal, stewarded by his mentor Sid Sheinberg, were willing to indulge Spielberg, waiting for him to see sense again and spend their money. No one thought it had a chance. Indeed, he had never been so *unmechanical*. There were flying bikes, levitating fruit, and, of course, an alien lifeform made with cunning artifice, but the film floats on the guile of its young characters and their clandestine plots, so serious and funny, matched at every beat by Spielberg's intuition with the camera.

Spielberg often protested that he was a journeyman without a signature style. But he protested too much. *E.T.* was a great flourish of style.

"I can unequivocally say that my most enjoyable experience and the best result came out of the E.T. experience."

Steven Spielberg

'I think that if you look at his work from this period and don't realize you're seeing a master of framing, timing and rhythm, a born moviemaker, then in some essential way you don't understand movies,'[11] wrote Charles Taylor in *Salon*, returning to the film on its twentieth anniversary re-release.

Everywhere Spielberg acted on instinct. Anxious to impress, he had always agonized diligently over his choice of cinematographer. Now he jumped on the phone, calling up the relatively untried Allen Daviau, who had shot *Amblin'* before drifting into television.

'Would you photograph my next feature?'[12] he asked the stunned Daviau. He wanted someone hungry, who could work fast, who was 'going to make an audacious first impression.'[13] It was another perfect piece of casting.

Spielberg called for contradictory approaches, the real and dreamlike. A world much smaller and more immediate than *Close Encounters*, there are barely more than four locations: woods, house, school, and the cluttered estate. But it is a world held in a spell, as Daviau encircles Elliott's life with veils of mist or a magic-hour ambience of soft orange skies. Ordinariness spooked by the breath of enchantment, this was as much German Expressionism as candid Americana. Has the alien brought this divine radiance with him? Freeing himself from the tyranny of storyboards, Spielberg shot from the hip. Quite literally at the eye level of E.T. or Elliott, with the camera never drawing attention to itself, but always in the thick of things.

'I still haven't been able to shake off the anaesthetic of suburbia,'[14] he said. In suburbia, he knew, kids have secrets. 'What better place to keep a creature from outer space a secret from the grown-ups?'[15]

E.T. is the ne plus ultra for how Spielberg electrifies his fantasies with lived experience: the Brownian motion of children clattering round a home, the

Above: A suburban fairy tale – as Elliott (Henry Thomas) investigates a mysterious sound from the outhouse, Spielberg fearlessly drenches the scene in light and mist.

Left: Global phenomenon – Mike (Robert MacNaughton) and Elliott (Henry Thomas) educate E.T. as to his whereabouts, with Elliott's bedroom a wonderland of American childhood.

Opposite: Gertie (Drew Barrymore) plays dress-up with their new housemate, to Elliott's horror. The house was a brilliantly conceived muddle. What Spielberg knew to be the signs of real life.

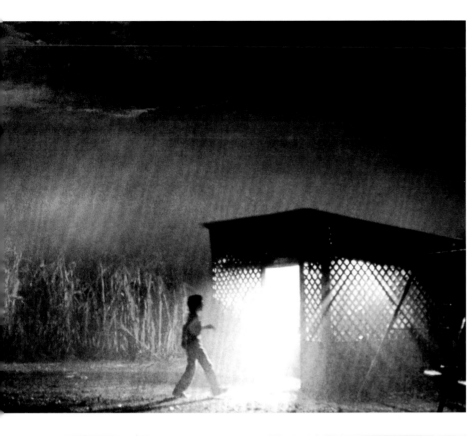

petty squabbles and sibling rivalries, the rituals of game night or Halloween, and that Altmanesque touch of overlapping dialogue. Another index of Spielberg's memories, Jim Bissell's production design embodies what cultural critic Karal Ann Marling called 'the marks of hard use.'[16] It is impossible to conceive of these rooms as sets.

Salon's Taylor saw both a satire and poetization of American life. 'Spielberg's work reminded you of what was good about America – the optimism, the oddball enthusiasms of ordinary folks, and the way people stake out their own space in the noisy, free-for-all bumptiousness of family life.'[17]

So much of the film takes place not even in the mothership of the household, but within the shifting ambience of Elliott's bedroom, lit with quaint simplicity by draping a yellow handkerchief over a bulb, or shooting through stained glass, or the lowered blinds. It is like a film noir, with a fugitive kept hidden by children. Daviau would press his director to know exactly the time of day each scene took place, lowering the sun and raising the moon, as the vast solar system gazes on this lonely suburb.

Mathison put the day's script on pocket-sized cards for the kids, sticking around to keep spirits high. She had this wonderful notion of how E.T. would return home to tell of a planet populated by children. Still to have his own kids, Spielberg was a surrogate father to a fictional family, spending his lunches playing Pac-Man with Thomas, directing his hero-cypher almost by osmosis. He spoke of having 'to metabolize according'[18] to his young actors, giving them the time and space to feel their way into a scene. He needed to be ready for 'a gift from the

gods'[19] – that take when life spills into the frame. They existed in a bubble, shooting the interiors at Laird International Studios at Culver Studios, free from interference, and enclosed in a shroud of secrecy that the press failed to penetrate.

E.T. is as familiar as a memory, but impossible to place. The genre is Spielberg. It's an alien visitation movie, another *encounter*, but small as an indie. It's a rescue story, a quest to return the castaway to his encroaching spacecraft shaped like Jules Verne's salt shaker. It's a coming-of-age story too, and a parable of the fraying verities of American life – all is not well in the family unit. The eighties are far from idealized. Is this why it struck such a chord? Divorce was the unacknowledged secret of an ordinary America where every other house was a broken home. As Elliott snaps to one of his brother's bewildered friends, 'This is reality, Greg.'[20] Bar the self-absorbed *Kramer vs. Kramer*, no Hollywood film had depicted the fallout of divorce with such honesty. But it was just as much a comedy, with this fish out of water getting to grips with the foibles of Californian life.

The routines are as perfectly timed as Chaplin. On first sight of her unexpected housemate, Gertie vents her lungs, E.T., that empath, matches her scream for scream, and a room dissolves into slapstick chaos as a mother's voice calls querulously from below – it's like a sequence from *Raiders*, we're laughing but strung out with the threat of discovery.

Certainly, it belongs to the pantheon of great children's stories: Kipling, Baum, Dahl, George MacDonald, and J.M. Barrie's *Peter Pan*, that ever-present inspiration. There is a radiant moment, among so many, when Mary reads that very story aloud to a spellbound Gertie – just as Spielberg's mother had read it to him – and E.T. listens in. The part where the reader is called upon to believe in fairies, as we will E.T. back to life at the end. Here too are the sly schemes of Nancy Drew and the Hardy Boys.

Spielberg draws on movie myths: *The Wizard of Oz, Lassie Come Home, Whistle Down the Wind, Night of the Hunter,* and Victor Erice's evocative *The Spirit of the Beehive*, in which two impressionable girls harbour an enemy soldier during the Spanish Civil War, believing him to be Frankenstein's sorry creature. E.T. and his crew are genteel botanists, reminding us of the haunting robots in Douglas Trumbull's *Silent Running.* And there is that kinship with his own *Close Encounters*.

Above all, *E.T.* has the structure of a love story. They meet, bond, defy the odds, and part in sweet sorrow. As the camera pans down from a starlit sky, those first moments of alien exploration were imagined by Mathison in a forest clutched from the Mitteleuropean heart of the Brothers Grimm, and fine-tuned to a lush northern Californian Redwood canopy by Spielberg. He recalled Mother

Left: Saving the day, Elliott (Henry Thomas, in his distinctive red hoodie), E.T. and the youthful gang flee the flabby suits of adulthood.

Below: Brotherhood – Mike (Robert MacNaughton) follows the trail to the missing E.T., the landscape turning autumnal with the ailing alien.

Night from *Fantasia* – more Disney – drawing her cloak over the world. It could be a different planet. Blades of torchlight announce Man, keys jangling at his hip, and we are thrust into a chase, a jagged montage as unnerving as the first scenes of *Jaws*. With a low centre of gravity, E.T. waddles like a drunkard, but is capable of crashing through the undergrowth, that animal shriek cutting through Williams' surging score. Is there a better director of openings? Eleven minutes without a line of dialogue conclude with E.T. gazing upon the glow of civilization.

Daviau's cinematography was vital in the alchemy of transforming polyurethane into flesh. Too much light and E.T. was clearly a puppet, too little and he was obscured in shadow. Spielberg wanted to see the face 'just enough.'[21] Daviau bounced pockets of light onto that ancient skin using tinfoil.

'E.T. could not only look sad, he could look curiously sad,'[22] reported Spielberg with satisfaction. The beatific visitor was made by Carlo Rambaldi, the Italian animatronic marvel who had sculpted the Giger-designed creature in *Alien*, but spins Darwinian aggression into a saintly oddball, who has risen up the evolutionary scale into emotional telepathy and elevating bikes. A flying Elliott is silhouetted against a silver moon, a fairy-tale image that risks going too far, but we are transfixed, in too deep to question such marvels.

Here was another inversion of the *Jaws* nightmare. A dream puppet so good he could appear whenever and wherever Spielberg chose. Once Elliott and the camera get a good look at him, E.T. reveals a wrinkled, reptilian, skin, extendable neck, and a slender, Michelangelo finger that glowed at the tip – the Spielberg touch.

Of course, Spielberg had demanded the impossible – a creature both old and childlike. The beings that totter from the Mother Ship in *Close Encounters* are surreal adjuncts to their heavenly technology. E.T. called for a *performance*. Baby-faced in that big-eyed Disney way, a glimmer of *Bambi* or *Dumbo*, but mixed with the sage-like creases

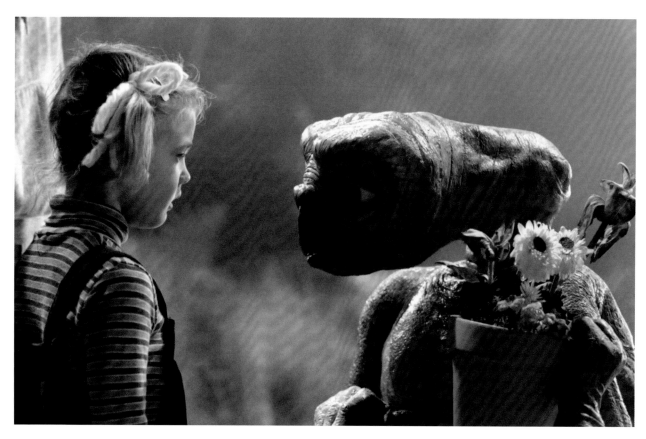

Above left: The empath test - linked to his froggy-looking best friend, Elliott (Henry Thomas) can't bring himself to dissect a frog in science class.

Above right: The art of simplicity - to create E.T.'s POV beneath a bed sheet for the Halloween scenes, Spielberg attached a sheet to the camera with two eye holes cut out of it.

Opposite: Gertie (Drew Barrymore) bids farewell to E.T. - on set the young actors happily interacted with the E.T. puppet as if he was a living thing.

of poet Carl Sandburg, the wry calm of Einstein, the furrowed brow of Hemingway, and the glowing heart of a thousand painted Christs. God is never far from Spielberg's fantasies.

The director asked for a 'fluoroscope'[23] of *E.T.'s* innards – a literal beating heart before our eyes. Hearts are an inflamed motif: as a dying alien resists the surge of defibrillator paddles, each shock sends Elliott and the audience reeling.

After Rambaldi admitted defeat in the matter of full body movement, a trio of separate actors occupied the suit for the walking shots (including Pat Bilon, a two-foot-ten nightclub bouncer). The 'A-version' of the puppet, three feet tall, was capable of a concerto of eighty-five movements through a web of hydraulic and electrical cables.

Debra Winger contributed a first version of that gurgling, cooing, purring voice with a toddler's syntax, 'E.T. phone home!'[24] Sound editor Ben Burtt ended up working with radio actress and heavy smoker Pat Welsh, layering in recordings

of raccoons, otters, and horses, and the heavy, fitful breathing of his sleeping wife, suffering with a cold.

The reliably questioning eye of critic David Thomson wondered if it might be a more interesting film if there was at least one scene 'where [the alien] was a little less than perfect.'[25] E.T. may not be wicked, but he is impish. Locating beer in the refrigerator (a trace of a runaway dad?), belching and watching TV in the American way and, in a comic flourish, transmitting his inebriation to Elliott at school. This film gathers meta-meanings to its breast, movies as emotional conduits, as E.T.'s experience of the John Ford romance *The Quiet Man* takes shape in a science class run amok with liberated (E.T.-like) frogs, and Elliott mounting a chair to kiss the prettiest girl (Erika Eleniak, later of *Baywatch* fame).

An itch of paranoia still permeates the film, as it had *Jaws* and *Close Encounters*, with the faceless authorities, clad in space suits, hazmat masks, and the cold clarity of science, who come to sheath

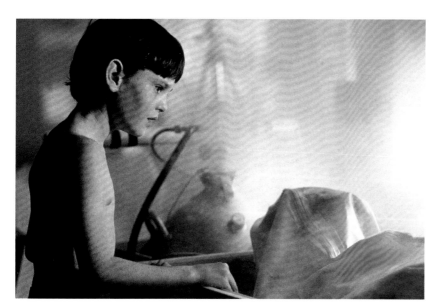

Left: Back from the dead – Elliott (Henry Thomas) witnesses the miracle of E.T.'s glowing heart, allowing the director to dabble in Christ-like imagery.

Below: The sympathetic Keys (Peter Coyote) was a second cipher for Steven Spielberg – the adult man still in tune with his childhood.

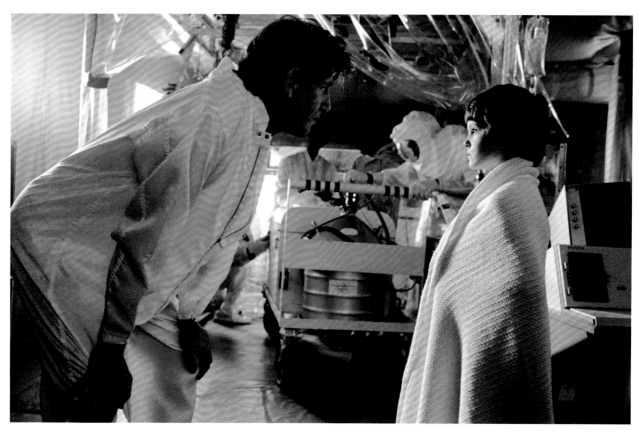

the house in plastic. It's a horror movie move, Spielberg's dark side. Man as space invader. When Peter Coyote's Keys turns out benign – another lost boy – there is slight twinge of disappointment that Spielberg is going easy on us. Recall too the kid in a Nixon mask trick-or-treating during the gorgeous, sunset Halloween, where Daviau simply draped the camera in a sheet with eyeholes to create E.T.'s hidden perspective.

Has anyone departed Spielberg's central film with their heart still intact? It's a heartbreaker, a tearjerker, as emotionally draining as *Raiders* was exciting. Does that make it uncool compared to the salt-tang of *Jaws*? It is not sentimental. When a smitten Pauline Kael, of all critics, called the film a 'bliss out,'[26] for once her take falls short. There is bliss, to be sure, but the film is driven by an undercurrent of anguish that lives longer in the psyche than most horror

films. It can be harder to endure at times than *Jaws*. The Disney secret is made flesh – that trauma is the abiding sensation of fairy tales. Not only that the authorities may root out the stowaway in a broken home, or that suburbia will poison his heart, but the certainty that childhood will end.

We can never shake the dread that Elliott and E.T. will have to part.

Is there a more perfect image in all that Spielberg has put on the screen than the shot toward the end of *E.T.* when Elliott, believing his cosmic friend has perished, confesses his love? Spielberg shoots it through the glass of the metal casket and Thomas is close enough for his breath to gently condense on the cool glass, another mist. 'I must be dead,' he whispers, 'because I don't know how to feel.'[27] Both E.T. and his innocence have slipped away. Meanwhile, Mike retreats to the confines of a cupboard, surrounded

by toys he has grown out of, desperate for the solace of childhood.

Such savage intimacy gives way to more standard, sunlit Spielberg exhilaration at the end, and the relief has been earned, with a resurrected E.T. (is it love or his own kind back in orbit?), Christ on a bike in his white robe, lifting the boys above the heads of the authorities and their guns, as John Williams' music soars. Are we being manipulated by a master? Having our heartstrings played like a harp? If so, we are willing victims.

The success was so unprecedented, so phenomenal, there was a point at which it was estimated that Spielberg, with his share of the profits, was earning half a million dollars a day. Overtaking *Star Wars*, which had overtaken *Jaws*, it became the biggest film of all time, making a staggering $793 million, as the merchandise machine went into overdrive.

Right: Beyond all the classifications applied to *E.T. the Extra-Terrestrial* – science fiction, fairy tale, children's adventure, comedy – it is ultimately a love story.

The week *E.T.* opened, Spielberg treated himself to one of the original Rosebuds from *Citizen Kane* – going for a cool $60,500 at Sotheby's – that great cinematic symbol of lost childhood.

People forget that *E.T.* was a cinematic event – after the long queue, nervous that you would get in at all, every seat taken, it was a communal act to share our tears in the dark. The first preview in Houston was like a holy experience. 'I don't think there has ever been an audience like it,'[28] recalled Universal CEO Sid Sheinberg, watching his indulgence flower into history. As the lights came up, Spielberg had tears flowing down his face to match the sodden aisles. And when it was chosen for the closing night gala at the Cannes Film Festival in 1982, an audience of hardened critics and ornery film folk rose as one, exulting Spielberg's little picture.

'We were crying for our lost selves. This is the primal genius of Spielberg,' acknowledged author Martin Amis, sent to interview a weary director, 'and *E.T.* is the clearest demonstration of his universality.'[29]

Basking in the benediction of that smoky light, reviewers saw a European spirit mixing with a technocratic kid. Spielberg shows 'the uncanny intuitive force of a space-age Jean Renoir,'[30] said *Rolling Stone*. 'He's the Fellini of our electronic games culture,'[31] said *LA Weekly*. *Time* would have put him on the cover, the most successful popular artist of his age, if it hadn't been for the Falklands War.

And there were some, inevitably, cold to its warmth. 'What's so great about what these aliens have to offer?'[32] wondered Don McKellar in the *Village Voice*. *Newsweek* ran a column under the banner 'Well, I Don't Love You, E.T.'[33]

Spielberg had been instrumental in establishing the landscape of the blockbuster, the new economic model for Hollywood – spend more to make more.

Opposite: In his element – Steven Spielberg frames a shot of Peter Coyote and Dee Wallace, with Henry Thomas never far from his side. The young director had relied on pure filmmaking guile to create a masterpiece.

Below left: Against all predictions, the unassuming *E.T. the Extra-Terrestrial* (it was far from a blockbuster) became the biggest film in the world.

Below right: One man and his starship – after the phenomenon of E.T., Spielberg's reputation soared, and he became a household name and a Hollywood brand.

His success had ushered the eighties into the studio ledgers. But *E.T.* emphatically reminds us that his success was a product of something deeper and more instinctual.

'Like Disney – and more remotely, like Dickens – his approach is entirely non-intellectual, heading straight for the heart, the spine, the guts,'[34] continued Amis in his appraisal of this young, bearded messiah of the movies.

Spielberg sealed his childhood in cinematic amber. That yearning never wholly departed his filmmaking, but after the apotheosis of *E.T.* he was never quite the same. By no means lesser, but different. He came out of the film knowing he wanted to be a father. And that he wanted to move on as a filmmaker too – to try out adult subjects, forgetting perhaps that childhood is often the most profound material. Heartache is ageless.

They had shot almost chronologically, reaching that final scene, when Elliott – unlike Neary – refuses an invitation to the stars, at the very end.

'Come,' beckons E.T.

'Stay,' replies Elliott.

The look on the creature's face – a puppet! – is of exquisite agony.

'Ouch,'[35] he says, their secret word for injury, but there is no healing this wound.

'The emotion was genuine,'[36] said Spielberg. Those last days of shooting were the saddest he had ever experienced on a film set.

LOST BOYS

Twilight Zone: The Movie (1983), *Indiana Jones and the Temple of Doom* (1984), *The Color Purple* (1985), *Empire of the Sun* (1987), *Indiana Jones and the Last Crusade* (1989), *Always* (1989), *Hook* (1991)

In the spring of 1983, Steven Spielberg had lunch with Poldek Pfefferberg, a luggage salesman who had emigrated to Los Angeles from West Germany. Not that the director knew it yet, a stone is being cast into a deep well. There are few more significant moments in his life. A few months earlier, Universal's ever-wise Sid Sheinberg had called. 'I have your next movie,'[1] he'd informed him, and couriered over the *New York Times* review of a book by the Australian Thomas Keneally. *Schindler's Ark* told the remarkable, little-known story about a German industrialist, Oskar Schindler, who saved thousands of his Jewish factory workers from the gas chamber. And now Spielberg was hearing it first-hand. Pfefferberg had been on Schindler's list.

'When will you tell our story?' he urged.

'Ten years from now,'[2] responded Spielberg, with more honesty than he may have realized.

It was the opposite rebuke to Truffaut's – make a story about *adults*. For a decade, Oskar Schindler lurked on the edge of his consciousness. Spielberg resisted, fretted, took easier paths, and made splendid films, but he was like Neary, irresistibly

called to enlightenment on the dark side of the mountain.

By 1993, he would have nine more films to his vaunted name. Moreover, mentoring new talent, spreading his influence as producer, that name was elevated to a brand, a guarantee of satisfaction across buzzy genre hits like *Poltergeist, Gremlins, The Goonies, Back to the Future*, and *Young Sherlock Holmes*. He was the artist mogul – the popcorn Barnum.

Yet an uncertainty entered his directorial choices that spoke of a battle with the magnitude of his fame. The demand that he shake the world anew with every release. Away from two further *Indiana Jones* adventures, both reliable hits, nothing came close to the order of *E.T. the Extra-Terrestrial* or *Jaws*. That old identity crisis reasserted itself. What kind of director did he want to be? It was becoming existential. 'I was losing my identity as Steven Spielberg,'[3] he said, imagining himself transformed, Kafka-like, into a piece of celluloid, sprockets down the side of his face.

Add another anxiety to the mix: Hollywood's quiet disdain for its golden son in the lack of anything more than

Left: Short Round (Ke Huy Quan), Willie Scott (Kate Capshaw), and Indiana Jones (Harrison Ford) take a dark path in *Indiana Jones and the Temple of Doom.*

Below: An edgier adventure – Ford's Indy takes the radical option in the finale of the thrilling but controversial prequel.

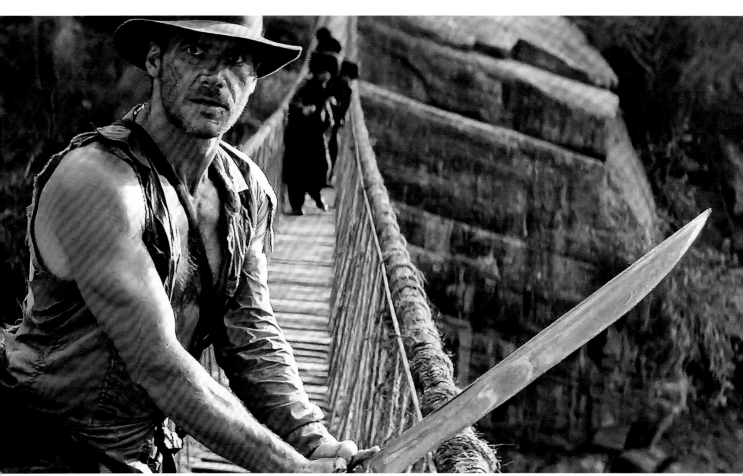

technical Oscars. Somehow *Jaws* hadn't warranted a Best Director nomination, *Close Encounters of the Third Kind* had failed to garner a Best Picture nod, and *E.T.* had been beaten to the major awards by the grand but turgid *Gandhi*. The outsider kid still yearned to be one of the gang.

There was still comfort in responding to the old instincts. To retreat to the toy cupboard like Michael in *E.T.*, keeping the grown-up world at bay. What would be the worst thing anyone could say about a Spielberg movie?, he was asked on *60 Minutes* in 1982.

The answer came quickly: 'That they found it boring.'[4]

First out of the box was *Twilight Zone: The Movie*, based on the Rod Serling-hosted television series – weekly stories served with a horror and science-fiction garnish. The offer came from Warner Brothers CEO Terry Semel, who coveted Spielberg's talents and profit margins.

To put together a collection of four short and not-so-sweet 'episodes', with Spielberg directing one, while inviting directors of the moment, John Landis, Joe Dante, and George Miller, to helm the others. Essentially, a Spielberg short in a chocolate box of mixed quality (it cost little, but made little: $29 million). Miller's tale, *Nightmare at 20,000 Feet*, is generally regarded as the best.

For *Kick the Can*, Spielberg called upon Richard Matheson to write the screenplay. The cult author had provided episodes of the original series, and the short story behind *Duel*. Spielberg was back rooting in the soil of his boyhood, joking about how he was raised by three parents, 'mum, dad, and the television set.'[5] He was a disciple of *The Twilight Zone*, and directed the episode *'Eyes'* for Serling's subsequent series *Night Gallery* in 1969. This was borderline self-satire. Or, as the *Village Voice* groaned, 'lugubrious self-parody,'[6]

catching the general tenor of reviews. It was the Spielberg dilemma writ large, thick with style, eager to please.

The moribund residents of Sunnyvale Rest Home are magically returned to their childhood dreams (and forms) by Scatman Crothers' mysterious Mr. Bloom. Each will come to realize they cannot face life's hardships over again, while Mr. Bloom moves on to bring illumination to the next retirement home – like Mary Poppins, or E.T., or Steven Spielberg.

Indiana Jones and the Temple of Doom is often criticized as the darkest of the *Indy* films, not least by its director. 'I wasn't happy with the second film at all,' he admitted, years after it became another smash hit (at $333 million). 'It was too dark, too subterranean, and much too horrific. I thought it out-poltered *Poltergeist*. There's not an ounce of my own personal feeling in *Temple of Doom*.'[7]

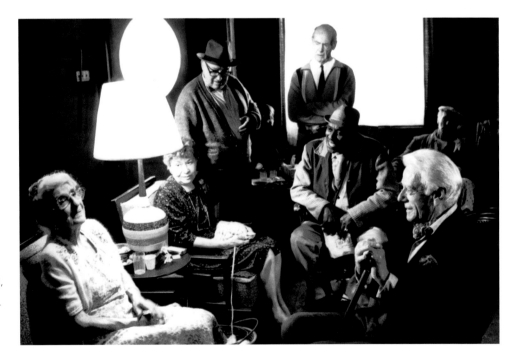

Right: Doing the twist – Helen Shaw, Selma Diamond, Martin Garner, Bill Quinn, Scatman Crothers, and Peter Brocco star in the Steven Spielberg 'episode' of *Twilight Zone: The Movie*.

1983 **TWILIGHT ZONE: THE MOVIE**
Director (segment Kick the Can)/Producer

Under pressure from Paramount (and Spielberg) America's Motion Picture Association introduced a new certificate, the PG-13, to ensure family audiences were still invited to the intrepid archaeologist's scary sophomore. For all his or the critics' squeamish complaints, *Temple of Doom* resounds with Spielbergian ingenuity, humour, peril, those magnificent, partway slapstick stunts, and an exoticism of its own. For some, the tale of evil Thuggee cults, magical stones, heart extractions, and child slavery is second only to *Raiders of the Lost Ark* in a diminishing five-film sequence. And *Temple of Doom* detractors have a rather selective memory – with its melting Nazis and propellor-brained beefcakes, *Raiders* had hardly played nice. These are jaunty horror movies.

It was George Lucas who pushed for the darker mood, something that had worked with *The Empire Strikes Back*. Together they vowed not to follow generically what had worked in *Raiders*, but channel the same comic brio – and the same recipe of a magical MacGuffin craved by leering bad guys – into a different setting, exchanging Egyptian desert for Indian caverns. There was also a cache of ideas, which for various reasons (budgetary or story) had never found their way into *Raiders*. Lucas had wanted Harrison Ford's hero to show up in a tuxedo, directly sending up the exemplar of James Bond, which is exactly what happens before the credits in Shanghai.

The opening is bravura Spielberg, bravura *Indy*, kicking off with the director's first musical number (exempting the jitterbug sequence of 1941) – Cole Porter's *Anything Goes*, all Busby Berkeley heels and sequins. Irony on irony, we meet Indy *out* of his element in a nightclub done up in a blaze

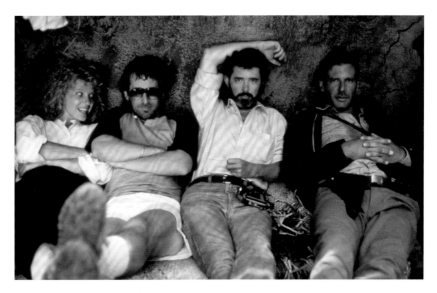

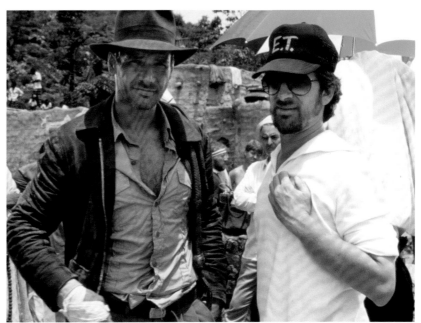

Top: All-action cinema - Kate Capshaw, Spielberg, George Lucas, and Harrison Ford take a well-earned siesta on the Sri Lankan set of *Indiana Jones and the Temple of Doom*.

Above: If the hat fits - Harrison Ford and Spielberg spotted sporting iconic headgear in the wild.

INDIANA JONES AND THE TEMPLE OF DOOM
1984 Director/Actor (uncredited)

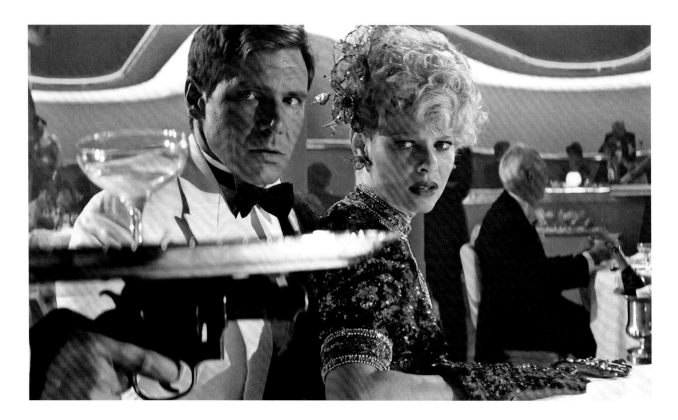

Above: A fish out of water – Indy (Harrison Ford) and Willie Scott (Kate Capshaw) run into trouble in the sensational, musical-themed, nightclub opening to *Indiana Jones and the Temple of Doom*.

Right: Runaway hit – Steven Spielberg dared the critics to classify his new film as a rollercoaster ride.

STROKES OF GENIUS (TV MINISERIES)
1984 Director (introductory segments, uncredited)

of faux-mystical décor. Cue: poisoned champagne, care of lip-curling Chinese gangsters. Cue: gunfire. Cue: dancing girls. Cue: chaos, as he whirls about in his own madcap musical chasing a vial of antidote. Anything goes! It's a declaration of intent, as Indy and American singer, whiner, and general drag Willie Scott (Spielberg's future wife Kate Capshaw – funnier than we tend to remember) finally crash out of a window, through a fleet of awnings, and into a passing car, driven by a kid. Spielberg pushed to give Indy a loveable if spiky sidekick in Short Round (the lively Ke Huy Quan), to soften the film's edges.

The script came at a three-week gallop – and the pace never lets up on screen – written by Gloria Katz and Willard Huyck (the witty husband-and-wife duo behind *American Graffiti* and a vital contribution to *Star Wars*) following a five-day summit with Spielberg and Lucas at the latter's home in Marin County, California.

One of the enduring thrills of *Temple of Doom* is that it is structured as a progression of Freudian nightmares: escaping a plane minus pilots and parachutes (in a life raft!); a banquet serving eyeball soup; a tunnel teeming with insects (shot in those pre-CGI days with literally thousands of bugs); a booby-trapped ceiling; a pit of boiling lava; and a runaway mine cart (shot by literally building a rollercoaster on Stage 4 of Elstree Studios). Huyck wondered how many of these images had bubbled up out of the director's childhood phobias.

The exteriors were found in the lush jungles of Sri Lanka; it was the interiors at Elstree that proved a struggle with Ford suffering a herniated disc in his back (Indy was hard on the star), delaying production for weeks, and necessitating greater sleight-of-hand with his stunt double Vic Armstrong.

Through a modern lens, the racial elements do look more fraught: that

Below left: Giving Indiana Jones a cute junior sidekick in Short Round was a risk that came off, with the aid of Ke Huy Quan's sparky performance.

Below right: *Temple of Doom* would have its detractors, but the film was another massive hit, and has become a cult favourite over the years.

the film portrays its Indian characters as ghoulish cultists, gluttonous sahibs, slaves, or desperate if wry villagers. White Saviour Syndrome? This is Indiana Jones, surely, armoured in leather and satire. It is safe to laugh in the dark.

The raised eyebrows would be arched even further with Spielberg's next; his every move patrolled by the cognoscenti.

Alice Walker had eyed the young director, white, preppy, nervous, but apparently the most popular entertainer on Earth, and decided she liked him. It was the most unforeseen meeting. The magician director and the Pulitzer Prize-winning author of *The Color Purple*, a period piece, written from a female perspective, and regarded as a set text for the black experience in America.

Even within its early-twentieth-century, Southern milieu, this earthy, epistolary novel encompassed marital abuse, incest, and a lesbian love story. Delivered in a distinctive African-American vernacular. It centres on the hardships transcended by the unlettered Celie (Whoopi Goldberg, a vibrant stand-up suggested by Walker), her children stolen away, wrenched from beloved sister Nettie (Akosua Busia), and left in thrall to a brutal husband, Mister (Danny Glover). A transformation inspired by two of numerous lives that cross her path: the outspoken Sofia (a determined Oprah Winfrey), who marries Celie's stepson, and charismatic blues singer Shug (Margaret Avery), Mister's former mistress and Celie's lover.

These were themes close to Spielberg's heart: the binds of family, the search for identity, for love, and an exploration of America. Among so many lost boys, here was a lost girl.

So it was a less calculated move than it appears. Less the hunt for an Oscar,

levelled at Spielberg by the press, like Indy chasing a treacherous idol. The novel was passed on to him by in-house producer Kathleen Kennedy – merely to read, and he could immediately see and feel the film within its pages.

Indeed, it is simplistic to parse the switch to literary matters, first with *The Color Purple* and then *Empire of the Sun*, as a conscious move to adult-themed material. Both remain coming-of-age stories. 'The big difference in *The Color Purple* is that the story is not larger than the lives of these people,'[8] he said. Here the characters were the story.

White director syndrome? Walker had agreed to Spielberg. Maybe she liked the irony. Maybe she liked the idea of launching her story into the mainstream – and actually getting it made at Warner Brothers for $15 million. And she had liked *The Sugarland Express*. Though she was discomforted by Spielberg's appreciation for *Gone With the Wind*, with all its painful stereotypes.

The Color Purple made respectable money ($99 million), but the response was

"These were themes close to Spielberg's heart: the binds of family, the search for identity, for love, and an exploration of America. Among so many lost boys, here was a lost girl."

Opposite: Susan Beaubian as Corrine and Desreta Jackson as Young Celie in *The Color Purple*. The choice of Spielberg to direct the film of the award-wining novel caused a negative stir at the time.

Right: Turning the tables – Celie (Whoopi Goldberg, right) finally puts the cruel Mister (Danny Glover) in his place.

Below: A family saga – Akosua Busia and Jackson play the younger versions of sisters at the heart of Alice Walker's story.

mixed. Eleven Oscar nominations and not a single win was almost spiteful. Critics dished out equal portions of praise and discontent over much the same thing – the lyricism Spielberg applied to the book.

They shot on location in Marshville and Anson County, North Carolina, during the hot summer of 1985, with Walker often on set, providing additional dialogue and advice to the cast. She had written a more explicit first draft, which had been subdued (some argued neutered) by the Dutch-born writer Menno Meyjes.

Spielberg likened it to Dickens: a life filled with tribulations, then a miraculous restoration of fortune by the end, with the sisters reunited in a flurry of purple flowers, spray-painted a more intense lilac. Scenes of blues and gospel singing are another flirtation with the musical (the book would be re-adapted as a musical in 2023). Spielberg instinctually mythologized, calling upon the grandees of cinema. The John Ford of *The Grapes of Wrath*, with its deep focus care of *Citizen Kane* cinematographer Gregg Toland. The

AMAZING STORIES (TV MOVIE)
1986 Director (segment The Mission)/Executive Producer (uncredited)/Writer

David Lean of *Doctor Zhivago*, soaking up the landscape. On set, Spielberg would explain his ideas to Goldberg, a movie geek herself, by way of other films: this was a *To Kill a Mockingbird* moment, this a *Casablanca* scene.

Was it too pretty? Embalmed in filmmaking? There is no denying the conviction and rawness of the performances (Goldberg, Winfrey, and Glover were encouraged to ad lib). The *New York Times* declared a 'colossal mismatch' of sensibilities, but something in Spielberg's showmanship was 'stirring.'[9] The *Los Angeles Times*, however, decried disastrous decisions at every turn (apart from the casting) to coarsen or prettify the book. 'The result, alas, is the film purpled.'[10]

Cut to 1 March 1987. On the first day they shot in Shanghai (the *real* Shanghai), everything went wrong. The five thousand extras spilled across the road, ignoring the protestations of the assistant director, wrecking the careful lines of the shot. The

AD sought his master's forgiveness, but Spielberg beamed. 'Looks great!'[11] he said. So they rolled cameras, capturing the chaos, a director adapting to the elements as he once had on *Jaws*.

What drew him to *Empire of The Sun*, said Spielberg, recalling his adaption of J.G. Ballard's fictionalized memoir, was a story about 'the death of innocence, not an attenuation of childhood, which by my own admission and everybody's impression of me is what my life has been.'"[12]

Written by playwright Tom Stoppard, Spielberg's most accomplished film of the era is a genuine historical epic, but under his own terms, coolly recalibrating his themes (those growing pains) to the shock of the Second World War.

The true story of an English boy left to fend for himself as the Japanese take control of Shanghai in 1941, the book had come to him by stealth. Hoping to revive the fortunes of an ageing David Lean, he offered to produce his idol's planned

adaptation of Ballard, withdrawing when Lean prickled at his advice. When the veteran abandoned the project, daunted by shooting in China, unsure the episodic novel contained a movie, Spielberg took over, identifying in Jim's sequestered childhood among the city's wealthy suburbs an echo of his new existence, locked in an ivory tower of success.

'From the moment I read the novel, I secretly wanted to do it myself,'[13] he admitted. More than *The Color Purple*, hopeful against the dark, here is a new bleakness in its portrait of human desperation, the amorality of survival, yet still seen through the eyes of an abandoned boy. It is a spiritual successor to *E.T.*, only there is no magical friend to bind his heart to Jim. This boy's bike is stolen, along with his boots.

Book and film are consciously Dickensian: *Oliver Twist* refracted through Ballard's startling memories, with Jim falling under the dubious patronage of American hustler Basie (John Malkovich,

EMPIRE OF THE SUN
1987 Director/Producer

a unique presence in all of Spielberg),
a sourly amusing Fagin. Under Basie's
tutelage, Jim will be transformed into
an Artful Dodger, light-fingered and
streetwise. What Ballard calls his
'unsentimental education.'[14]

The light and dark sides of Spielberg
come together for an ambiguity not
seen before. The exalting images of
the Spielbergian touch are fringed
with death. Jim's adoring gaze falling
upon a Japanese Zero fighter, framed
in a blizzard of orange sparks, being
readied for its Kamikaze swan dive. A
stadium filled with abandoned antiques
like Indy's relics, useless traces of lost
colonialization. American fighters strafing
the Japanese airbase, all velocity and
carnage, cheered on by Jim from a rooftop.

Above: A fairy tale of war –
early on in *Empire of the Sun*,
Jim (Christian Bale), arrayed
in Arabian Nights fancy dress,
encounters the surreal sight
of a downed Zero fighter on
the outskirts of Shanghai.

Left: Oliver Twisted – the
scenes of Bale's young Jim
surviving on the streets of the
war-torn city are knowingly
Dickensian.

Chosen out of the 4,000 who auditioned, twelve-year-old Christian Bale, already charismatic, already intense, portrays Jim as borderline insane. He is as solemn as Henry Thomas, but closer to Cary Guffey in *Close Encounters*, heedless of danger, alien to his former self, Alice adrift in a wonderland of war. The line between imagination and reality has blurred. The spirit that has animated Spielberg's work.

Like *Jaws*, there is a clear two-act structure: city and camp. Losing the grip of his mother's hand (that stab of Spielberg trauma), Jim must survive on the streets of Shanghai. The city is enclosed in the coldest light we had ever seen in a Spielberg film: a scowling constellation of greys, where neon-fronted picture palaces and building-sized murals for *Gone With the Wind* cut through the gloom like reports from another world.

It is a film of grandeur, certainly, but with a harder, more perplexing, intuitive texture than Lean might have brought. Spielberg tunes into the surreal edges of Ballard's writing, reframing his sublime, spellbound, Norman Rockwell suburbia into a world gone mad.

The second, more listless act relocates to the Soochow Creek internment camp, shot in the hot, white light of Andalucía, Spain, and a tale of two surrogate fathers: corrupt, idolized Basie vying with Nigel Havers' weary Dr. Rawlins, determined to educate this wildling. But Jim's soul longs for the air, listing the features of the planes that soar over his head.

'To me, flying is synonymous with freedom and unlimited imagination,' said Spielberg, trying to explain why he is so often drawn to the motif, 'but, interestingly enough, I'm afraid to fly.'[15]

There were still critics turned off by Spielberg's theatricality. Virtuosity has

its limitations, grumbled the *Washington Post*, 'the film is overburdened with epiphanies.'[16] Whereas the *AV Club*, appreciating an almost neglected film (it made only $22 million on release), spoke up for the project 'in which Spielberg began spiking his sentiment with a sense of loss.'[17] Had they not seen *E.T.*?

Empire of the Sun is a crucial way station on the journey to *Schindler's List* and Auschwitz, and *Saving Private Ryan* beyond: the prison camps, the marches, the bargaining for life, a film unblinking in the face of death. The god light Jim sees from afar is the atomic bomb laying waste to Hiroshima. Apocalypse has replaced Mother Ships. Spielberg said he wanted to 'draw a parallel between the death of the boy's innocence and death of the innocence of the entire world.'[18]

The final scene is extraordinary. Not a parting, this time, but a reunion. Jim's tearless, uncomprehending, ancient eyes staring into space as his parents fail to recognize him.

Above: This other boy's life – Christian Bale and Steven Spielberg on the Spanish location for the Japanese internment camp. *Empire of the Sun* revealed a darker and much more ambivalent side to the director.

Left: Father figure – Jim (Bale) will fall under the questionable influence of the crooked Basie (the excellent John Malkovich). Yet is it not Basie who equips him to survive?

Below: A world inverted – Jim fearlessly stands up to an enemy soldier, while the surrounding adults remain dumbfounded

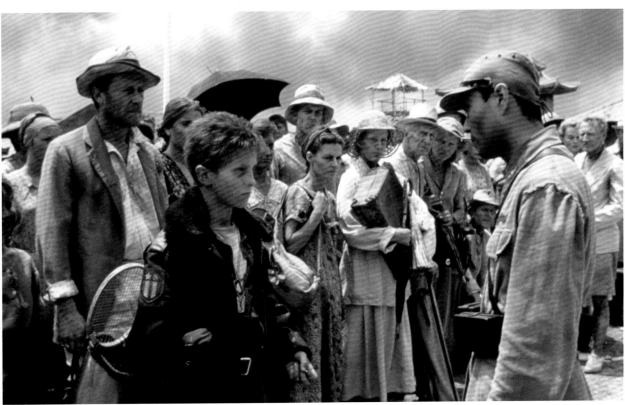

Back to basics. For we demanded nothing less. *Indiana Jones and the Last Crusade* has a different register to its predecessors. All the ingredients are in place. Spielberg certainly, and to an extent Lucas, were attempting to atone for the ferocity of *Temple of Doom* by doubling down on the formula for *Raiders*: the dogged quest for a Christo-Roman artefact, in this case the Holy Grail (a literalization of Indy's lifelong quest for the unreachable prize); the desert setting; the chase sequences, curlicued with sight gags; cartoon Nazis, and melting faces (here accelerated ageing). The tone is almost larkish.

Lucas had dangled the idea of 'a haunted house movie.'[19] An African Monkey King script by Chris Columbus threatened to put them back into the racially insensitive waters of *Temple of Doom*. Once the Grail was agreed as the holy MacGuffin, Spielberg insisted on a father-son angle.

After a first, uncharacteristically talky act of Ford's Indy, looking a little more weatherworn (it's the mileage), wending the winding trail toward the treasure, *The Last Crusade* launches into a double act. A knowing franchise delivers (for now) its most calculated punchline – that the father of Indiana Jones is played by James Bond. It's the ultimate doffing of the hat. And in the casting of Sean Connery, dotty, professorial, perpetually irked Henry Jones, absentee father, grew more robust and funny. In the third *Indy*, plot (which is sprightly rather than relentless) plays second fiddle to character, and it still made $474 million worldwide (banishing the memory of recent hiccups).

Did we really need to dig up Indy's backstory? To make sense of a character defined in the moment, and in Ford's pained expressions? Something was gained and something lost – an archetypal mystery. Once you have a father, there is a childhood. A family theme slammed home by the bait-and-switch opening (weakest of the pre-credit bonanzas), the Paramount logo matching a sandstone

peak in Monument Valley, prima facie Americana, John Ford territory. Nudge, nudge – wink, wink. The joke is that the guy who resembles Indy is no more than a good-natured but dishonest fortune hunter, scavenging for a priceless Cortez crucifix in a remote cave, and the peppy boy scout (River Phoenix) is the young Indiana Jones. This is 1912, and the ensuing chase, a Keaton-esque dash (cue – outright lifts from *The General*) along the roof of a circus train (with due deference to *Dumbo*), is freighted with exposition as running gag: the obsession for archaeology, the phobia of snakes, the whip, and the hat are each explained away. The boy scout motif was a reference to Spielberg's childhood, drawing Indy back toward self-portrait. It's an exuberant, finely-mounted sequence, but overthought all the same. We gain answers to questions we hadn't asked.

With a greater air of self-parody to the constructs of the *Indy* universe – spinning fireplaces in German castles, motorbike chases, Zeppelins, hanging from tanks, the traitorous girl (Alison Doody) who beds both Joneses – the film rattles along its well-trodden path, shooting in Venice, Spain, Jordan, and good old Elstree. There's no taste for the weird. The finale, another tomb of sorts in an unspecified corner of Araby, can't compare to the carnival of traps in the South American jungle at *Raiders'* inception. Spielberg claimed he was 'consciously regressing'[20] with the film, having some fun, and Indy was regressing with him.

Below: The third Indiana Jones adventure was an attempt to get back to basics – which meant the sight of Indy (Harrison Ford) punching Nazis on a speeding tank.

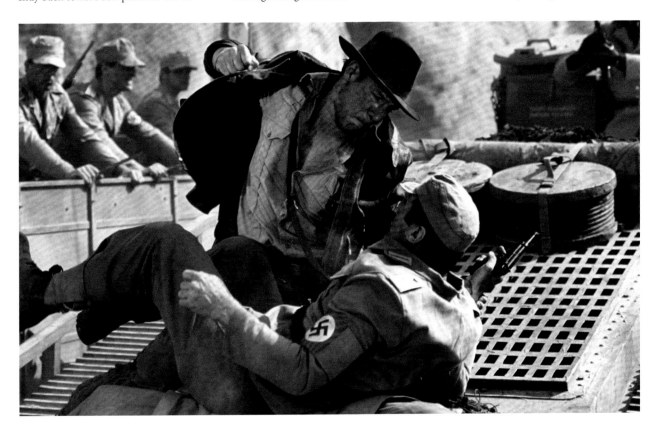

It's the chemistry between Ford and Connery that sings, with Stoppard returning to put some zest into their dialogue. There is such joy in *Crusade's* brazen starriness. Ford the established superstar, whose fame had burst out of his work with Lucas and Spielberg; Connery a legend from a galaxy far, far away – the blockbusters of their youth. The Grail, Indy comes to understand, is his father. That theme of reconciliation makes this the most personal of the original trilogy. Spielberg was estranged from his own father. The final shot of Indy and friends riding into a blood-orange sunset is charged with momentousness and reverie – a farewell to all that. If only.

Always is another film about death. Or, at least, the afterlife. It is Spielberg's first remake, of *A Guy Named Joe*, a 1943 MGM melodrama starring Spencer Tracy and Irene Dunne. *Always*, for biographer Joseph McBride, is Spielberg's midlife-crisis movie. He was forty-three and divorced (from actress Amy Irving). His childhood was growing fainter. *A Guy*

Named Joe was the second film to make him cry (after *Bambi*). He was twelve, and his parents were in the midst of a break-up, the icy shard that would pierce his work. It was a metaphysical romance about a WWII pilot (Tracy), shot down in combat, who returns as a ghost to help his grieving widow (Dunne) find love again. Life goes on, the film extols. 'As a child I was very frustrated, and maybe I saw my own parents in it,'[21] mused Spielberg, who had been pondering the remake as far back as 1974.

From the outside it came across as a curio. Why on earth was Spielberg remaking a forgotten piece of soft-glow Hollywood in present-day Montana with airborne fire-fighters and attendant grease monkeys replacing war-time pilots? They do, at least, fly vintage Second World War Douglas A-26 Invaders. *Always* was another Spielberg film desperate to take off and soar like an urge to entertain.

For once the film cried out for movie stars, but the casting retained a bravely

salty, Spielbergian sensibility. Having pondered Paul Newman or Robert Redford, he followed his nose back to alter ego Richard Dreyfuss in the Tracy role of doomed pilot Pete Sandich, with Holly Hunter as his true love Dorinda Durston, and John Goodman as comic sidekick Al Yackey. The homage to old Hollywood is found in the divine presence of Audrey Hepburn, in her final appearance, as the angelic Hap. Wandering among the Cedars, she brings a quiet aura of enchantment sorely missed in the upcoming *Hook*.

Tellingly, every special effect was written out of the movie. All the supernatural gimmicks of Pete passing through walls. The tone was one of the hardest things to pin down. How comic should it be? How tragic? How romantic? How magical? The film has its charms, all the leads are reliably good (though it's impossible to fathom what Hunter sees in the lunk Brad Johnson as her new romantic interest), but the box office was unmoved ($74 million looked like a flop).

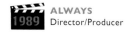

ALWAYS
1989 Director/Producer

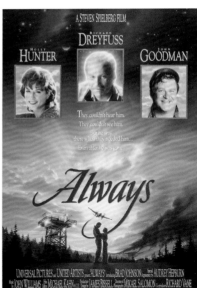

Above left: *Always* was an oddity – Steven Spielberg's only true remake until *West Side Story*, a metaphysical love story set against the backdrop of Montana's airborne fire-fighters…

Above right: …but it did offer the reassuring sight of Richard Dreyfuss returning to a Spielberg film for the first time since *Close Encounters of the Third Kind*.

Right: Pete Sandich in gimmick-free ghost form (Dreyfuss) watches on as Dorinda Durston (Holly Hunter) finds new love with Ted Baker (former Marlboro Man Brad Johnson).

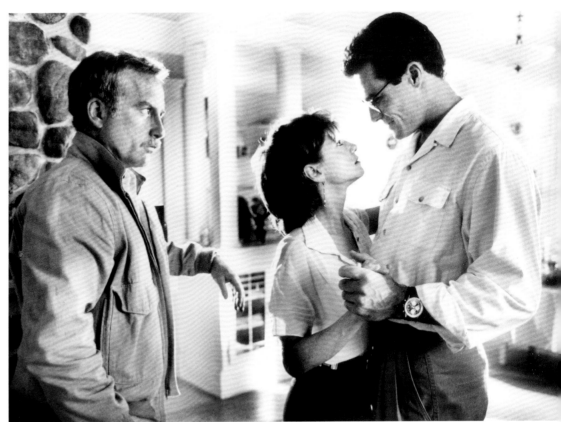

In hindsight, *Hook* can be put down to misplaced enthusiasm, though at the time it was talk of the town. Have you seen those incredible sets? Industry heavyweights were coming and going like the Universal Tour. For the first half of 1991, Neverland spilled across soundstages at Sony Pictures (it was their $75 million party): a dream playground of pirate galleons, treehouses, and London rooftops, as intricate as clockwork, as big as a theme park, as stagy as Broadway. Are we supposed to detect a hint of the pantomime in their ersatz reality?

Based on a script by Jim V. Hart and Malia Scotch Marmo – with an uncredited Carrie Fisher rewrite – it sounded like an awfully big adventure. Robin Williams as a middle-aged Peter Pan, who has forgotten how to fly, drawn back to old haunts to rescue his children, snatched by

Above: The unbeloved *Hook* – Robin Williams' Peter rediscovers his uplifting mojo in time to battle his foe.

Right: Touched by a hint of tragedy, Dustin Hoffman's charismatic Captain Hook is one of the film's more successful elements.

THE VISIONARY (VIDEO)
1990 Director (segment Par for the Course)

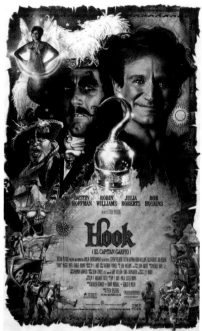

Above left: All at sea – despite being safely land-locked on soundstages, Steven Spielberg was back in the uncertain waters of *Jaws*, with *Hook* running forty days over schedule.

Above right: Though often taken for one of Spielberg's few flops, *Hook* actually made a profit.

pirates rather than aliens. Spielberg had considered making it a musical.

Hook suffers as *1941* did, though not as severely, from a filmmaker trying to direct his way out of material that didn't fit. Which is ironic, given it was a high-concept riposte to that long-running gag about being the Peter Pan of Hollywood. What if Peter grew up? It was Spielberg's fears manifest, dubbed his 'Peter Panic'[22] by the ever-snide *Village Voice*.

Unlike Lucas, Spielberg is unmoored by the challenge of world building; he needs the gravity of the real. The world of Indiana Jones is far-fetched, but we feel the sand beneath his feet, we taste the blood on his lips. Everything in *Hook* is stage-managed, even its symbolism. There are pleasures: Dustin Hoffman as the forlorn Captain Hook, more lost than the Lost Boys without his rival; the opening scenes of Peter as an uptight Los Angeles attorney (he is the absent father!); Bob

Hoskins' malaprop-dropping Smee; John Williams' sparkling score. But the film was, no other word for it, panned. 'There are too many characters, too many props, too many signs, too many costumes,'[23] sighed the *Chicago Sun-Times*. 'Like something from the imagination of an uncharacteristically winsome Hieronymus Bosch,'[24] fussed the *New York Times*.

It made $300 million, but no one was crowing. This was a failure of craft. Was it Spielberg who had forgotten how to fly? It wasn't that he needed to grow up, he needed to remember who he once was.

HOOK
1991 Director

MAKING HISTORY

Jurassic Park (1993), *Schindler's List* (1993)

Branko Lustig awaited his turn. The brief speeches that followed the ovation were dignified, respectful, a note of quiet satisfaction overruling the usual euphoria. There was also unmistakable relief. As convinced as industry prophets were of victory, Steven Spielberg must have wondered if the ultimate humiliation still awaited him.

Not this time. Presented by Harrison Ford (there is a significant embrace, a private moment in front of billions of viewers) *Schindler's List* had won the Academy Award for Best Picture.

'Ah wow! This is the best drink of water after the longest drought in my life,'[1] quipped Spielberg, despite everything still a boy scout.

Lustig was the last of the producers to reach the microphone, the focal point of the Dorothy Chandler Pavilion on the night of 21 March 1994. His words were forceful, though he said them calmly.

'My number is 83317... It is a long way from Auschwitz to this stage.'[2]

With *Jaws*, Spielberg had invited a TV crew to join him in his living room to watch the nominations being announced, only to be left crestfallen and embarrassed on camera when he was absent from the

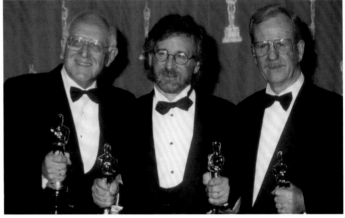

Best Director category. It was a tactical error – a glimpse of hubris.

With *Schindler's List*, he stood defiant and the Academy were unable to resist. Set within history's event horizon, it was a film made with unyielding passion and astonishing craft, expressed like a deep breath. Of course, a few months earlier, he had gifted Hollywood the biggest film of all time (again), establishing a new species of blockbuster gilded with the miraculous technology of computer-generated imagery. In *Jurassic Park*, dinosaurs had roamed the Earth again.

Was nothing beyond him?

Above: The Academy Award for Best Picture goes to... The three producers of *Schindler's List*: Branko Lustig, Steven Spielberg, and Gerald R. Molen.

99

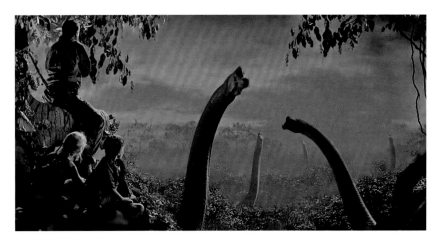

Left: Dinosaurs reborn – Spielberg could not resist the chance to bring the great lizards back to life in *Jurassic Park*, which almost predictably became the biggest film of all time.

Below: A monster hit – palaeontologist Alan Grant (Sam Neill) distracts a T. rex from her dinner.

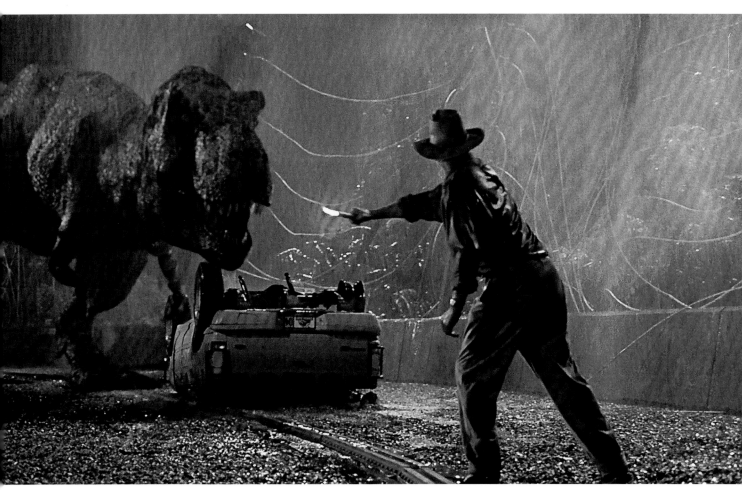

It was a year like no other, in a career like no other. In 1993, Spielberg confirmed and redefined all that we thought of him. He was still the world's premier entertainer – that illustrious IP! – and within the same twelve months, virtually back to back, he made a masterpiece of a new order. A masterpiece that would lead him, virtually uncontested (his fellow nominees surely accepted defeat), to this moment: seven Oscars, but crucially Best Director and Best Picture.

Two films as contrasting as night and day (and there is a sensation of one being set during daylight and the other in the darkest hours). Two films that could have come from no other director.

Rewind the picture, back to 1989, when Spielberg met with a doctor-turned-novelist and erstwhile filmmaker (he had directed *Westworld* and *Coma*), with the intention of developing a movie set in a Chicago emergency ward. Michael Crichton, Chicago-born, smart as a whip, lofty and lean as a basketball centre, was a tall man who wrote tall stories with a Spielberg-like knack for wielding the zeitgeist like a fountain pen. That hospital project evolved into the seminal show *ER*, base camp toward the peak of golden-era television.

Crichton happened to mention the novel he had recently finished. About a theme park filled with dinosaurs, cloned from 65-million-year-old DNA traced to mosquitos preserved in amber. He had a gift for rendering his cockamamie thrillers credible with scientific rhetoric. History was repeating: Spielberg persuaded Crichton to let him read the galleys. Unlike *Jaws*, with its biting cynicism, *Jurassic Park* plugged back into the catalyst of his childhood: alongside UFOs and aircraft, he was a sucker for dinosaurs.

He called back the next day. 'I'd like to make it.'

'I'll give it to you if you guarantee to direct it,'[3] replied Crichton.

It wasn't quite so simple. Crichton's agents, as scheming as the film's wheedling lawyer Gennaro (Martin Ferrero) – gobbled up by a Tyrannosaurus rex (a gross-out in-joke to keep the mood light) – had instigated a bidding war for the rights, setting a $1.5 million minimum, and the permutations began to fly. Warner Brothers touted Tim Burton. Columbia had Richard Donner. Fox suggested Joe Dante. But Universal had Spielberg – *Spielberg!* – plus Crichton's tacit agreement, and the deal was done, promising a budget of $60 million.

He may have been the one to propose *Schindler's List*, but Universal's Sid Sheinberg implored Spielberg to tackle *Jurassic Park* first. The studio needed a summer blockbuster, the industry needed it. They wanted their pound of flesh. There were hints that one would insure the other; the commercial giant to offset the art film. Spielberg was compelled by

Above left: Steven Spielberg frames his shot – the dinosaur at this stage a figment of his imagination. *Jurassic Park* would take a major step into the future of special effects by recreating the past.

Above right: The iconic poster art for the film's release – if ever there was a preordained hit it was this dinosaur thriller. Indeed, it could be deemed Spielberg's first knowing attempt at a blockbuster.

Opposite: Created with a mix of Stan Winston's animatronics (for closer interactions) and Industrial Light & Magic's CGI (for wider shots), the T. rex embodies the film's quest for dinosaur realism.

his own demons. That urge for spectacle was like a boulder at his heels. After *Hook's* creative failure, he needed to set things right. Regain his confidence.

'I have no embarrassment in saying that with *Jurassic* I was really just trying to make a good sequel to *Jaws*. On land. It's shameless,'[4] he admitted.

The plot is equally streamlined. On another island, like Amity, designated for pleasure, nature bares its teeth. But the panic is self-inflicted: where Crichton's *Westworld* had the robot exhibits turn on the guests, now dinosaur clones reap evolutionary-ordained havoc when the electrified fences are sabotaged. A sample of handpicked brainiacs and grandchildren – a test audience – strive not to fall down the food chain. This is

the school of Mary Shelley, Arthur Conan Doyle, Jules Verne, and H.G. Wells – man playing God! – recalibrated to the disaster movie playbook.

Jurassic Park is the first of his films to truly embody the cliché of Spielberg as ringmaster. Even the *Indy* trilogy had a premeditated, Old Hollywood panache; we basked in its ironic style. With *Jurassic Park*, audiences stampeded to cinemas with Pavlovian hunger. Dinosaurs by Spielberg! The logo *was* the film. Within four months it had broken *E.T. the Extra-Terrestrial's* record, finally reaping $913 million worldwide (Spielberg's cut was estimated at $250 million), making history.

Crichton delivered a first draft, David Koepp began again with a second, sticking

close to the book. In their discussions, Crichton was amazed how Spielberg described his dinosaur attacks, seeing the film in his head. Muscles moving beneath the skin, the weight of a giant foot squelching into mud. It was about conveying life. He wanted the T. rex to sprint after a jeep at sixty miles an hour.

'Steven,' the writer pressed, 'how are you going to *do* this?'[5]

The question seemed immaterial to Spielberg. Cinema would find a way.

From deal to shoot, they had twenty-five months in which to bring dinosaurs back to life. An era otherwise known as preproduction. The plan was for full-scale animatronics mixed with advanced go-motion miniature animation for wide shots. That was until Industrial Light &

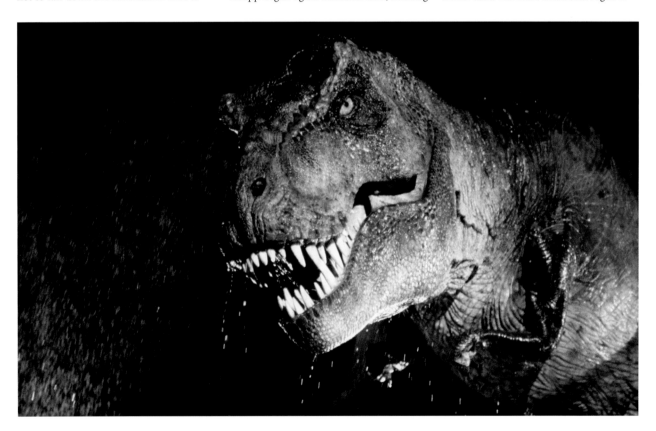

 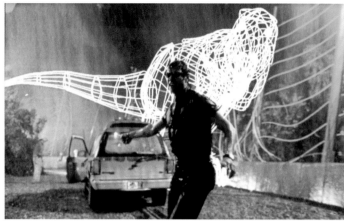

Above left and right:
Bringing dinosaurs back
to life - Industrial Light &
Magic would figure out how
to inject life into computer
animation. This was the first
time the 'real' had been
imitated with pixels.

Magic's Dennis Muren (ahead of the
curve, having worked on *Terminator 2:
Judgment Day*) showed Spielberg a demo
of the Gallimimus charge in pure CGI
and everything changed.

Special effects carry little capital for
Spielberg as such. The son of a computer
programmer, naturally he thrilled to talk
of pixels and mainframes, but he is a
pioneer by association. The story leads
the way. The determination to show a
potpourri of dinosaur species in all their
scaly raiment.

There with his friend, proverbially
putting his head in the shark's mouth,
George Lucas likened the moment to
Edison's lightbulb (somewhat forgetting
James Cameron's contribution).

Creation, reproduction, evolution:
the medium becomes the message. Now
computers could recreate dinosaurs,
model-makers were condemned to
extinction. Yet it is the computer system
that proves the Park's Achilles heel.

Looking back, it is the tactile
animatronics, built and operated by the
brilliant Stan Winston for close-up magic,
that have weathered better – the very
techniques that had handicapped Great
White Bruce. CGI was still evolving.

Shooting from 24 August 1992, with
exteriors in Hawaii, the rest spread
between Universal and Warner Brothers
studios in Burbank, Spielberg finished
with twelve days to spare. For all the
new-fangled technology, it is essentially
a greatest hits. Who is Sam Neill's gruff,
child-unfriendly palaeontologist, Alan
Grant, but Hooper from *Jaws* spliced
with Indiana Jones? The characters are
the weak link: Jeff Goldblum's
chaotician Ian Malcolm is a slick
Cassandra ('Boy, do I hate being right
all the time'[6]), as broody palaeobotanist
Ellie, Laura Dern squeals more than
Willie in *Temple of Doom*, while Samuel
L. Jackson (chain-smoking keyboard
jockey) and Bob Peck (big-game hunter
in khaki shorts) only hint at something
more interesting. The kids in question,
gibbering wrecks Joseph Mazzello and
Ariana Richards, are surprisingly quick
sketches – we never see the park
through their eyes.

Spielberg turned to fellow director
Richard Attenborough to play Prospero-
like Svengali John Hammond, softened
from the book's more rapacious mogul
(another hungry dinosaur). He grows over
the film, good with an intense close-

Right: Something scaly this way comes – Laura Dern, Jeff Goldblum, and Bob Peck give a spin to the classic Spielberg 'staring up in awe' motif with their 'listening in terror' mode.

Below: Park strife – Lex Murphy (Ariana Richards), Alan Grant (Sam Neill) and Tim Murphy (Joseph Mazzello) go off-trail in a deadly theme park.

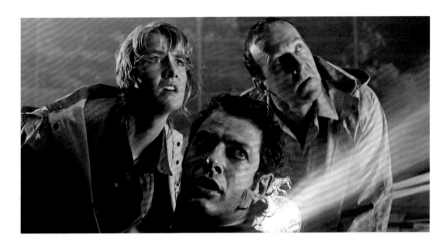

Left: Scientific fiction? John Hammond (Richard Attenborough, second from left) shows off his raptor incubation unit. There was much debate as to whether *Jurassic Park's* theories rang true.

Below: Ellie Sattler (Laura Dern), Tim Murphy (Joseph Mazzello), and Alan Grant (Sam Neill) examine an ailing Triceratops – one of the more significant dinosaur animatronics.

up, but we can only wonder what Sean Connery might have done with the part.

The film takes time to find its feet. We're reminded how fleet *Jaws* is – the horror loose before the credits. For twenty-five minutes, the film can't shake off exposition, endless talk of dinosaurs.

Jurassic Park, while great entertainment, reflected Julie Salamon in *The Wall Street Journal*, 'doesn't resonate like a great movie.'[7] Critics took to calling it a thrill-ride. 'It delivers where it counts,'[8] enthused *Variety*.

Once the apex predators are loose, the rules of horror assert themselves, and Spielberg rises to the occasion. There is a three-act structure: that chewy set-up (chancing a bold early view of brachiosaurs), T. rex attack (outside), with velociraptors for dessert (inside). The latter acts provide towering set-pieces. When it is simply, joyously a monster movie in the hands of a maestro. Concentric ripples in a tumbler of water (achieved by a plucked guitar

under the SUV dashboard) announcing the entrance of the T. rex with *Jawsian* dread. The attack is a rodeo of sheer Darwinian might. It is the agile raptors, almost human-scale, who unleash that lithe Spielbergian wit. There is a sly ambivalence about whether we should be rooting for the reptiles.

The finale is a deranged riff on E.T. making himself at home – dinosaurs meet civilization! Opening doors, scattering pans, leaping through ceiling tiles, chittering like birds as they sniff out those child-flavoured morsels, the raptors are wicked fun. A snorting breath on the kitchen door is as avaricious as Elliott's misty sigh in *E.T.* was a signal of love. The shot of genetic codes reflected across ancient scales is one for the hall of fame.

Eyes are the key motif, this infernal sizing up of humanity. The dilating iris of the T. rex in a flashlight beam, the cat-like calculations of the raptors, contrasted with the terrified

stares of Neill, Dern, or Peck, or the audience, believing our own eyes.

Jurassic Park is satirical in its way (there are flickers of *1941* and *Hook*, a goofiness), a film about the film industry. It's a theme park gone rogue! The camera roams a gloomy gift shop, shelves filled with redundant lunch boxes and cuddly toys. While beyond the stalls, the toy stores were bursting with dinosaur replicas, and dino-styled rides sprouted at Universal's actual theme park across the fence from the backlot. Slimy Nedry (Wayne Knight) is selling secrets to a rival, while his costumes pay meta-homage to *The Goonies*. This is a story about entertainment out of control.

Submerged beneath Spielberg's flare for building tension, beat by throbbing beat, can we detect a parable about the perils of blockbusting? They can eat you alive. As his dreams collapse, Hammond delivers his *cri de cœur*: 'With this place, I wanted to show them something that wasn't an illusion. Something that was *real*.'[9]

Six weeks after the final shot of *Jurassic Park*, Spielberg was on a plane to Poland, ready to face his fears.

'There was a huge overlap,' he recalled: '*Schindler's List* and *Jurassic Park* were almost directed in the same breath.'[10]

On Józefa Street, Szeroka Street, and Straszewskiego Street. In the quiet suburb of Płaszów. Actual places scattered across Kraków. Outside the gates of Auschwitz-Birkenau itself, the metropolis of death, beneath slate-grey skies. In all thirty-five locations, he moved at speed, freeing his camera from overthink and storyboard. He had been denied permission to shoot within the former concentration camp (the World Jewish Congress feared he was turning the Holocaust into a theme park – not the first or last to doubt his intentions), and reconstructed the rail yards on the opposite side of that cast-iron sign.

Arbeit macht frei – Work sets you free.

'It wasn't like a movie,'[11] said Spielberg. The long years of gestation were not unusual. There were projects that demanded his immediate attention, and others he approached warily, working through draft after draft. With *Schindler's List*, he knew he had been censoring himself, thinking his audience would never accept it, not from him.

Spielberg feared portraying the Holocaust, as any director might. Its horrors threatened the limits of what might conceivably, tastefully, even morally be shown on a screen. Theodor Adorno's quote rang in his ears: 'There can be no poetry after Auschwitz.'[12] There were searing documentaries, foremost among them Alain Resnais' *Night and Fog* and Claude Lanzmann's nine-hour memorial *Shoah*. Films he watched repeatedly. There was the influential if unconvincing 1978 miniseries *Holocaust* (produced by

Above: A tale of two Germans – at the centre of *Schindler's List* lies the crucial friendship-rivalry-manipulation between Amon Göth (Ralph Fiennes) and Oskar Schindler (Liam Neeson).

Opposite: In marked contrast is the meaningful relationship between Schindler and Jewish accountant Itzhak Stern (Ben Kingsley, left), who serves as the German industrialist's conscience.

Lustig). And melodramas spun from history like *The Pawnbroker*, *Sophie's Choice*, and *Music Box*. How would he negotiate his own nature to entertain? Might he cheapen the truth? Worse still, exploit it? He would take no fee (no 'blood money'[13]), donating his profits to charities and the foundations he set up.

He wasn't the first to try: MGM commissioned a script from Howard Koch in 1963, with Connery in mind. Billy Wilder (who lost his mother to Auschwitz) hoped to make it his swan song. In his confusion, Spielberg tried to pass it on to Roman Polanski (another survivor), Brian De Palma, Sydney Pollack, and Martin Scorsese – who came close. That was before Spielberg pleaded for it back, offering *Cape Fear* in return.

The time had come. There were outside factors: CNN reports of growing antisemitism, Holocaust deniers gaining significant air time, the silence of schools on the subject. But it went deeper. This was an awakening. He was halfway through *Hook* when he knew.

Scripts had wrestled with the long, factual novel, its many characters and locations, event piled on event. How to compress it all into a feature film. Author Thomas Keneally tried, then *Out of Africa* screenwriter Kurt Luedtke, before Steven Zaillian, hired by Scorsese, proposed a character piece, another triumvirate – the battle for Oskar Schindler's soul. It's almost classical: Schindler (Liam Neeson) – profiteer, womanizer, scoundrel, saviour – is caught between the devil of Płaszów concentration camp commandant Amon Göth (Ralph Fiennes) and quiet angel Itzhak Stern (Ben Kingsley), accountant and guardian to the Jewish workforce sequestered in Schindler's enamelware factory. Clinging to humour, the cast called it a 'buddy movie.'[14]

Spielberg pushed for a more 'horizontal'[15] story, Zaillian's script growing to 195 pages, 359 scenes, the director's longest film at 3 hours 15 minutes. He wanted to portray the Jewish families in parallel to Schindler's mission, lives the German saved and many he couldn't. Also to invoke personal testimony – camp women pricking their fingers to rub blood into pale cheeks, a boy taking refuge in a cesspit. There were to be no epiphanies. No beams of heavenly light, only searchlights. The nature and moment of Schindler's transformation must remain an enigma.

Acres of editorial would be spent divining how this was unlike any previous Spielberg. But as biographer Joseph McBride extolled, it is far more enlightening to ask how the film is 'profoundly *characteristic* of Steven Spielberg.'[16]

Schindler's List is closer to *Jaws* than *Jurassic Park*. Not in subject, but in the art and vitality of its making. Here is the present-tense immediacy of those early films, only with this radical relocation in place and time. It was a realization of what had gone astray in recent years. When making movies, Spielberg now accepted, 'you can't do things consciously.'[17] A masterpiece welled up from within him.

Shooting between 1 March and 11 May 1993, the budget was a comparatively slender $22 million, but the scale was prodigious: 126 speaking parts, 30,000 extras, 148 sets, and a crew of 210. No one was immune to the chilling echo in the marshalling of complex scenes and the *Aktions* of the past.

It was as hard a production as *Jaws*, but now the currents belonged to history. Polish-born cinematographer Janusz

Kamiński saw Spielberg 'directing from his heart,'[18] setting his scene, then responding to it intuitively, living on that improvisational edge developed on the *Orca*. Averaging thirty-five set-ups a day, he amassed more coverage than his last five films put together, unwilling to miss a thing. He refused his pensive cast rehearsal time, wanting the panic. He made constant adjustments to the frame, the so-called *mise-en-scène*, where theme, narrative, style, and psychology commingle. How else would you tell this story?

Authenticity was everything: the forensic detail of the sets or costumes, something in the faces of the extras, and the spasms of cruelty dealt out by the Nazis. 'It has to be real,'[19] he would demand, again and again. Enjoyment is the wrong word, but he was *fulfilled* by each scene, each shot, each crystalline moment. 'Let them see that,'[20] he cried, then moved on again.

Above: Ben Kingsley consults with Steven Spielberg on the set of *Schindler's List* in Kraków. The director decreed that even behind-the-scenes stills would be in black-and-white.

Opposite: Spielberg lines up a shot of Jews being loaded onto a train – on *Schindler's List*, the director was driven as he never had been before, completing numerous set-ups, not allowing himself room to second-guess his ideas.

Gone were the props of crane, zoom, and Steadicam. His 'utensils,'[21] as he called them, laughing. The filmmaking must never draw attention to itself. He puts us *inside* history, as witnesses, the task producer and survivor Lustig pressed upon him.

As soon as he read the book, Spielberg knew he would shoot in black-and-white (and with genuine black-and-white stock to prevent a mildly resistant studio from releasing a colour version for television). To match the old newsreels, the monochrome of the real camps. Black-and-white wasn't a disguise, it was clarity – it accentuated the blemishes, he insisted, interviewed on set. He was talking all the time, a font of facts, scarified truths, filmmaking objectives, reminding himself of *his* mission.

'So when you're in a ghetto like this, black-and-white details every single wall, all the bricks, all the chipped plaster on the façades of these ghetto dwellings.'[22]

There were times he could barely look. When the prisoners were forced to run circuits of the camp, naked to the elements, he turned his back to his own scene.

Older extras approached him, urgent to tell him their stories. They had seen it. The Nazis, the ghetto, the liquidation. It was horrifying to see it again: the yellow stars on Jewish arms, the red and black swastikas (colours we would never see). He took their pale faces as a mark of approval. This was an act of remembrance.

Did he truly weep every night? New myths gathered around the production,

the story of Spielberg undone by his subject once each day had wrapped. He was insulated by family, who had travelled to Poland to be by his side, and relieved by the double burden of giving two hours a day to catch up with his dinosaurs. Afterwards editor Michael Kahn (by his side since *Close Encounters of the Third Kind*) urged him back to the flood of footage from *Schindler's List*.

Spielberg was discovering himself through the film. Or rediscovering. Locating his Jewish heritage, the Orthodox life he had dismissed by high school, still bullied as the kike kid. He recalled the stories his grandparents had told him about the Shoah. 'The Jewish life came pouring back into my life,'[23] he said. This is what made it personal. Who he became.

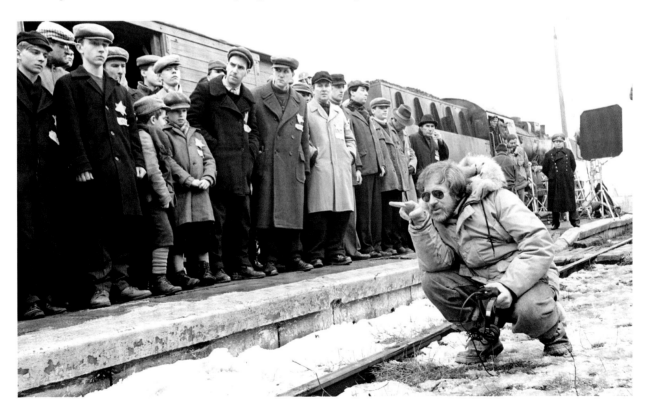

Right: Blessed bureaucrats – Itzhak Stern (Ben Kingsley) and Oskar Schindler (Liam Neeson) keep up the façade that theirs is a business operation.

Below: Partying with Nazis – Steven Spielberg draws a marked and often humorous contrast between Schindler's two central friendships.

The genius of *Schindler's List* lies in how Spielberg confronts the Holocaust with filmmaking. This is not a separate part of him, some new way of being as an artist, this was everything he was. All the skills honed in the company of Indiana Jones (and the gurning Nazis he could never return to). All of his fluency, and depth of feeling. That blend of life and film. All of his talent. All of his instinct.

'It's as if he understood for the first time why God gave him such extraordinary skills,'[24] eulogized David Denby in *New York* magazine.

In their delirium of praise, critics called it documentary-like, unblinking, unshowy; a new, naked, purified Spielberg, more reporter than filmmaker (forty percent of the film is handheld). And they called it beautiful, with a

"It's as if he understood for the first time why God gave him such extraordinary skills."

David Denby, *New York*

voluptuous, movie-like lustre. Like film noir. Or a spy movie. A tincture of genre on the cold Polish wind.

This was German Expressionism mixed with Italian Neorealism, confirmed Kamiński. European traditions, cinema's backstory: *Metropolis; Rome, Open City; The Third Man*. For Schindler at play, floating through the Nazi hierarchy, wining and dining, the party badge on his lapel, an actor on a stage, there is a varnish of forties Hollywood. He could be Bogart or Gable. There are montages worthy of Chaplin – Schindler's rapt attention over a procession of pretty but ineffectual typists, then smoking listlessly as a crone races across the keys.

Setting aside the monumental context of *Schindler's List*, it is a compelling film, full stop. Fiction guides us through the

torment of fact. The paradox of Schindler gave Spielberg his story: between ghetto, camp, train stations, and the ovens of Auschwitz, the suave industrialist will broker for the lives of his workers with Göth and the monolithic Nazi machinery. There was talk of Kevin Costner and, unthinkably, Mel Gibson canvassing for the role, but Spielberg knew better than to disturb his hyperrealism with the blur of stardom. He had seen Neeson on Broadway, gone backstage, witnessed his bonhomie first-hand – the man already.

Schindler stands in marked contrast to Spielberg's previous leading men, all those ciphers. He doesn't have that same 'troubled energy,'[25] noted *Premiere's* John H. Richardson. Spielberg saw Schindler as his most romantic character. 'He romances the entire city of Kraków, he

romances the Nazis, he romances the politicians, the police chiefs, the women. He was a grand seducer.'[26] Maybe there is a dash of Belloq to him, a hint of Basie.

Glum and dissatisfied on his first day of filming, feeling the cold, Neeson was confronted by Lustig, who simply rolled up his sleeve and showed him the indelible mark of Auschwitz. That was all the motivation he needed. Books could be written on Neeson's performance alone, a flux of self-interest, swagger, bravado; all those gusts of irritation, all that bountiful charm.

A perfect detail, the slightest sound edit: the creak of leather from Schindler's expensive jacket as he expounds on his part of the endeavour to a bewildered Stern. 'I'd see that it had a certain panache.'[27]

Beneath the impeccable suits, an awakening. This is another coming-of-age story. Another study of an ordinary man called to heroism by extraordinary circumstances. The German who becomes a mystical father to a thousand Jews.

In Fiennes' plump, handsome, death-dealing Göth – by Keneally's reckoning, Schindler's 'dark brother'[28] – we measure evil in human quantities. Watching the first of three takes from the video test with Fiennes, Spielberg didn't bother with the second or third. It was a 'sexual evil'[29] he saw in the British actor, a hunger. Göth is a lethal child, petulant at his lot, taking pot-shots at prisoners from his balcony, while his storm-tossed psyche is tormented by his attraction to his Jewish maid (Embeth Davidtz).

The most astonishing performance comes from Kingsley as Stern, stoic, dignified, bespectacled, an intellectual man as vigilant as a cat, in whom the horrors are so often parsed into reality.

And somehow still partner in a delightful odd couple with Schindler. This is a film about so much, not least the guises of friendship, counterfeit and genuine.

Every performance speaks of a rigour to bear witness. Davidtz as Göth's shattered maid, trying to keep her sanity. Caroline Goodall as Emilie Schindler, another harried blonde wife watching her husband being consumed by a quest. And it is Israeli actor Jonathan Sagall who plays Poldek Pfefferberg, the luggage man who had told Spielberg his story ten years before, portrayed as a black marketeer, a Schindler of the sewers (an Artful Dodger), saving his skin by clearing luggage from the Nazi path.

The dread descends as implacably as snowfall. The Spielberg touch turns ice-cold. His talent for mythologizing the mundane rises to a new purpose. All these Nazi motifs delivered as crisply as a drum roll: collapsible chairs, typewriters, sheafs of paper, nibs dipped

Above left: The cold commandant – Steven Spielberg knew instantly that Ralph Fiennes was right for Amon Göth. He gave the Nazi a very human evil.

Above right: In one of the film's most intense and confounding subplots, Göth wrestles with his attraction to Jewish maid Helen Hirsch (Embeth Davidtz).

Opposite: The liquidation of the Kraków Ghetto is the dark heart of *Schindler's List* – a staggering demonstration of Steven Spielberg's gift for mounting massive set-pieces without any loss of emotional detail.

in ink, stamps, lists. The camera tracking through a station between piles of clothes, shoes, photographs, to meet the mute incomprehension on the face of a Jewish jeweller as gold teeth are scattered before him. No one thought of it as epic – it was a landscape of faces. John Williams withholds his fanfares for Itzhak Perlman's anguished violin and a suite of sober, softly hopeful Jewish-inspired themes, only building to choral peaks to lament the dead.

Kahn's editing is extraordinary. The film has a multitudinousness that recalls *1941*, yet he and his director are in absolute control of the narrative. Stories lie within stories, character vignettes, all these accumulated tragedies, an accounting of lives – a list. What drives the film forward is the almost hypnotic play-off, back and forth like a heartbeat, between the movie-like melodrama of Schindler's schemes, his many performances, and an unequivocal chronicle of history. The sudden staccato of arbitrary death, the blood running, spurting, gushing as black as bureaucratic ink, has a sickening absurdity – this is the reasoned portrayal of the unreasonable.

We watch the liquidation of the Kraków ghetto through burning eyes. The lines, the murders, the abject confusion. The crowds have the scattered, loose-limbed verisimilitude of the beaches of Amity, anxiety passing through bodies like an electrical current. Spielberg keeping track of every character as details accumulate into a symphony of terror and outrage as crazed as Hieronymus Bosch: stethoscopes at walls, the German pianist playing Mozart amid massacre, the ghostly strobing of machine-gun fire at ghetto windows. Each day the air was left stinging with cordite.

The girl in the red still stirs debate. This one flash of colour, a red coat on a lost girl, rotoscoped by ILM, that catches us off guard. Soundings have been taken: that she stands as a symbol of blood, innocence, or the individuality of life amid a tableau of colourless death. Is there a knowing echo of Elliott's red top from *E.T.?* A rebuke to his old optimism? She is based on fact. This girl in red, recalled by Schindler, maybe six years old, ignored amid the chaos, was something he couldn't get over. Spielberg would enlarge on his intentions, that she symbolizes how world leaders – Roosevelt, Stalin, Churchill – knew of the Holocaust, but for so long did nothing. She was, he said, this 'glaring red flag that anybody watching could have seen.'[30]

Film historian David Thomson cited the red coat as the film's fatal flaw: 'In that one small tarting up… there lay exposed the comprehensive vulgarity of the venture.'[31] Like much of the inevitable backlash, this reads as fixation, a need to keep Spielberg in his toy-box. There was a chorus of dissent who saw indecency in the story's happy ending, as those on Schindler's list are saved, the actual survivors bearing witness over the credits.

'All the cadavers we see we don't know and all the people we identify with are saved,' chided Danièle Heymann in *Le Monde*. 'And that's not how history goes.'[32]

Shoah's Claude Lanzmann publicly took against Spielberg. How could he tell the story of saving a thousand lives in the face of six million dead (whose story is surely

Below: The List is life – with a single Russian soldier arriving to liberate them at the end of the war, Schindler's workforce realize that they have become a wandering tribe once more.

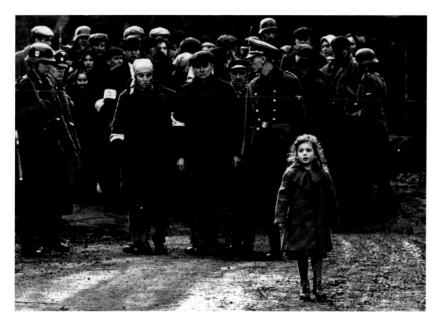

beyond drama)? But Spielberg doesn't let us forget. We will follow Schindler's women, fallen onto the wrong list, all the way into the showers of Auschwitz, only for water to pour on them. Outside, the camera rises over the long lines to the chimney and its forlorn smoke. The girl in the red coat will be seen again – another body being carted toward a hellish pyre, the ash falling like snow.

Spielberg was certain it would fail, but audiences were felled and the box office unprecedented (it made $322 million). World leaders came to screenings, as it took on the nobility of a historical document, something that has diminished history's perception of it as a film. The Academy's adulation was pre-ordained. But felt somehow secondary.

Tom Hanks tells a story. How he and Spielberg were walking along the street shortly after the film's release, and a young woman approached the director. 'I just had to tell you,'[33] she began, trying to frame her response to the film,

but became completely undone, crying her eyes out. Spielberg calmly tried to reassure her. Telling her this is why he had made the film – so people would realize. She got herself together and departed. As they walked away, Spielberg broke down. 'Steven hadn't been quite prepared for the emotional power of what he has done,'[34] reflected Hanks.

Jurassic Park was a skilfully manufactured entertainment, an attempt to fill every empty cinema seat. *Schindler's List* was an attempt to fill a void within himself. In so doing, he was filling a void in the world. Here's the thing. Beyond everything we can say about his central film, arguably his best, the heart of Spielberg's power remained the same. He could make us feel what he feels.

Above left: The girl in the red coat was controversial – many critics saw it as the sole moment where the film drew attention to itself, but Steven Spielberg wanted to make an emphatic statement about its moral gaze.

Above right: *Schindler's List* would not only bring Spielberg his cherished Oscars for Best Director and Best Film, it became a huge global hit. He was expanding the power of cinema to communicate.

TIME TRAVELLER

The Lost World: Jurassic Park (1997), *Amistad* (1997),
Saving Private Ryan (1998), *A.I. Artificial Intelligence* (2001)

How do you follow 1993? So often it is success rather than failure that anchors Steven Spielberg. Like no other filmmaker, everything he does is held in comparison with everything he has done. How does Spielberg compare to *Spielberg*? His first instinct was to take a break. News that made the front page of *Variety*. There would be no new film for three years, but the term 'break' was a relative distinction. He worked tirelessly. Executive-producing breezy crowd-pleasers *The Flintstones* (as Steven Spielrock), *Casper*, and *Twister*. Setting up the Shoah Foundation, a visual archive of Holocaust testimony. In three years, his team collected the memories of over 53,000 survivors.

Then the ill-fated attempt to shake the status quo of the industry by launching a new studio in DreamWorks SKG, the initials standing for the three contrasting men at the prow of this doomed vessel: Spielberg, studio executive Jeffrey Katzenberg, and media mogul David Geffen. Proclamations were made. How they would champion idiosyncrasy and art. How they would dictate taste. Such were the dreams of Charlie Chaplin, Douglas Fairbanks and the coterie of

silent stars behind United Artists in 1919, before abandoning their studio to the conformity of Hollywood.

There were DreamWorks hits, garlanded with Oscars: Spielberg's own *Saving Private Ryan*, *American Beauty*, and *Gladiator*. Lucrative franchises in *Transformers* and *Shrek*. And the inevitable flops. Such is the quotidian studio toil. But without a distribution network they were reliant on partnerships with existing studios, so profits (and credit) were halved. It was an attempt to cut against the grain of a system Spielberg had reinforced for years. He was fighting his own legacy. Moreover, he was not designed for the rigmarole of marshalling a studio, the incessant meetings, keeping an eye on the bigger picture. He was itching to get out into the yard again.

It was said of Kubrick that he was never not making a film, even though he was seldom in production. The same is true of Spielberg, if more productively. Projects circled like jets, or mother ships, waiting for inspiration to take hold. Or obligation – that responsibility to keep the Hollywood wheels oiled. After 1993, he saw himself going 'back and forth from entertainment to socially conscious movies.'[1]

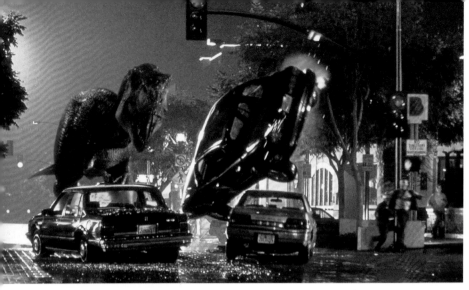

Left: Road rage – the T. rex invades downtown San Diego in *The Lost World: Jurassic Park*, a finale devised and shot (in Burbank) after Steven Spielberg had started making the sequel.

Below: Post-human – a super-robot of the far future (voiced by Ben Kingsley) examines android boy David (Haley Joel Osment) in the elusive finale of *A.I. Artificial Intelligence*.

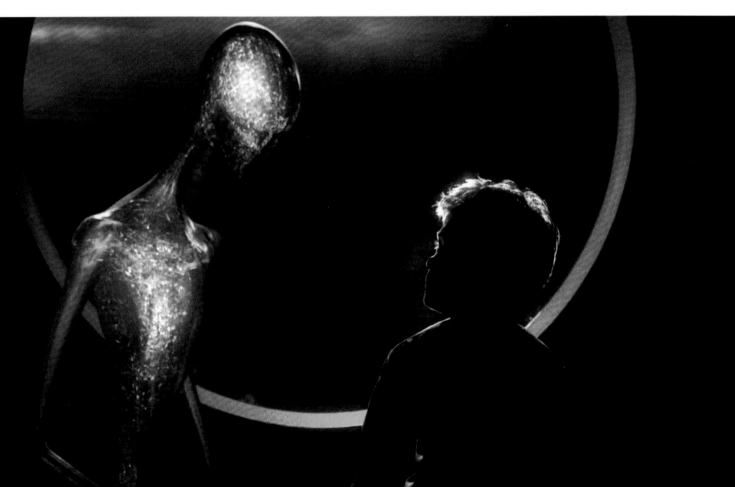

STEVEN SPIELBERG'S DIRECTOR'S CHAIR (VIDEO GAME)
1996 Director

Above: Something scaly this way comes Mk.II – Julianne Moore, Vince Vaughn, and Jeff Goldblum perfect their version of the listen-to-the-dino-footsteps shot in *The Lost World: Jurassic Park*.

Indeed, 1997 resembles an attempt to repeat the double-act of 1993. Bona fide blockbuster first, daunting historical enquiry next. One to repay Universal's faith in him, one to telegraph the boldness of DreamWorks. Back to dinosaurs, then slavery. Both *The Lost World: Jurassic Park* and *Amistad* falter because, in each case, Spielberg was trying to make a *Spielberg* film. And there was trepidation.

'Coming back from those three years of not directing, I didn't want to jump into the deep end of the pool,'[2] he admitted.

Shooting from 6 September 1996, the second *Jurassic Park* is a work of inevitability rather than inspiration. Spielberg has never been a franchise guy. Sure, he had qualms about standing aside to watch *Jaws* be sullied by increasingly soggy sequels. But he never doubted his refusal to 'blemish the memory'[3] of *E.T. the Extra-Terrestrial* with a return trip. *Indiana Jones* is a serial adventure, akin to

Bond's missions, the chance to catch up with an old friend.

On *Jaws* a failure of filmmaking mechanics allowed Spielberg's storytelling gifts to flourish. *The Lost World* is state of the art, it's dinosaurs-a-go-go, with new CGI-spawned species leaping out of the bushes (Compsognathus! Stegosaurs! Pachycephalosaurs! Pteranodons! Mamenchisaurs! Parasaurolophus!) But the tautness of story is lost.

Spielberg liked the idea of cleaving to Arthur Conan Doyle's namesake novel, in which a plateau is sealed off from time. What the director called an 'incursion into a real prehistoric land.'[4] In this case, Isla Sorna, a second dino-island that somehow went unmentioned in the first film, mixing Hawaii exteriors with the Redwood National Forest in California for a more primordial aesthetic. There were surely stronger routes to a sequel. Dinosaurs loose in the ruins of a

theme park? The shaving can containing embryos dropped by bad apple Nedry? This is a breeding ground with no fences, and no direction for the story to take. Little more than an assembly of confrontations with dinosaurs, David Koepp's script could be animatronic.

The characters are even thinner: Jeff Goldblum's Ian Malcolm takes centre stage and it doesn't suit him – the supercilious wisecracks have been dropped for a mopey, why-me froideur; Julianne Moore steps in where Juliette Binoche feared to tread, but can't make her excitable 'behavioural palaeontologist'[5] behave convincingly; while Vince Vaughn's eco-warrior photographer is excess baggage. Like

Twister this is a disaster movie where the heroes court disaster. Nigel Andrews in the *Financial Times* saw it as 'free association on the first film's plot.'[6]

Spielberg grew impatient with the material while shooting. 'Is that all there is?' he found himself asking. 'It's not enough for me.'[7]

Of course, he can still assemble thrill like a game of Jenga: opening with a little girl set upon by a gang of knee-high Compies (a mischievous nod to Hitchcock's *The Birds*); Moore squirming on a splintering pane of glass with nothing but the crashing surf below; unseen raptors carving paths in tall grass; and a T. rex chewing traffic lights in downtown San Diego (in fact, Burbank).

Below: Reptile house – Spielberg playfully riffs on *E.T. the Extra-Terrestrial* when a boy wakes to find a T. rex at his window

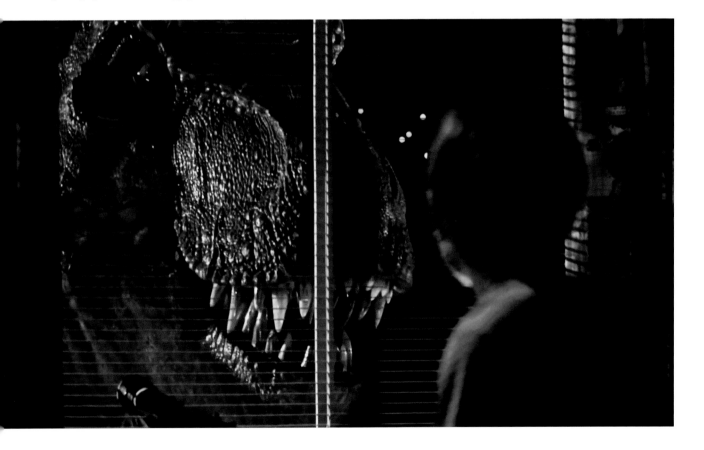

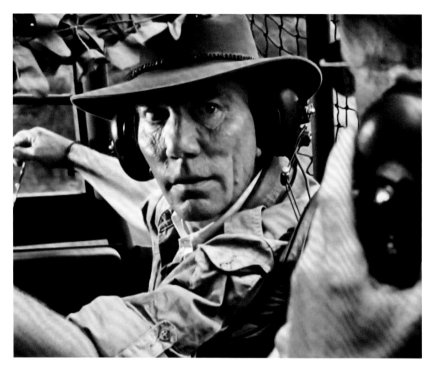

But the film isn't concentrating. That impregnable authenticity is missing. *Jurassic Park* is fantastical but sure of its conceit: cloned dinosaurs loose in a would-be theme park. With *The Lost World* there are plot holes, incomplete ideas, endless running hither and thither. How does a T. rex eat a ship's crew then lock itself back in the hold? Roland Tembo, Pete Postlethwaite's Haggard-esque revision to Bob Peck's big game hunter, never gets his confrontation with the biggest trophy.

The money came rolling in (at $619 million only the biggest film of the year), but the satire has lost its teeth, with John Hammond's InGen in the hands of his rapacious nephew (Arliss Howard), determined to exploit the dinosaurs with a studio-like urge for bigger and better entertainments. It's a sequel about sequels!

Above: Hunters – Pete Postlethwaite as master tracker Roland Tembo, after the biggest game of all in *The Lost World: Jurassic Park*.

Right: Gatherers – eco-warriors Nick Van Owen (Vince Vaughn) and Sarah Harding (Julianne Moore) come to the aid of a baby T. rex.

Left: Courtroom dramatics – Roger Sherman Baldwin (Matthew McConaughey) makes his case in unappreciated slavery drama *Amistad*.

Amistad is a swerve into adult matters, a loquacious courtroom drama with slavery as its backdrop. Like *The Color Purple*, there came the inevitable backlash. Spike Lee fumed about another white saviour story. Spielberg's DreamWorks partners might have wondered why they got politics and not dinosaurs. Pitched to him by producer and choreographer Debbie Allen in 1994, star of *Fame*, he was simply amazed by this historical obscurity.

'Did that happen?'[8] he pressed.

He had his opening. Between Sierra Leone and the New World in 1839, within the airless hold of the Spanish schooner *La Amistad*, captured with intense close-ups, the slave Cinqué prises free the nail that tethers his chains. He is played by Djimon Hounsou, who had gone from Paris homelessness to catwalk model, and brings a magnetic mix of righteous fury and vulnerability.

In Janusz Kamiński's strobing storm-light, phantasmal with Dutch tilts – a prelude to the unrelenting salvos of the film to come – Cinqué leads a bloody mutiny. They end up off the coast of Connecticut, and at the centre of a legal battle between the Spanish court, which claims ownership; the American justice system, eager to try them as murderers; and the abolitionists who take up their cause, which ends up before the Supreme Court.

The events onboard, so powerfully realized, are withdrawn into flashback. Instead, we get a lot of talk in oaky rooms from a wine-rack of vintage voices framed with authentic sideburns. This would be Spielberg's most august ensemble until *Lincoln*: Matthew McConaughey as crusading lawyer and protagonist Roger Baldwin, Morgan Freeman, Pete Postlethwaite, Stellan Skarsgård, Nigel

Hawthorne, Chiwetel Ejiofor, and, having a ball, Anthony Hopkins as former president John Quincy Adams, cast when Dustin Hoffman dithered.

Oscar-nominated for supporting actor, Hopkins gets a showboating, seven-page monologue, delivering the film's central lesson in a single take. 'The natural state of mankind,' he preaches with a whimsical lilt, 'is freedom.'[9]

Shooting from 18 February 1997, over a brisk 48 days, the production took in antique American locations in Newport, Rhode Island, Boston, and Washington Square, as well as the coast of San Pedro. The *Amistad* was built, almost to scale, in a Van Nuys warehouse, a nightmare inversion of *Hook's* pantomime sets. Kamiński mixes Goya-esque shadows with the glow of Winslow Homer and Thomas Cole for America's childhood.

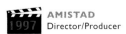

AMISTAD
1997 Director/Producer

Below: Emancipators assemble – Anthony Hopkins (as former President John Quincy Adams), Djimon Hounsou (as escaped slave Cinqué), and a young Chiwetel Ejiofor (as translator Covey) lead a formidable cast in *Amistad*.

'I'm in a period where I am experimenting, and I am trying new things that challenge me,' said Spielberg. 'And as I challenge myself, I in turn challenge the audience.'[10]

The apolitical *wunderkind* has been replaced by an elder statesman. The state of the nation will loom over the second half of his career, most notably in *Amistad*, *Lincoln*, and *The Post*. Indeed, *Amistad* serves as a prequel to *Lincoln*. These events lit the fuse that led to the Civil War, brought to a close in that later, more dynamic film.

Amistad is another Spielbergian encounter. Between two people (Cinqué and Baldwin), two cultures, two continents. But a premeditated worthiness stifles the spring-heeled naturalism of old. 'I kind of dried it out,' he confessed in retrospect, 'and it became too much of a history lesson.'[11]

Tellingly, *Amistad* made only $44 million (family members called to express their condolences), while *Titanic* swept the Oscars and upset box office records, and it was James Cameron who was celebrated for touching the hearts and minds of millions.

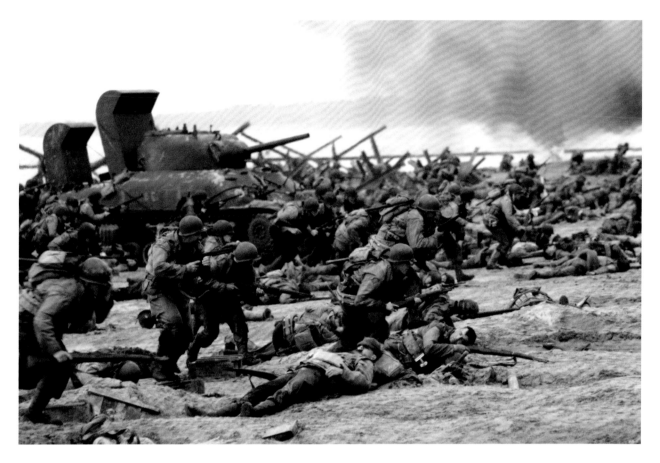

Saving Private Ryan opens on the overcast morning of 6 June 1944 and the trembling fingers of Tom Hanks. In truth, this stark image is preceded by a framing device in which an unidentified veteran visits the American Cemetery in Normandy. Let's not quibble, the following twenty-five minutes proved that Spielberg still had the capacity to dumbfound us with filmmaking. Which, as Anthony Lane noted in the *New Yorker*, is largely because the scenes 'tell you almost nothing. They just show.'[12]

What does Spielberg have against beaches? The D-Day landing that sets his first war film in motion – a war film, that is, in the essential depiction of combat – is

a tableau of hell. Amity is transformed into a delirium of random death, filmed in a storm-cloud monochrome streaked with fire and blood. A look born of Robert Capa's famous *LIFE* magazine photographs, and John Huston's 1945 feature-length report from *The Battle of San Pietro*, where he lowered his camera to knee height to keep from getting his head blown off.

It was the first thing Spielberg shot, setting out his aesthetic terms. From 27 June 1997, for three and a half weeks, the production crawled up an eight-mile stretch of beach at Curracloe, Ireland, using 750 extras from the Irish reserve forces.

Above: The Omaha opening – the devastating and seminal beginning to *Saving Private Ryan* completely transformed our perception of D-Day, and of what a war movie could achieve.

SAVING PRIVATE RYAN
1998 Director/Producer

A man with his arm blown off dumbly holds the limb, another clutches at purple intestines crying out for his mother, another still is ignited into an orange inferno by a leaking flame-thrower. Slow-motion is induced like a slur. Soldiers group in clumps, knots of desperation. They make gains at incredible cost. Survival, heroism, whatever you want to call it, is a matter of luck.

As with the *Aktions* of *Schindler's List*, Spielberg dispensed with storyboards, resisting the pull of the spectacular, ensnaring chaos with handheld cameras (operating one himself) and no more than three takes. They were combat cameramen, he instructed his team, if blood splattered the lens, so be it. 'I just went to war,'[13] he said.

Watching these wrenching, hallucinatory scenes, an invasion of our senses, it is we who sit like Chief Brody with the air warping around our uncomprehending faces. Aswirl in plotlessness, there is but one abiding lesson – war is nothing like the movies.

They shot in strict chronology: from boats to water to sand to the relative protection of the sea wall. That linearity applied to the whole film, as if events were unfolding before them. Across the three-month production, moving from Ireland to an abandoned airfield in Hatfield, north of London, and the pastures of Oxfordshire, Spielberg moved fast, keeping his actors off balance.

He was invoking the *experience* of war. Within actual combat, he said, it's 'personally very contradictory.'[14] Ordinary men are thrust into both moral and physical turmoil. School teachers have to kill. The just cause can seem far away. It contravened every staple of the summer movie, yet it became a huge hit, making $482 million on a budget of $70 million.

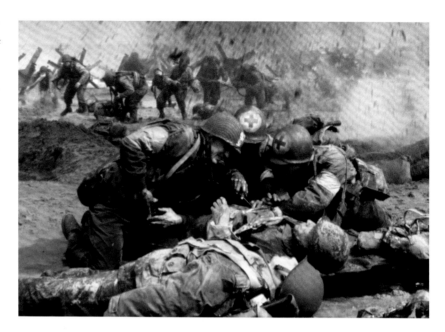

Narrative begins to coalesce around Hanks. He is a life-raft of stardom in the pandemonium. And with the beach held, the camera returns to a body among the many, on whose backpack we see a name – 'S. Ryan'[15] – and story asserts itself like oxygen. The film, and frankly the genre, will never be the same.

Robert Rodat went through eleven drafts of *Saving Private Ryan*, a script he had sold on spec to Paramount. Somewhere along the line, Hanks was ensnared as Captain Miller, the leader of the film's squabbling platoon. It was he who passed it on to Spielberg. Though agents scurried around the edges.

The director had been mulling over a men-on-a-mission movie for years, something in the vein of *Where Eagles Dare* or *The Guns of Navarone*, or the gung-ho war movies he made as a kid, roping in the boy scouts for *Fighter Squad* and *Escape to Nowhere* (about a GI trapped behind enemy lines). But he was a changed man, a changed filmmaker. When he

Above: Filming on the Irish beach at Curracloe for three weeks, Spielberg let his camera operators loose among the carnage as if they were wartime cameramen.

Opposite: Men on a mission – from the left, actors Adam Goldberg, Demetri Goritsas, Tom Hanks, Matt Damon, Maximilian Martini and Tom Sizemore prepare for the German attack.

read Rodat's script, he thought of his father. Arnold Spielberg had been a radio operator in the Pacific, with a store of dark stories like Quint in his cabin. They had been reconciled after fifteen years of near silence, and this was his son's gift.

Accepting his second Oscar for Best Director, Spielberg singled out his father: 'Thank you for showing me that there is honour in looking back and respecting the past... This is for you.'[16]

Reading Stephen E. Ambrose's *Band of Brothers*, Rodat had been struck by the story of the Nilands, three brothers reported dead in the Second World War, with their poor mother receiving all three telegrams on the same day. In their stead, Rodat invented the Ryans, three brothers killed in action, and the

mission to locate the surviving fourth brother at the behest of the American government. Miller's outfit will be handed this dubious enterprise. That more lives would be sacrificed to save one is another vexing contradiction.

The strongest influence on Spielberg's daring *vérité* was the personal testimony he encouraged from veterans. Life, he well knew, offers visions out of the reach of screenwriting. He went back through Rodat's earlier drafts, reinstating darker concepts that had made Paramount tremble: that Miller would be doomed, and Jeremy Davies' cowardly interpreter Corporal Upham would *not* be redeemed.

The surviving Ryan is played by Matt Damon, a boyish new talent picked after Robin Williams gave Spielberg a

preview of *Good Will Hunting* (Spielberg has such a nose for nascent stardom). The young actors of Miller's platoon were consciously drawn from the American indie scene: Barry Pepper (as the God-fearing sniper), a young Vin Diesel, Adam Goldberg, Giovanni Ribisi, and Edward Burns, with Tom Sizemore as the sturdy Sergeant Horvath.

The scalding realism of the early scenes holds true across the film (how opposite it is to *1941*), an episodic journey across battle-scarred Normandy toward Ryan. It's another Spielbergian quest where the Holy Grail is a man: a series of trials bested and leadership tested. Hanks' subdued performance as Miller speaks to the terrible cost of war to a man's very identity.

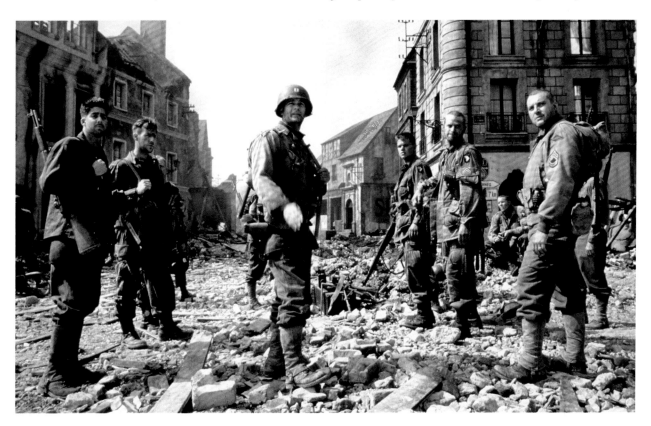

THE UNFINISHED JOURNEY (SHORT)
1999 Director

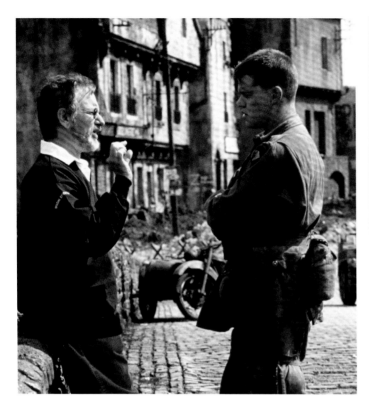

There were critics who complained that beyond the beach the structure was formulaic, even contrived, nothing more than adrenalized melodrama. It is one of Spielberg's most divisive films. There were those who saw a master finally re-invoking the boldness of *Schindler's List* for another fountainhead of history.

Historian Antony Beevor is for and against the film, but very much in favour of a storyline that 'rightly dramatizes'[17] the clash between patriotism and individual survival. 'Those mutually contradictory values are, in many ways, the essence of war,'[18] he says.

Between yomping and griping, skirmishes flare up. An attempt to rescue French children, freeing a German prisoner, and a costly raid on a machine gun nest, all bring the group close to

crisis. Dale Dye, the film's irrepressible military advisor, with three tours of Vietnam behind him, stamped out any A-list habits during boot camp.

The vicissitudes of the Vietnam movie, the grunt-level slog and dehumanization of *Platoon, Full Metal Jacket,* and Coppola's *Apocalypse Now,* are applied to the Second World War, but with the moral counterpoint of a righteous war. Set against the horrors of *Schindler's List*, we know the path these men trod, while complex, was finally good. Which led, predictably, to accusations of Spielberg attempting to banish the spectre of Vietnam. In the *New York Times,* Vincent Canby remarked that 'with *Saving Private Ryan* war is good again.'[19]

Great wealth has granted Spielberg the luxury of collecting Norman Rockwell

Above left: Directing Private Ryan – Steven Spielberg deep in discussion with a then little-known Matt Damon as the pivotal solider, chosen for his boyish looks and talent.

Above right: As uncompromising as it was, *Saving Private Ryan* still became a major box office hit. The name of Spielberg now stood as a challenge to the viewer rather than a comfort.

Opposite: After *Empire of the Sun* and *Schindler's List,* the rigour that went into *Saving Private Ryan* proved that Spielberg was a titan of historical realism.

"... with *Saving Private Ryan* war is good again"

Vincent Canby, *New York Times*

paintings. He loves 'how Rockwell spoke volumes about a certain kind of American morality.'[20] Is this Rockwellian optimism what separates him from his old Movie Brat platoon?

D-Day is bookended with the Battle of Ramelle, a fatal misjudgement on Miller's behalf to stand with his brothers in a bombed-out French town. The rumbling of encroaching Panzers carries the dread of an incoming T. rex, before another bravura display of visceral combat, but on a more movie-like footing. We know these characters and feel their loss, each gains a storyline, and a remarkable death. The old man who frames the story turns out to be Ryan – saved.

Spielberg deservedly won that second Best Director Oscar. Who else was marrying the technical and the dramatic on such a level? Even so, the loss of Best Picture (to the featherweight *Shakespeare in Love*) mars the film's legacy as arguably the most influential war movie ever made. The vicissitudes of the Academy could still bite.

Things have changed. Ideas accumulate in his films. Emotions are harder to fathom. The suburban poet fades from the picture. In his place is a time traveller, drawn both to the courage and cataclysm of the past and dystopian futures. We began to ask ourselves, what exactly is a Spielberg film?

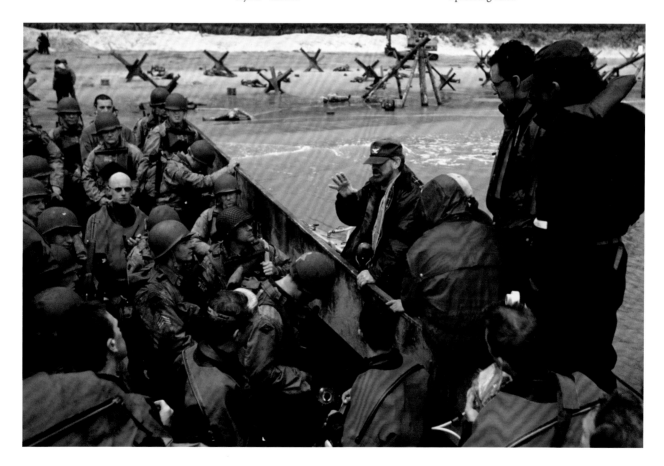

JAWS: DELETED SCENES
2000 Director

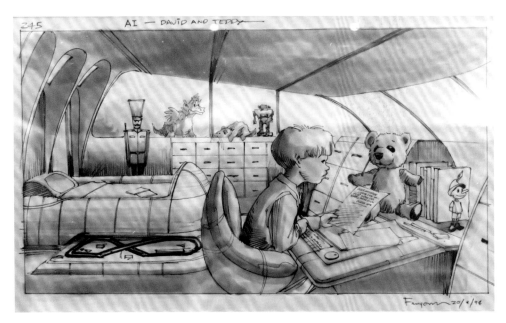

Left: Early production art for *A.I. Artificial Intelligence* (created for Stanley Kubrick by Chris Baker, known as Fangorn) reveals how the charming Teddy's links with the Pinocchio story pre-existed Steven Spielberg's involvement.

With Kubrick's death in 1999, he had lost not a peer but, cinematically speaking, a father figure. They had developed a long-distance relationship - calls in the dead of night, with Kubrick heedless of time zones in his Hertfordshire redoubt. 'It was a one way street,'[21] laughed Spielberg. Kubrick gave nothing away. But now he was making a Kubrick film, bequeathed boxes of notes, production art, and existing scripts for a project called *A.I.* – Spielberg would spell out the title for the obvious echo.

Based upon a screen story by Ian Watson (ninety pages accompanied by 650 sumptuous illustrations), based in turn on a short story by Brian Aldiss (*Supertoys Last All Summer Long*), with a screenplay credited to Spielberg (if anything, an act of archaeology), *A.I. Artificial Intelligence* is very much Kubrick's child. It is the tale of a robot simulacrum of a boy (HAL masquerading as Elliot) in a flooded future, science fiction spun with the thread of fairy

tale. Filmed over the summer of 2000 in Oregon and California, to appease Stanley's ghostly presence Spielberg was up to seven takes.

In the twenty-second century, a fake boy has been invented, a 'mecha'[22] of such sophistication he can even love, or simulate it. David (Haley Joel Osment with airbrushed skin) will be adopted by a heartbroken mother named Monica (Frances O'Connor), whose real son is bound within a coma – like *Sleeping Beauty*.

Kubrick had wanted a 'real' robot boy as his star, but special effects couldn't match his ambitions as they had with Spielberg's dinosaurs. He began to suspect the film needed Spielberg's warmer touch. Defending himself from a petulant media, Spielberg maintained that the sweeter ingredients were Kubrick's, and the darker stuff his own. 'People don't know either of us,'[23] he insisted.

It was Kubrick who made the influence of Carlo Collodi's *The Adventures of Pinocchio* explicit, adding a Jiminy Cricket

to accompany David in the form of an enchanting toy bear, Teddy, who walks and talks as warily as an old man (he was voiced by Jack Angel with the instruction to imitate Eeyore from *Winnie-the-Pooh*). Industrial Light & Magic met this challenge with animatronic aplomb.

The best way to describe *A.I.* is the most obvious – it is a Kubrick film directed by Spielberg, at times with startling power, at others more uncertainly. Perplexing both critics (though the BBC's Mark Kermode deemed it Spielberg's 'enduring masterpiece'[24]) and audiences (though it still made $236 million), *A.I.* grows more prescient by the year. The first half is the most stimulating, with David eerily trying to fathom a human household, as we try to fathom David. It is *E.T.*, but now the boy *is* the alien.

It was a film, he said, asking how we 'judge creatures who look and act and behave just like us.'[25] What is a real human?

![clapperboard icon 2001] **A.I. ARTIFICIAL INTELLIGENCE**
Director/Producer/Writer

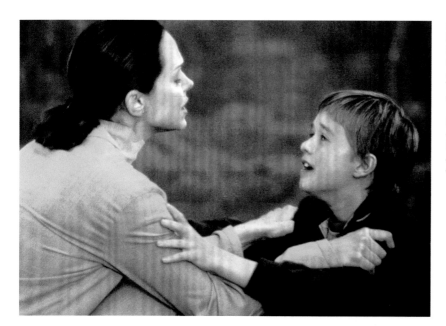

Left: In a flash of Spielbergian trauma, mother Frances O'Connor abandons artificial boy David (Haley Joel Osment) in the woods. The question is: why should we feel anything?

Below: Dystopian dolls – Spielberg watches his actors, Osment and Jude Law, bring their characters to artificial life.

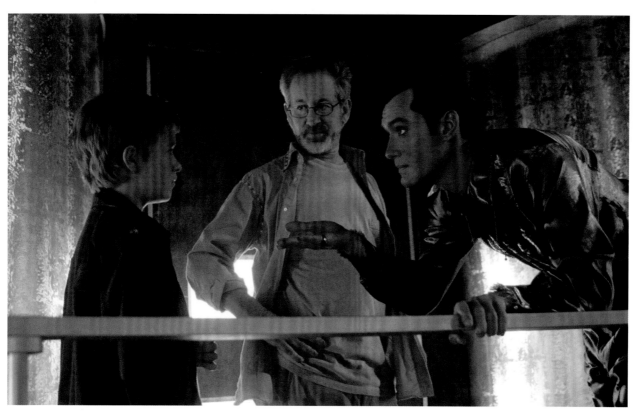

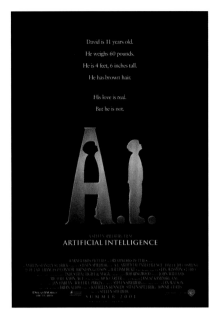

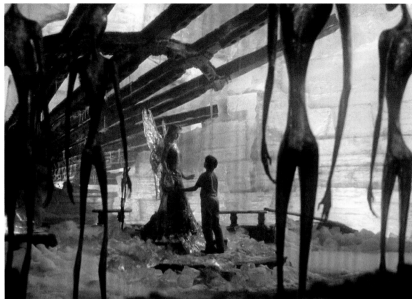

Above left: *A.I. Artificial Intelligence* remains one of Spielberg most enigmatic and intriguing films, arguably closer to his own sensibility than Kubrick's.

Above right: A science-fiction fable – David (Haley Joel Osment) consults with the Blue Fairy (voiced by Meryl Streep), watched by the super-robots of the future.

Then a scene tuned to a Spielbergian frequency of distress (recall Elliott parted from E.T., Celie wrenched from her sister's arms in *The Color Purple*, Jim losing his mother's hand in *Empire of the Sun*). With her real son recovered, Monica abandons the artificial version in the woods. Exit David, pursued by a bear.

Once David is fending for himself, the film loses its edge. David becomes another lost boy, and more human in his vulnerability. He escapes a Flesh Fair (where mechas are tortured for entertainment), befriends a fake guy named Joe (a doll-like Jude Law), visits the theme-park-themed Rouge City, and finally meets his maker (William Hurt as God or Geppetto or Kubrick) in a drowned Manhattan, with skyscrapers as black as monoliths.

One comparison to be made is with Ridley Scott's *Blade Runner*, based on the science fiction of Philip K. Dick, whose replicants are like exuberant and dangerous children. Significantly,

Spielberg had been developing his adaptation of Dick's *Minority Report* before *A.I.*

At the end of *A.I.* we are back with Kubrick and the baffling reaches of *2001: A Space Odyssey*. Rather than a Star Gate, David is frozen for 2,000 years (his coma), to be awoken by miraculous super robots, with mankind long extinct. He is offered the fulfilment of his wish by these graceful, Giacometti-like mecha angels (was this how Spielberg imagined his alien visitors in *Close Encounters*?), but at a price. His mother can be cloned from a lock of hair, like the dinosaurs locked inside amber, but only for a single day of the love he craves. Was this *really* a happy ending? Kubrick would be proud.

THE SUBURBAN MOGUL

Ten significant Steven Spielberg productions

Poltergeist (1982)
Poltergeist is the dark to *E.T. the Extra-Terrestrial's* relative light, where evil spirits invade a suburban household via the TV set and a small girl is stolen away. It's essentially Barry's kidnap from *Close Encounters of the Third Kind* spun out into a terrifying if squeamish yarn.
Alternatively: *Monster House* (2006)

Gremlins (1984)
Spielberg made the key suggestion of keeping the ultra-cute Gizmo front and centre of Joe Dante's horror spoof of *It's a Wonderful Life*. That way, the kids had something to root for as small-minded America succumbs to a swarm of darkly hilarious reptilian critters.
Alternatively: *The Goonies* (1985)

Back to the Future (1985)
Rejected by virtually every studio in town, Spielberg championed Robert Zemeckis' hit time-travelling comedy on the beauty of the premise. What if a misunderstood teen could go back in time to witness his parents as hapless teens?
Alternatively: *Who Framed Roger Rabbit* (1988)

Men in Black (1997)
More ironic genre play, this time directed by Barry Sonnenfeld, who turns the paranoid hokum of *The X-Files* into a Will Smith action-comedy in which aliens have been secretly living among humans for decades. In a wry cameo, they apparently include Spielberg.
Alternatively: *Transformers* (2007)

Band of Brothers (2001)
Spielberg's seminal mini-series, co-created with Tom Hanks, was a response to the verisimilitude of *Saving Private Ryan*. Based on Stephen E. Ambrose's 1992 book, and mixing in real-life testimony, we follow a company of American infantry from Normandy to Hitler's Eagle's Nest redoubt at Berchtesgaden.
Alternatively: *The Pacific* (2010), *Masters of the Air* (2024)

Above: Christopher Lloyd and Michael J. Fox in Spielberg-produced smash *Back to the Future*.

Memoirs of a Geisha (2005)
For four years, Spielberg dallied over Arthur Golden's best-seller about a young woman sold into the life of a geisha in pre-war Japan. But he kept postponing to make other films, and finally allowed Rob Marshall to take over.
Alternatively: *Letters from Iwo Jima* (2006)

Super 8 (2011)
Directed by protégé J.J. Abrams, this is an unabashed love song to the Spielbergian cliché - a kid with the filmmaking bug encounters a cantankerous alien. 'What I love, and what Steven Spielberg has in his work, is a sense of unlimited possibility, the sense that life could bring you anything,'[1] eulogized Abrams.
Alternatively: *Arachnophobia* (1990)

American Sniper (2014)
Spielberg and Clint Eastwood formed a mutual admiration society after *The Bridges of Madison County*, *Flags of Our Fathers*, *Letters from Iwo Jima*, and *Hereafter*. This divisive Iraq-themed biopic became Eastwood's biggest hit.
Alternatively: Peter Jackson's *The Lovely Bones* (2009), the Coen brothers' *True Grit* (2010)

Indiana Jones and the Dial of Destiny (2023)
Having spent years developing a fifth Indy adventure, Spielberg took the shock decision to hand the reins to James Mangold, while he made *The Fabelmans*. The weary, over-CGI'd clutter that resulted - a tale of an aged Indy mixed up in time travel - was proof that the series had always been personal.
Alternatively: *Jurassic Park III* (2001)

Maestro (2023)
This biopic of the great conductor-composer Leonard Bernstein was passed on by Martin Scorsese to Spielberg in 2018, who brought in Bradley Cooper to be his star. But it clashed with *West Side Story*, which Bernstein composed, and when Cooper canvassed to direct, Spielberg accepted a producer's role.
Alternatively: *First Man* (2018)

BETWEEN WORLDS

Minority Report (2002), *Catch Me If You Can* (2002), *The Terminal* (2004), *War of the Worlds* (2005), *Munich* (2005), *Indiana Jones and the Kingdom of the Crystal Skull* (2008)

The pace quickens. Steven Spielberg is in full flow. His mythical reputation allows him to go wherever inspiration takes him, still driven by the possibilities of his medium. He says he needs work 'that will frighten me.'[1] Distinctions blur. Entertainments are deadly serious, grown-up movies light on their feet. Notice how his characters are perpetually in flight. Chasing or being chased.

Back to the Future writer Bob Gale suggested a change in archetypes in his maturing mentor. Where once Spielberg was Elliott, filled with yearning, now he was Jim from *Empire of the Sun*, wary of the world, restless with schemes, but still looking to the sky.

Spielberg is an artist troubled by the impact of the 9/11 attacks (surreally film-like on his television set), and America's knee-jerk response; by the dark threats made by an obsessive fan-cum-screenwriter, arrested for felony-stalking outside his home; by the removal of a cancerous lesion from his kidney. Less beloved, his films are coruscating and unpredictable, they strike a nerve. He holds a mirror up to the world the size of a movie screen.

With the outstanding *Minority Report*, it was the 'blend'[2] of genres that was alluring. Defying the toy-line mandates of the millennial blockbuster, it is science fiction without question, but as much a film noir, directing a spotlight onto human rights at a pressing time.

Spielberg and Tom Cruise had been looking for the perfect occasion to combine their talents, and their celebrity, for years. They had history. It was Spielberg who had cast Cruise alongside Dustin Hoffman in *Rain Man*, before relinquishing this Oscar-worthy odd couple to Barry Levinson when detained by *Indiana Jones and the Last Crusade*. They had come close to adapting F. Scott Fitzgerald's *The Curious Case of Benjamin Button*, which reversed the clock on its strange hero. *Minority Report* sent the clock forwards to a dark future. 'I think my first direction to Tom was, "No smiling!"'[3] laughed Spielberg.

Philip K. Dick's philosophical 1956 story foretold of 'Precrime.'[4] In an America nudging totalitarianism, a blur of technology and mysticism allows a trio of human 'Pre-Cogs,'[5] (including a dazzling Samantha Morton), bound to an eggshell-blue floatation tank, to dream fractured

MINORITY REPORT
Director

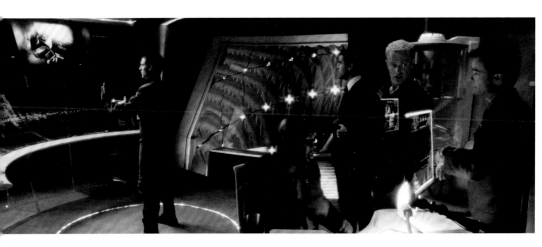

Left: Multitasking – in *Minority Report* Steven Spielberg was playing with multiple genres: science fiction, cop film, political thriller, and film noir.

Below: Mystic or detective? John Anderton (Tom Cruise) assembles the not-yet facts to discover the crime that has been predicted to happen.

Left: Uncanny evidence – in the one supernatural element of *Minority Report*, three Pre-Cogs, bathed in nutritious water, gain glimpses of crimes with only hours to spare

Opposite: Like a premonition of *War of the Worlds* to come, roving tripod robots try to gain a glimpse of the replacement eyes of John Anderton (Tom Cruise).

Below: Whenwillhedoit – the knowingly named Agatha (a marvellous Samantha Morton) carries the clues to solving a murder John Anderton (Tom Cruise) is due to commit.

futures like Greek oracles – evidence of murders yet to be perpetrated. Police are then dispatched to the scene of the nearly-crime. Dick was ruminating on themes of free will and determinism. Can we be guilty of murder *before* it has been committed? Is our path as fated as the strictures of a screenplay? It's almost Orwellian.

Picked up as a potential sequel to Arnold Schwarzenegger's hyperactive Dick-adaptation *Total Recall*, the rights had pinballed between studios, before Cruise became enamoured and called his friend. Spielberg enlisted screenwriter Scott Frank (*Out of Sight*), who spent two years injecting the director's ideas into novelist Jon Cohen's draft, watching *The French Connection* for inspiration, waiting for A-list schedules to align. Dick's story was no more than a blueprint, Spielberg insisted. Even so, the moral conundrums remain. And the jaded futurescape. The accepted subgenre is future noir.

Shooting from 22 March 2001, with DreamWorks and 20th Century Fox providing $102 million, *Minority Report* is as close to Hitchcock as Spielberg has ever come. As critic Molly Haskell surmised, the opening ten minutes are a 'high-tech update of *Rear Window*.'[6] It is a demo of Precrime. The Pre-Cogs stir, the name of the almost-guilty is carved into a wooden ball like a lottery winner, and the cops swoop in to stop a distraught husband stab an unfaithful wife.

Then the classic Hitchcockian wrong man scenario. John Anderton, the name of Cruise's burdened Precrime officer and zealot, rolls out, accompanied by visions of a murder he is destined to commit. And he runs, pursued by his own men, and Colin Farrell's Justice Department suit sent to assess whether Precrime has a future. Bergman-icon Max von Sydow looms in the background like an Easter Island statue.

Seeking conviction for his science fiction, Spielberg convened a think-tank of futurists in a Santa Monica hotel before production to brainstorm Washington D.C. in 2054. The result is retro-revolutionary, with the familiar integrated into the speculative. Cops sport jet packs and flit toward incipient murder in hover-ships shaped like hairdryers; the world is abuzz with interactive newspapers, personalized advertising, a proliferation of screens; while curvaceous, self-driven cars stream up the flanks of skyscrapers like elevators. But this is still recognizably Washington D.C.; still the charming streets of Georgetown, where they shot on location; still well-known (if ironically dated) brands: Lexus, Nokia, Gap, American Express. In the post-9/11 present into which the film was released (to make a $358 million splash), the USA Patriot Act now allowed the government to collect personal data *Minority Report* style.

Spielberg pioneered previz technology to see the scenes to come, just as the Pre-Cogs glimpse possible outcomes. Cruise's detective of the still-to-happen sifts through their premonitions on glowing screens – all these partial scenes,

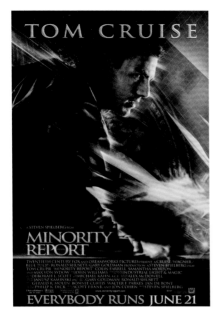

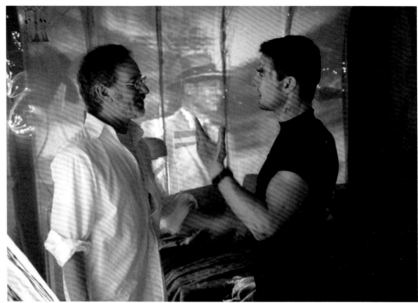

settings, and faces – trying to decipher the sequence like a 'human Avid,'[7] as the director dubbed him.

Seeking the stealth of film noir, Spielberg returned to classics like The *Maltese Falcon* and *The Big Sleep*. He had longed 'to bring to the photo-realism of film a kind of abstract expressionism.'[8] A bleach bypass provided a wash of cold, metallic blue, deepening shadows, and leaving faces drained of colour.

Minority Report also happens to be Spielberg's blackest comedy. Who would have predicted a blindfolded Cruise chasing his eyeballs down a corridor? Retina scanning is the rage, so Anderton picks up a fresh pair of eyes on the black market (with a wink to the eyelid clamping of *A Clockwork Orange*). Recalling the visual trickery of De Palma or Scorsese, Spielberg lifts the lid off the scuzzy hotel where Anderton is recovering in an ice bath, granting the camera a panoptic view as a swarm of nimble spider bots search for their quarry, each room recounting its own

story. This is a born entertainer's impulse to prise fun from political discourse. What the *New Yorker* called the film's 'ferocity of invention.'[9] Anderton ends up dropping his old eyes, essential for opening old doors, which roll into a drain. Hitchcock would have cheered.

At first glance, *Catch Me If You Can* is as light as a soufflé. 'It has tremendous *joie de vivre*, which is reflective of who the real Frank Abagnale is to me,'[10] agreed the director. John Williams' score is a jazzy rush of sax, bass, and vibraphone. Frank Abagnale (Leonardo DiCaprio) was the real teenager who masqueraded as a teacher, doctor, lawyer, and pilot, cashing forged cheques worth millions to keep his dream afloat, one step ahead of the FBI in the shape of pen-pushing grouch Carl Hanratty (Tom Hanks).

Definitions can be deceptive (and this is a tale of deception), for beneath the gleaming surface lie the wounds that compelled its counterfeit hero. Another lost boy, haunted by a feckless crook of a

father (Christopher Walken), runs from a broken home.

Jeff Nathanson's vibrant, multi-layered script had drawn the likes of David Fincher and Miloš Forman to its flame, but it called to Spielberg on a personal level. He and Frank had so much in common.

Frank assembles a personality like an actor. He's as charming and self-serving as Oskar Schindler, as bold as Indiana Jones, a long-limbed *Pinocchio* playing at being a real adult. He comes to resemble a filmmaker, manufacturing reality with pinpoint skill. Frank is a god of detail, a master illusionist, an improvisor of distinction. He goes to see *Goldfinger*, the projector beam casting its dream light above his head, mesmerized by Sean Connery's 007 in an immaculate Glen

Plaid suit. By the next scene, Frank wears an identical three-piece.

When he was a bit less than sixteen, Spielberg donned a suit and tie, fixed his expression, and walked onto the Universal studio lot like he owned the place. 'I did that for a whole summer long during my high school vacation,'[11] he recalled. He was chasing his dreams and technically trespassing.

The tale is something of a myth with family connections to Universal's librarian Chuck Silvers. All the same, *Catch Me If You Can* interrogates the wellspring of another anxious childhood. After all his success, could it be that Spielberg still felt like an imposter?

DiCaprio was twenty-seven, but could knock ten years off his age with a change

Below: Like father, like son – charlatan senior Frank Abagnale (Christopher Walken) passes on his dubious wisdom to charlatan junior (Leonardo DiCaprio) in *Catch Me If You Can*.

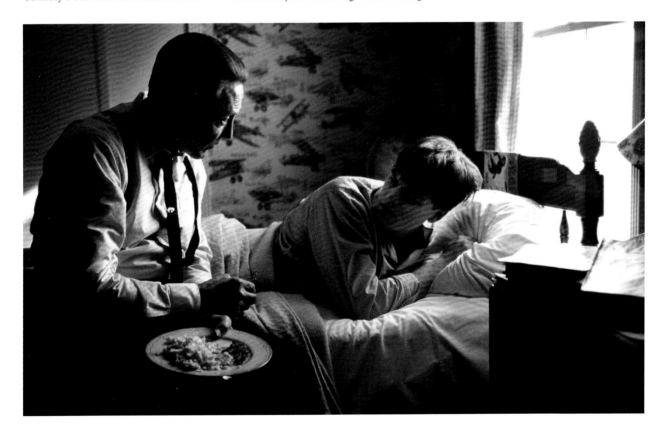

Above: Living the high life – in a flash of the sixties dream, Catch Me If You Can has Leonardo DiCaprio don a pilot's uniform and swan into the airport with Pan Am cabin crew.

of posture. All arms and legs in one scene, as graceful as a swan the next. He was at an interesting juncture in his career. *Titanic* had effectively side-tracked his talent. 'His life became mythological,'[12] said Spielberg, well versed in shooting stardom. This was a story about acting, featuring a star desperate to act.

Hanks had simply called producer Walter F. Parkes: 'Do you think Steven would let me play the FBI agent?'[13] The answer was a vociferous yes, though Hanks still called DiCaprio to make sure it wasn't an imposition. Who better for bumbling, harried, decent Hanratty? The character is another deception: he is charismatically ordinary, a schmo with the guile to get his man. He lives for the chase like Hook longing for Peter.

Starting on 7 February 2002, they shot at a sprint, flitting across North America: Los Angeles, New York, Montreal, Quebec, New Jersey, 147 locations in fifty-two days. Michael Kahn's editing is as nimble as a tap dance. We spin through the pop-bright universe of Frank's creation, thrilling to his escapades, the crisp details of his scams. Clad in a pilot's uniform, DiCaprio escorting a bouquet of sky-blue Pan Am beauties became the signature shot. With the director's precognition of future stars, Amy Adams, Ellen Pompeo, and Elizabeth Banks will fall under the conman's charming spell. A fairy tale interrupted by Hanratty having his shirts ruined in an olive-drab laundrette.

Making a mint with $352 million, even the film dances between identities. Never quite a comedy, or a caper movie, or a biopic. The American Dream, it suggests, is a matter of fabrication.

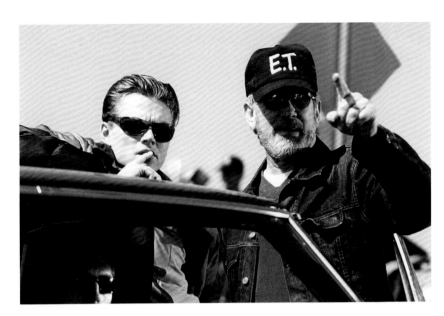

Left: DiCaprio and a clearly branded Steven Spielberg survey the scene ahead. It would have crossed the director's mind that there was a great similarity between Abagnale's detailed cons and the process of filmmaking itself.

Below: Close call – Tom Hanks as striving Agent Hanratty almost gets his man, before DiCaprio's Abagnale smooths his way out of another tight corner.

The Terminal did okay at the box office (making $218 million), but critics were impatient with its whimsical take on real life. That of the Iranian, Mehran Karimi Nasseri, stuck for eighteen years in Paris' Charles de Gaulle Airport having mislaid his refugee passport. We have Viktor Navorski (Hanks as another everyman all at sea), whose point of origin – the fictional Krakozhia, which sounded like an Ernst Lubitsch put-on – has been overtaken by civil war, leaving him trapped between worlds at John F. Kennedy International Airport, New York.

It was the nearest Spielberg had come to an undisguised comedy since *1941*. He called it a 'vacation'[14] – a chance to tread lighter still, but beneath the slapstick and Hanks's on-the-nose charm, flirting with Catherine Zeta-Jones' pretty flight attendant, lie the unwelcoming arms of the new America. The concept of nationhood, of belonging, are thrown into a bitter light, with Stanley Tucci as the pinched face of officialdom. Like E.T., Viktor only wants to get home.

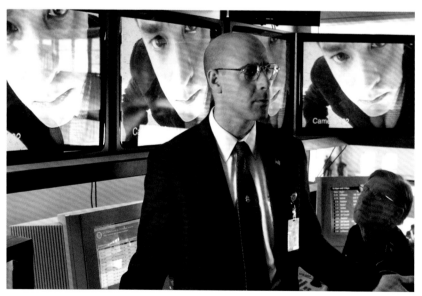

Above left: No country for an odd man – in *The Terminal*, traveller Viktor Navorski (Tom Hanks) finds himself nationless as news of a civil war in his homeland flashes onto television screens.

Left: Stanley Tucci as Acting Field Commissioner Frank Dixon, villain of the piece – the bureaucratic face of America.

THE TERMINAL
Director/Producer

Left: Immigrant stories
– trapped in the airport,
Viktor (Hanks) befriends
the multicultural night shift
including the janitor Gupta
(former vaudeville performer
Kumar Pallana).

Below: Catherine Zeta-
Jones' flight attendant bonds
with Viktor in a purpose-built
outlet of Borders – get it?

Spielberg turned to prison movies
for the routines of Viktor figuring
how to feed himself, where to sleep,
and how to make friends among
the multicultural nightshift (the
true representation of American
goodness). Amid all these men on
the run, it was a film about stasis.

The Terminal succeeds as a Kafkaesque
fable of bureaucracy stacked against
the innocent, what *The Observer* aptly
described as 'Frank Capra's *The Trial*.'[15]
The three-storey, 58,000 square-foot
terminal, purpose-built in a hangar at
L.A.'s Palmdale Regional Airport, was
Spielberg's largest single set since the
landing strip of *Close Encounters of the
Third Kind*. Inspired by Jacques Tati's
Playtime, with its hyperconsumerist
Paris, this is a temple to commercialism,
where Spielberg's camera glides across a
gleaming dystopia of brands. Oblivious
to the satire, everyone from Krispy
Kreme to Valentino was invited to install
simulacra of their own outlets. The joke
is that Viktor is already in America.

"That kind of collective fear is a dangerous animal"

Steven Spielberg

War of the Worlds relocates H.G. Wells to contemporary New Jersey. The tale of Victorian space invaders is transformed into a lavish, post-9/11 sci-fi-horror starring Tom Cruise as crane operator, lousy dad, and walking Springsteen song Ray Ferrier, surviving an alien onslaught that arrives with the shattering abruptness of those planes striking the Twin Towers. Buildings crumble before his eyes and dust clogs the streets.

With Paramount and the wilting DreamWorks granting the movie a budget of $132 million (and returning a fulsome $592 million), 2005 bore the hallmarks of another blockbuster-art film double act, with *Munich* to follow. But science fiction was now a repository for Spielberg's darkest thoughts. He admitted to preying upon 'the idea of terrorism.'[16] Something alien to the American psyche.

War of the Worlds remains his only classic adaptation, even if the 1953 Byron Haskin version held greater sway in his imagination than the book – American soldiers versus hovering Martian lozenges was, for the time, a revolution in special effects. In 1994, he had outbid rivals for the original script to Orson Welles' 1938 radio adaptation, which had stirred widespread panic that an actual invasion was underway. That was in there too. It was also consciously the antithesis of *Close Encounters*, where a father saves his family (defiant teenage son Justin Chatwin and luminously aghast daughter Dakota Fanning) as they flee aliens armed with death rays and

WAR OF THE WORLDS
2005 Director/Producer

Opposite above: Too-close encounters – H.G. Wells's iconic tripods lay waste to New Jersey in Steven Spielberg's grim contemporizing of *War of the Worlds*.

Above: Kooky local Harlan Ogilvy (Tim Robbins) offers Ray Ferrier (Tom Cruise) and his daughter Rachel (Dakota Fanning) questionable haven – one of Spielberg's concerns was how individuals withstand terror.

Right: Made in the shadow of 9/11, *War of the Worlds* remains the darkest of what might be considered Spielberg's entertainments.

sounding demonic horns instead of five-note arias.

The backdrop is high-end cosmic turmoil, surprisingly faithful to the framework of the 1898 book. Craning 150-foot tripods, their hubs shaped like seashells (Spielberg 'paid his respects'[17] to Haskin's curvilinear designs), striding across the autumnal landscape as if living things. Laser beams vaporize humans. A pestilence of red weed gives a new definition to rust-belt America. In a stunningly bleak tableau, a shattered 747 sprawls across suburbia like a limbless animal. Searching for the *vérité* shock of *Saving Private Ryan*, the director pursued an integration of CGI and shooting, conducting his effects like cast members. When they finally appear, however, the aloof aliens turn out to be disappointingly goofy tripeds to match their long-legged transports.

The crowd scenes are stunning. Spielberg's trademark anxiety reaches total social breakdown. 'That kind of collective fear is a dangerous animal,'[18] he remarked. America was under the microscope again. The beams of god light are now the glaring headlamps of a tripod, isolating a girl in a red top in a chilling recollection of films past.

But where was the 'zest and joyous energy'[19] of cinema's great optimist, wondered the *Chicago Sun-Times*? The film is relentlessly intense. The gripping centrepiece has Ray and his daughter hunker down in a basement with Tim Robbins' dangerously paranoiac local – this is 'extinction,'[20] he burbles, as the aliens rattle the windows in a malevolent re-run of *Close Encounters*. Ray resorts to a lethal course of action to save his daughter. The craft is sensational, but the view of humanity has reached a shocking low. Spielberg was experiencing his streak of seventies cynicism in the noughties.

If we had arrived blindfold to the cinema, would we have guessed the director of *Munich*? There are those penumbras of streetlight, a bluish glow to the night scenes, characters defined by silhouette. Spielberg admitted it was his most European film: in location, style, ambiguity, and the chessboard on which move and bloody countermove are conducted. *Munich* exists in a netherworld where moral certainty unravels, but killers have families, they eat together, sleep with their wives, and wonder if theirs is a just cause.

Like *Schindler's List*, he had been avoiding it. Producer Barry Mendel had first approached Kathleen Kennedy with the idea of adapting *Vengeance*, George Jonas's account of disillusionment spreading among the Mossad agents sent to kill the Palestinian ringleaders behind the slaughter of Israeli athletes at the 1972 Munich Olympic Games.

Spielberg remembered the ghostly images on his television set. 'I think it was the first time that I heard the words "terrorist" and "terrorism."'[21] He will double back on history with extraordinary invention, his camera glancing away from television screens broadcasting the original, grainy footage from Munich to his actors playing the terrorists on set. The real and imagined within the *same* shot.

But he had delayed. This was daring, even transgressive stuff. The facts of the book were hotly contested. With *Munich* he had everything to lose. He was likely to be attacked from all sides: Israel, Palestine, and that camp of American critics still insistent that Barnum stick to his circus tent. He would seek advice from his parents, his rabbi, hoping they would talk him out of it. Such reluctance, he knew, was the best reason to make it.

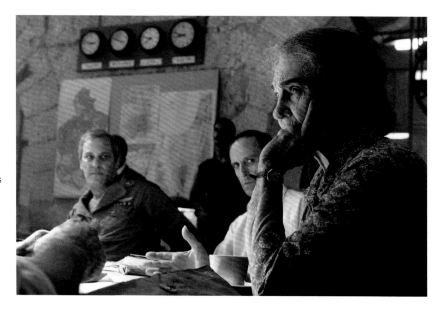

Written by playwright Tony Kushner, the story gravitates to Avner Kaufman (Eric Bana), instructed by Israeli prime minister Golda Meir (a captivating Lynn Cohen) to send a message to their enemies. Like *War of the Worlds*, this is a character study against the backdrop of conflict. Avner and his team, a striking array of actors as experts, killers, and ordinary men – Daniel Craig, Ciarán Hinds, Mathieu Kassovitz, Hanns Zischler – move between cities, guided by networks of informants toward their chosen targets, men as ordinary as them. We are stretched taut by each of the executions, which tremble on the edge of failure, Spielberg building his set pieces like ticking bombs. In one vivid image, a target is shot clutching his shopping, spilt milk mixing with blood, life mingling with death.

Munich has documentary resolve, but genre myths hover around these troubled assassins. This is the covert world of espionage stalked by the uncertainty of film noir. The prowling, geometric camera

Above: Israeli prime minister Golda Meir (Lynn Cohen) ponders the right course of action following the Munich Olympic terrorist attack in taut and prescient political thriller *Munich*.

Opposite: Agents of vengeance – Avner Kaufman (Eric Bana, second from the left) leads his team of burdened assassins, played by Daniel Craig, Ciarán Hinds, Mathieu Kassovitz, and Hanns Zischler

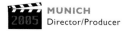

MUNICH
2005 Director/Producer

moves across crowded streets have the melancholy frisson of John le Carré. We are far from those old dreams of 007, despite the presence of Craig (newly enrolled as Bond) as the South African transport man, blue-eyed and quick to temper. 'Don't fuck with the Jews,'[22] he snaps with brittle bravado. Here too is the Costa-Gavras school of *Z* and *Missing*, and the electrifying panic of Gillo Pontecorvo's *The Battle of Algiers*.

Shooting in Rome and Malta, standing in for dusky Europe and the hot Levant accordingly, it was a production enshrouded in a nervy secrecy. Press were forbidden, security was heavy. Did Spielberg fear reprisals? Even on set, Arab actors worried that the sentiment

was anti-Palestinian, while Jewish cast members fretted it criticized Israel's policy of retribution.

It did neither. Spielberg's subject was the futility of violence. 'It can change people, burden them, brutalize them, lead to their ethical decline,'[23] he said. He pushed for a fictitious scene where Avner's team and a Palestinian unit absurdly crash the same safe house. They get talking, both sides wearily certain their mission has no end. 'You don't know what it is not to have a home,'[24] implores the Palestinian agent.

Spielberg was humanizing genre and humanizing history.

'Wanting to understand the background to a murder doesn't mean you

accept it,'[25] he insisted. Interviews turned into interrogations.

'*Munich* is by far the toughest film of Steven Spielberg's career and the most anguished,'[26] commended the *New York Times*. Despite a lacklustre $131 million worldwide, this is both a thrilling and bitterly perceptive film. As his story concludes, Avner washes up in Brooklyn, as nationless as Viktor. 'There is no peace at the end of this,'[27] he says.

The temptation proved too strong, the clamour too loud, best friends were too persuasive. Maybe he just needed to lighten up. Against his better judgement, Spielberg agreed to find out what had become of Indiana Jones. And, for that matter, Steven Spielberg. The

other one, who sprinkled his matinée dreams with sunsets and stunts like dance numbers. Even we suspected *Indiana Jones and the Kingdom of the Crystal Skull* was a poisoned chalice. It was like yearning for your childhood.

George Lucas had pictured Indy in the fifties, middle-aged and behind the times. Russians would replace Nazis, adding a bit of Cold War menace to the formula, besides the B-movie paraphernalia of atomic bombs and flying saucers. It was called *Indiana Jones and the Destroyer of Worlds*, before Spielberg decided J. Robert Oppenheimer references were 'too heavy.'[28] Lucas unearthed the crystal skull as the

MacGuffin, a pre-Columbian artefact with a knack for mind control.

This turns otherworldly in origin. Or, as the film designates its CGI invaders, inter-dimensional creatures from the 'space between spaces.'[29] Which was wasted breath on most viewers, who took them to be another batch of Spielbergian aliens. The first draft was written by Frank Darabont, who gave Indy a son, then Jeff Nathanson had a crack, before the reliable David Koepp joined all the dots.

All the while both Harrison Ford, and especially Spielberg, preferred to let the legacy rest like a relic, or a dinosaur preserved in amber – no good ever came from digging things up.

Below: Dusted off – Harrison Ford returns to his signature role, alongside Shia LaBeouf as punk-styled sidekick Mutt Williams, in the misbegotten fourth adventure *Indiana Jones and the Kingdom of the Crystal Skull.*

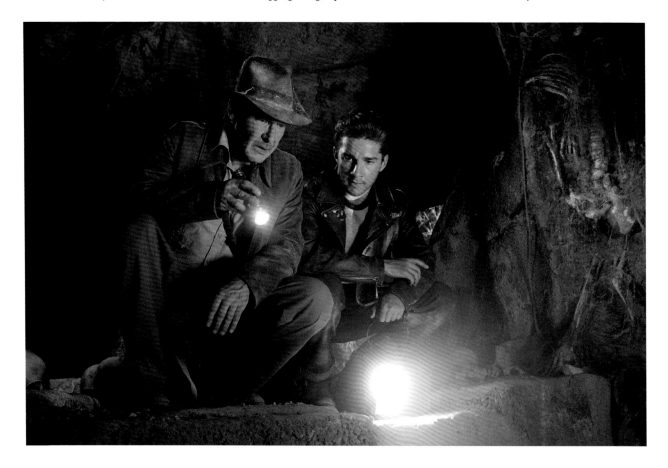

INDIANA JONES AND THE KINGDOM OF THE CRYSTAL SKULL
2008 Director

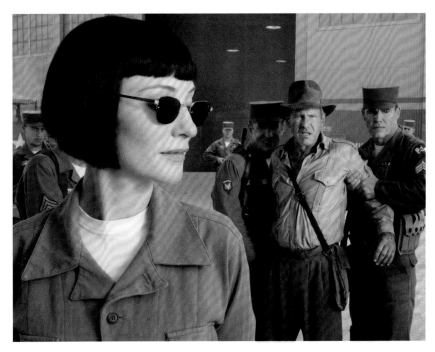

Yet here they were, back in cahoots with Lucas, with Ford slim enough to fit the costume, filming in New Mexico, Hawaii, California, and the grounds of Yale. The plot catches up with Indy in 1957, racing the scowling Soviets, led by frosty, bobbed Colonel Doctor Spalko (Cate Blanchett channelling Rosa Klebb in *From Russia with Love*), to a lost city in deepest Peru.

There are good scenes. An atomic bomb billowing skywards while Indy hides in a lead-lined fridge has the provocative tang of man wielding God-like powers. Man-eating ants are fun. But the intergenerational disputes, now between a grey-templed Indy and his Brando-esque companion Mutt Williams (Shia LaBeouf), have none of the old Ford-Connery magic. No one was fooled when Mutt turns out to be Indy's secret son with Marion (Karen Allen), another comeback to keep the nostalgia churning.

Janusz Kamiński did his best to mimic the cinematography of the long-since retired Douglas Slocombe. While Spielberg sought to 'approximate'[30] a younger director's enthusiasms. Everything about *Crystal Skull* is approximate. It's a pastiche of a pastiche, and another big hit (making $791 million). Audiences still yearned for that old hat.

Above left: Reorientating to the fifties, the baddies switch from Nazis to Commies, led by the icy Doctor Spalko (Cate Blanchett), but still chasing a mystical doodad to aid world domination.

Above right: *Kingdom of the Crystal Skull* was a big hit, but was a strange case of nostalgia for nostalgia's sake.

STRANGE HEROES

The Adventures of Tintin (2011), *War Horse* (2011),
Lincoln (2012), *Bridge of Spies* (2015)

His hair was grey. The glasses a fixture. The baseball cap gone. Steven Spielberg was sixty-five, but it was impossible to think of him as an older man. On set, he was dressed in a suit and tie. The rumour he'd had Costumes make him a suit like an undertaker in the nineteenth-century fashion was a silly myth. Nevertheless, he referred to the actors by their character names. Daniel Day-Lewis he called Mr President. He wasn't indulging them. It was about 'authenticity,'[1] he said. The actors had to feel as if they were stepping into 1865.

'I took this very seriously. Lincoln has not been honoured in a dramatic motion picture for seventy-two years,'[2] he declared. He hadn't been this vociferous since *Schindler's List*, refracting his knowledge through interviews, setting the stage.

Lincoln is the late-career masterpiece. But in a startlingly different vein to the brio of *Jaws*, the passion of *E.T. the Extra-Terrestrial*, or the wounding force of *Schindler's List*. Which may account for why it gets less attention. It had taken a decade of doubt to arrive in Richmond, Virginia on 17 October 2011, where the buildings still looked the part.

The interiors he built on studio soundstages were as quiet as a library. Spielberg insisted they be enclosed in four walls. The film was intimate not epic. This was a 'beautiful, literary piece,'[3] he said. Improvisation was frowned upon, the reactive looseness of old replaced by a formal dedication to Tony Kushner's script. They must be word-perfect. But don't go thinking this tale of political strife is straight-laced. It is among his funniest films. And most moving.

Lincoln was the father of America.

Away from set, Spielberg was now a father figure. Still the artist-mogul, he produced more than he directed, that brand name bolstering the genre-bait that people think he always makes, but seldom does. Career stratagems no longer applied. He awaited the urge, the list of projects swelling, scripts written and rewritten. Blockbusters withered on the vine: *Robopocalypse* (humans versus evil A.I.s) was on the verge of production when he changed his mind.

Barak Obama was in the White House, where the liberal-minded director was a regular guest, offering the chance to size up the interior for his attempt on the summit of Lincoln. The gloom had lifted.

Right: A date with destiny – his objective achieved, Lincoln (Daniel Day-Lewis) heads to the theatre. What is so tantalizing about Steven Spielberg's biopic is that such tropes as the assassination are no more than subplots.

Hope was restored. Spielberg is always so attuned to America – feeling its feelings. His films may still be set beneath the storms of history, but they course with hope and humour.

This chapter begins with an animated film. Of a kind. *The Adventures of Tintin* was made in partnership with New Zealand director Peter Jackson. Jackson was a fan, citing *Saving Private Ryan* as a major influence on the battles of his *Lord of the Rings* trilogy. They had much in common: a vital boyishness beneath their beards, oceanic talent, Oscars, and a passion for *Tintin*.

Written and drawn with inimitable style (which posed a problem) by the Belgian artist Hergé (real name: Georges Prosper Remi), Tintin is the intrepid young reporter chasing mystery across the globe in the company of wire fox terrier Snowy and bearded Scots scallywag Captain Haddock. On the release of *Raiders of the Lost Ark*, French critics had been quick to draw comparisons with the lifestyle choices of Indiana Jones. As Hergé biographer Pierre Assouline noted, Spielberg shared the Belgian artist's 'nostalgic quest for the lost paradise of childhood.'[4]

Negotiating the rights directly from Hergé in 1982, Spielberg pursued a live-action version. *E.T's* Melissa Mathison wrote a screenplay involving ivory hunters, Jack Nicholson was considered for Haddock, but Spielberg became uncertain. Was this *Indiana Jones Jr*?

In 2004, back in the mood, he challenged Jackson with creating a CGI Snowy – a thorny mix of bona fide animal and anthropomorphic ingenuity. By return of post, Jackson provided footage of a convincing Snowy with the director himself as Haddock (Spielberg maintained he would have been perfect

Left: *The Adventures of Tintin*, based on the graphic novels of Hergé, ostensibly marks Steven Spielberg's only venture into directing animation - albeit achieved with motion-capture.

Opposite: Volume control - Spielberg gives Andy Serkis (left) some pointers on embodying Haddockness, with producer Peter Jackson (second from right) behind, and Jamie Bell (Tintin, right) awaiting his moment.

Below: Belgian waffle - jabbering detectives Thomson (Nick Frost) and Thompson (Simon Pegg, or is it the other way around?) set about missing the obvious clue, while Tintin (Bell) catches on.

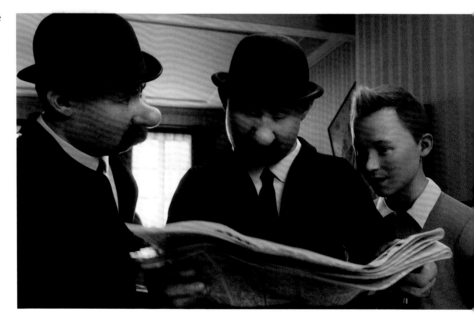

A TIMELESS CALL (SHORT)
2008 Director

casting), and the advice that having it all of a computer-animated piece would allow them to 'break away from the technical restraints'[5] and bring it close to a live-action experience. They could have their Belgian waffles and eat them. Capturing the boyish hero, with his tan spats, moon face, and unmistakeable blonde cowlick, as well as his eccentric comic-book world.

From the beginning, observed biographer Molly Haskell, the rhythms of Spielberg's plots, his antic blasts of action and humour, 'had been an implicit blend of cartoon and live action.'[6] This was *Tintin in the Kingdom of Motion-Capture*: real actors (dolled up in sensor-spotted Lycra like Pre-Cogs shivering with future shock) on quasi-sets (a ghostly grey mirage known as the Volume), delivering

their lines and movements to hot, dark rooms filled with computer terminals. These were the means by which James Cameron had created his photorealistic planet in *Avatar*, which had leapt to the summit of the all-time box office list.

The budget of $130 million was divided between Paramount and Sony. Hollywood saw it as a gamble. The script was divided between a trio of British writers, each a *Tintin* enthusiast, in Steven Moffat, Edgar Wright, and Joe Cornish, who threaded together Hergé's *The Crab with the Golden Claws* and *The Secret of the Unicorn* for an *Indy*-esque treasure hunt dashing from the streets of Brussels to the deserts of Morocco. The year is 1938, and during the pell-mell of investigation and slapstick –

circumventing Hergé's racial stereotypes – we learn how Tintin (Jamie Bell) and Captain Haddock (Andy Serkis) became acquainted, while outwitting the villainous Sakharine (Daniel Craig), ahead of bumbling, spoonerizing, identikit detectives Thomson and Thompson (Simon Pegg and Nick Frost).

During the thirty-two days of production at Playa Studios in Los Angeles (where *Avatar* was captured), the intemperate ocean of *Jaws* must have seemed millennia away. Now the waves could do his bidding, generated in a mainframe in New Zealand with uncanny accuracy – Jackson's Weta Digital would labour over the animating, with Janusz Kamiński advising on the colour palette. Spielberg would guide the camera himself,

THE ADVENTURES OF TINTIN: SECRET OF THE UNICORN
2011 Director/Producer/Lighting Consultant

receiving almost instantaneous playback on nearby monitors.

He claimed that he felt 'more like a painter.'[7] The glistening cobblestones of Brussels have a gorgeous noirish glow; the Moroccan dunes and labyrinthine bazaars perhaps a little too close to the sand-blown trails of the director's past.

He's a tough nut to crack, this Belgian reporter. The timbre of Hergé's 2D frames is unique. The film has a jazzy *Catch Me If You Can* exuberance. The extravagant chases recall the bulldozing clamour of *1941*, that love of Chuck Jones, with Spielberg gleefully conceiving sequences beyond the means of reality. There are divine touches (boozy Haddock distorted through his empty whisky bottles), brilliant transitions, wiseacre in-jokes (that quiff jutting from the surf like a fin!)

It did decent but relatively unspectacular numbers ($374 million), especially abroad. America remained nonplussed. The reviews largely depended on the devotion of the critic to Hergé. Some were enthralled. 'It's Tintinastic!'[8] squealed *Time*. Others saw it for what it inevitably was – ersatz *Tintin*.

Something is missing. Both of Tintin and his director. Hergé designed his hero to be a cipher for the reader, an outline onto which we project ourselves. He could be thirteen or thirty. A slippery idea that doesn't work on screen. Streamlined and inexpressive, Tintin is more android than David in *A.I. Artificial Intelligence*. The freedoms of animation don't suit Spielberg either. He needs the resistance of life, the strain of production, human beings. 'Hergé used body language to communicate emotion, anxiety, tension, anger,'[9] remonstrated Noah Berlatsky in *The Atlantic*. Where are those Spielberg terrors as taut as violin strings? His mustering of peril? The promised sequels have never materialized.

Below: All at sea – questionable mariner Captain Haddock (Andy Serkis, left) leaves the navigation to Tintin (Jamie Bell) and Snowy. *The Adventures of Tintin* would come under fire from purists for how far it departed from the art of Hergé.

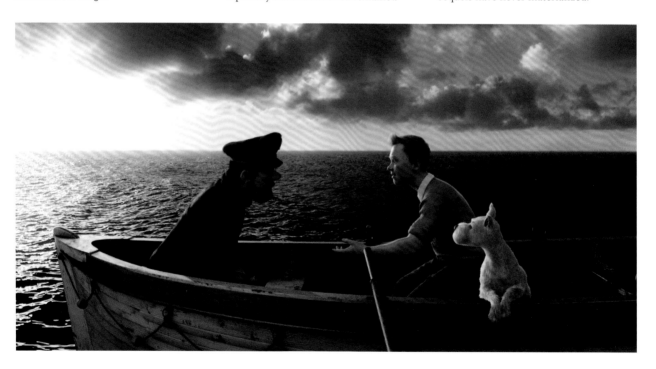

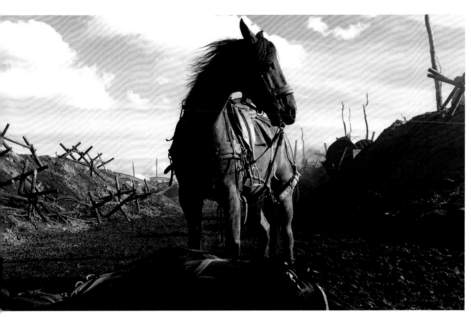

War Horse was inspired by the celebrated stage production at London's National Theatre more than by Michael Morpurgo's award-wining 1982 children's book. Kathleen Kennedy had seen the show in London, with its daring use of puppetry to portray the collision between history and bay Irish Hunter Joey, sold into the horrors of the First World War, far from his Devonshire farm and devoted companion Albert. 'I was stunned how emotional people were in the audience,'[10] she recalled. Spielberg knew a movie when he heard one, even if it risked Disney melodramatics. 'It's *National Velvet* on the Western Front,'[11] the *Hollywood Reporter* would carp.

These were strange heroes, a fake boy and a real horse, but – Indy aside – have any of his lonely protagonists conformed to the foursquare type? Spielberg was reminded of Carroll Ballard's *The Black Stallion*, and *E.T. the Extra-Terrestrial* too, in the bond between Joey and Albert (Jeremy Irvine, barely out of acting

school). This was the chance to bring his *vérité* to the agonies of the trenches – against the wishes of a drunken father (Peter Mullan), Albert enlists in search of his beloved horse.

'What was irresistible for me had nothing to do with global war,' claimed Spielberg. 'It was how Joey linked disparate characters together and the length to which Albert went to find him.'[12]

Written by Richard Curtis (*Notting Hill*) – a dozen drafts in three months – the scale was epic. From 6 August 2010, thousands of extras and 300 horses spilled over the fields of Dartmoor, Hampshire, and a recreation of the Somme, including 250 yards of trench, on a derelict airfield in Surrey.

If he wanted to taste the physicality of set again, he was now up to his neck in it, plunging into a hole dug for explosives to be submerged in ice-cold water. Things were going wonderfully wrong again. The weather was perfectly miserable. Irvine even picked up a case of trench foot.

Above left: One of fourteen different horses enlisted to play Joey, the hero of *War Horse*, on the battlefield set constructed in Surrey, England.

Above right: In a sense, Steven Spielberg's adaption combined the sensibilities of *E.T. the Extra-Terrestrial* with *Saving Private Ryan*. Another strange friendship, another frank depiction of war.

WAR HORSE
Director/Producer

Left: *War Horse* once again shows Steven Spielberg's knack for talent spotting. Among the large cast are early roles for Benedict Cumberbatch (left) and Tom Hiddleston (right), with Patrick Kennedy (centre).

Below: After the artifice of *The Adventures of Tintin*, Spielberg craved the reality of location again. He got a full dose with his recreation of the First World War, including specially designed mud for full authenticity.

War Horse is the closest Spielberg has come to the formalism of John Ford, or David Lean, or even Terrence Malick. War as a sin against nature. Like *Tintin*, however, the stage show had a personality unique to its medium. Everything about the adaptation was respectably conventional: the box office ($178 million), the reviews, and the Academy Award nomination for Best Film (with no expectation it would win).

There are powerful scenes. The suicidal charge of a British cavalry column (including Benedict Cumberbatch and Tom Hiddleston) into a blaze of machine gun fire. English and German soldiers uniting to rescue Joey (played by a mix of fourteen horses) from the barbed wire of No Man's Land. The *New York Times* saw 'an authentic kind of grace'[13] in Spielberg's ability to find compassion in the face of historical despair.

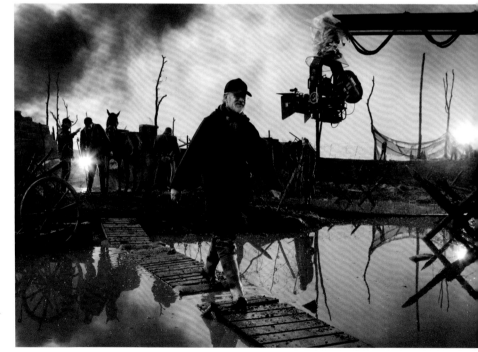

Which brought him to *Lincoln*.

He was an interesting proposition, Honest Abe. One closer to home than is immediately apparent: the humble showman, virtuous (to a point), family-orientated, equipped with a salty parable for every occasion, but possessed of titanic will.

The sixteenth President of America had been on Spielberg's mind for over a decade, another story he needed to wait out. To become the right Spielberg for his subject. He recalled visiting the Lincoln Memorial with his father, only six years old, fascinated by the immense, wrinkled hands, moved by the serenity in his face.

Spielberg had read Doris Kearns Goodwin's august biography *Team of Rivals* in 1999, still in galley form (it wouldn't be published until 2005), and sensed currents of possibility as great as Great Whites. A dinosaur in a coal black suit. The best-selling biography would famously land on Obama's bedside table. In 2001, Spielberg planned an epic of the Civil War told in seven pivotal battles, with John Logan's screenplay drawing from various sources. This was Lincoln prosecuting the war, *Saving Private Ryan* from the top down. Which was why the idea wore thin. Spielberg knew he could do it.

He turned to Kushner as screenwriter, remembering the experience of seeing his AIDS drama, *Angels in America*, on Broadway. Kushner had the immediacy of the great Paddy Chayefsky, turning thoughts and ideas into living dialogue. Using Goodwin's book, Kushner returned with a 550-page script that ran the distance of a mini-series. This was the full biopic treatment, dirt-poor Kentucky childhood to Gettysburg Address to Ford's Theatre.

The director dallied again. The writing was magnificent, but it was too obvious a

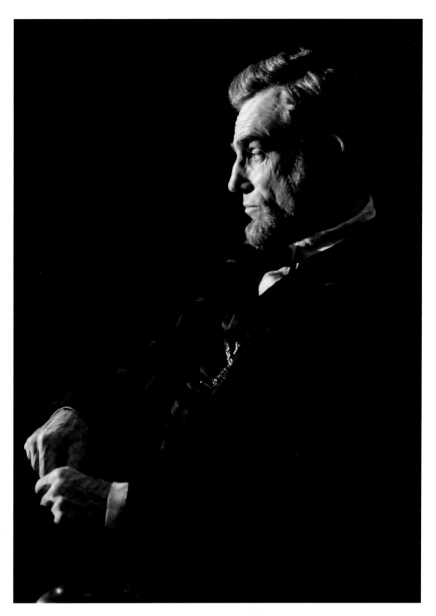

Above: Daniel Day-Lewis strikes a reflective pose as Honest Abe in Spielberg's masterful study of America's sixteenth President *Lincoln* – though the actor had taken some convincing to play the role.

LINCOLN
Director/Producer

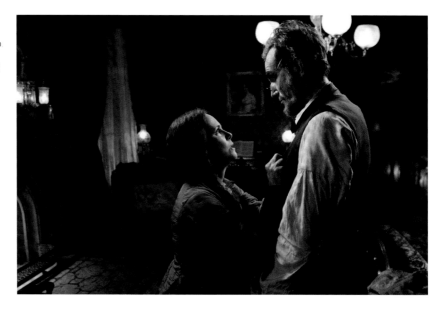

road – the hoary tread of the Hollywood biopic; the ennobled Ford and Fonda of *Young Mr. Lincoln*. Spielberg wanted to 'take him off his alabaster pedestal.'[14] With that, he made the inspired choice to use only the final sixty-five pages of Kushner's saga, narrowing his aim to the heated final months of Lincoln's second term. And, as it transpires, his life. Specifically, his attempts to get the 13th Amendment, abolishing slavery, fixed within the binds of the Constitution. Genre was cut loose: political drama bandied with biopic and the legalese of a courtroom thriller.

Unthinkably, Lincoln dared to obstruct peace in the Civil War, heaping more death upon his broad and bony shoulders, until the bill was passed by the House of Representatives. Allow the South's return to the Union and it might never be ratified. This was political brinkmanship with the soul of a nation at stake, Spielberg's hymn to democracy at its most valuable.

That was the mission. The Schindler-like obsession requiring all manner of

means to land the votes of wavering senators: argument, persuasion, threat, bribery. Idealism needs to twist a few arms, to wheedle and entice, to get its way. But what of the man? When the long-contemplated Liam Neeson withdrew, Spielberg was certain only Day-Lewis could carry off the wry, ruminative, tin-voiced emancipator given to quoting Euclid and Hamlet, and towering over rivals even without his stovepipe. First approached in 2006, Day-Lewis refused.

That was the Logan script, all the battles, and the Anglo-Irish actor was intimidated by a mythologized Lincoln. Still close after *Gangs of New York*, it was Leonardo DiCaprio who changed his mind.

'You need to reconsider this,' he told his friend. 'Steven really wants you for this and he's not willing to make the movie without you.'[15]

Day-Lewis agreed to read Kushner's script. Reassured this was a Lincoln more flesh than marble, he pressed Spielberg to delay for another year. He needed to immerse himself in history. What he

called 'the work in the soil.'[16] The result, as Peter Bradshaw raved in the *Guardian*, is more 'séance'[17] than acting. Spielberg spoke of a performance 'that would put us in a real-time encounter with the man, his legacy, and that century.'[18] Lincoln is wholly present, a weary, tender, burdened man, yet still a mystery. The Oscar for Best Actor would justly follow, the first to arise from a Spielberg film.

What a cast of actors. What an array of faces. The obdurate, granite facade of Tommy Lee Jones as tongue-lashing radical Thaddeus Stevens. Sally Field as Mary Todd Lincoln, all headaches and heartbreak, a burden to her husband, a tiger to his enemies. We gain another cameo of a brittle marriage. There are fifty-eight name parts, and every one of them was Spielberg's first choice.

As he had with *E.T.*, Spielberg made *Lincoln* with self-imposed restraint, keeping his camera as stately as his stiff-legged hero. The interiors of the White House and Capitol Building are cloaked in another wintry Spielberg monochrome.

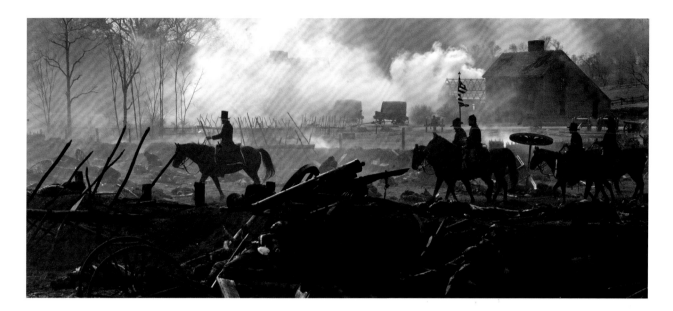

Light strains through muslin drapes or flickers tentatively from the hearth. Smoke and gloom hold sway, with just a hint of those early enchantments. The world looks lived in, cramped, the air clammy. Outside, it is as grimly overcast as the days when the weather turned on Martha's Vineyard. The past looks like hard work. It looks real. The ticking of Lincoln's watch is a recording of the actual model. The Civil War comes in fragments, bleak panoramas of battle and aftermath beneath bruised skies – a reminder of what Lincoln risked.

Yet the result still dazzles. And for contradictory reasons. It is talky but thrilling. Deeply serious but often very funny. Even absurd. In near-slapstick mode, three oily operatives, led by a profane James Spader, are dispatched across the country to bully the in-betweeners. Across the floor of the House, obstinate men with ornate facial hair hurl insults at one another in a baroque compendium of Twainian whimsy, Shakespearean declamation,

Top: In one of few scenes that venture out of Washington and into the fields of the Civil War, Lincoln (Day-Lewis, in stovepipe hat), visits the aftermath of the battle at Petersburg, recreated at Powhatan, Virginia.

Above: Tommy Lee Jones, as the indomitable emancipator Thaddeus Stevens, casts a withering eye on his fellow representatives in Congress.

"… a gripping moral tapestry of 19th-century American life, an experience that is at once emotional, visceral and intellectual."

Andrew O'Hehir, *Salon*

Above: By any means necessary – Secretary of State William H. Seward (David Strathairn) instructs Lincoln's trio of oily operatives (Tim Blake Nelson, John Hawkes, and James Spader) to apply the subtle and not-so-subtle arts of persuasion to wavering voters.

Biblical commandment, and the extravagant spin-doctoring of the day.

This was a new form of Spielberg. 'In this case, the pictures took second position to the language,' he said. 'And so I took, in a sense, a backseat.'[19] That belies the film's spellbinding rhythm. Another heartbeat between the raucous chamber and the gravity of a President – and a director – fixed on his goal.

'Buzzard's guts, man! I am the President of the United States of America! Clothed in immense power!' rails Day-Lewis conjoined with Lincoln, his hand slamming the tabletop to quell his nettlesome cabinet. 'You will procure me these votes.'[20]

Kushner was on set that day. 'Everyone's jaw was on the floor,' he recalled. 'It's one of the greatest things I've ever seen.'[21]

Consciously delayed until after the 2012 Presidential election, winning Obama a second term – to swerve realpolitik! – *Lincoln* found its audience. On a disciplined $60 million budget, it was a hit, making $275 million. Spielberg had outshone Ford and DeMille, declared Andrew O'Hehir in *Salon*, this was a 'gripping moral tapestry of 19th-century American life, an experience that is at once emotional, visceral and intellectual.'[22]

The Academy were back at their absurd worst. Out of twelve nominations, Rick Carter for Production Design and Day-Lewis were the only winners. *Argo* over *Lincoln* for Best Picture? History will have its say.

The file on Ethan and Joel Coen's computer was wryly labelled 'Hanks Versus the Commies.'[23] The sibling writer-directors had been hired to add a coating of their inimitable style to Matt Charman's script for *Bridge of Spies*. To bring out the absurdity of the Cold War. The threat of nuclear annihilation. As Kubrick had educated Spielberg with *Dr. Strangelove*, such a catastrophe could only be parsed with humour. If not a farce, like *Lincoln* this was a story brimming with coded language, arcane rules, bureaucratic

mazes, and jostling personalities. Meat and drink to those crazy Coen boys.

History ripples out from the moment Soviet spy Rudolf Abel (Mark Rylance) is snared by the FBI (a flock of dull Hanrattys) in 1957. The opening is another Spielbergian beauty. Setting the tempo, preparing us for the serpentine plot, as the genial Abel evades G-men on the bustling subway, the Manhattan crowds as ceaseless as an outgoing tide. When he's finally ensnared in a rundown hotel, the plot springs into action. To keep up global appearances, the US government want Abel to have the semblance of a legal defence, which falls to insurance lawyer James B. Donovan, a real William Holden type played with leisurely integrity by Tom Hanks.

To Donovan's frustration, the trial is a showpiece, a foregone conclusion. But he has the guile to convince the judge to stay execution – Abel is insurance against the day when an American might be caught behind the Iron Curtain. Soon enough, U-2 spy plane pilot Francis Gary Powers (Austin Stowell) ditches his malfunctioning jet over Mother Russia.

Charman's script had come to Spielberg the old-fashioned way. The British playwright had pitched it. The plot fascinated the director. It wouldn't stay put in a genre: spy story, courtroom drama, comedy of manners, and a tale of friendship as unlikely as Elliott and E.T. or Itzhak and Schindler, Donovan and Abel's bond transcends global politics.

Below: Show trial – James B. Donovan (Tom Hanks, centre) tries to mount a defence of Rudolf Abel (Mark Rylance, second from left) in the genre-dancing *Bridge of Spies*.

BRIDGE OF SPIES
Director/Producer

Right: James B. Donovan (Tom Hanks) tries to shake off a tail – the many guises of *Bridge of Spies* include that of an espionage movie, and Steven Spielberg rises to the occasion.

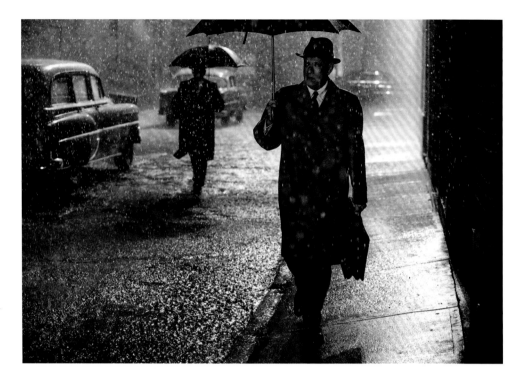

Spielberg had been keeping an eye on British theatrical marvel Rylance for years, and knew his hypnotizing detachment was perfect for inscrutable Abel. He may be the most elusive character Spielberg has ever put on screen. As the *New Yorker* said, 'we watch him watching everybody else, as if life were an infinity of spies.'[24]

There was the tug of the personal too. The scene of Donovan discovering his small son filling their bath, conserving water in case of nuclear attack, was drawn directly from one Steven Spielberg. He had been gripped by nuclear terror. The director recalled looking to the skies like Jim in *Empire of the Sun* and seeing the contrails of B-52s manoeuvring during the Cuban Missile Crisis. And his father visiting Moscow on a General Electric exchange trip, telling his son how the remains of the U-2 had been put on display.

Like *Catch Me If You Can*, *Bridge of Spies* is a film masquerading as a movie. The tone has a deceptive lightness, energized by that Coen wit, stirring quiet intensity when Donovan is called upon to negotiate the exchange in a riven Berlin.

They shot in Manhattan and parts of Berlin, with Wrocław in Poland (Kamiński's home town) posing as an East Berlin long since transformed. *Bridge of Spies* called for a mythologizing spirit. It is as distinctly a two-act tale as *Jaws*: New York and Berlin, land and sea to Donovan, where the currents of paranoia take different forms. New York gleams like a chrome bumper. The oak-lined offices have the well-heeled glamour of *Mad Men*. But vengeful shots are fired at Donovan's home. The idea is *contrast*: Donovan and Abel, West and East. The German city is an ice-box of frosted greys, a spy movie landscape (John le Carré, Harry Palmer,

The Third Man), with the fateful wall being raised like something in *Jurassic Park*.

With so many moving parts, the gears grind, and the box office was subdued ($165 million). But this is vintage Spielberg, another song to American decency. And another love story. The mismatched compatriots will part forever on Berlin's snowbound Glienicke Bridge (where they shot for five nights), with spotlights searching the night sky like beams from a mother ship. It's been another close encounter.

THAT SPIELBERG TOUCH

A far from exhaustive guide for how to spot a Spielberg movie without the credit

The Spielberg Face
It could be his signature image, a character staring in wonder or fear – directing our awestruck gaze from the stalls. To wit: Brody's stunned reaction to a close-up with the shark in *Jaws*, or Indiana Jones turning to see a giant boulder behind him in *Raiders of the Lost Ark*.

Broken Homes
In response to his troubled childhood, Spielberg put the broken American home at the centre of his storytelling. To wit: Elliott and his siblings living with their mom in *E.T. the Extra-Terrestrial*, and of course, *The Fabelmans*.

Dinner Table Nuance
We are guaranteed a telling character moment across a dinner table – that most human of settings. To wit: Neary sculpting the mashed potatoes in *Close Encounters of the Third Kind*, or the fretful scientists in *Jurassic Park*.

Everyman Heroes
Often what counts is not the extraordinary events so much as the artistry with which Spielberg captures the ordinary. To wit: Neary the Midwest electrician in *Close Encounters*, Captain Miller the schoolteacher in *Saving Private Ryan*.

Geeks
Spielberg is also often drawn to feature scientists – frequently getting a very real taste of science. To wit: ichthyologist Hooper in *Jaws*, and palaeontologist Alan Grant in *Jurassic Park*.

Bad Dads
Another homegrown theme – dubious fathers that echo Spielberg's view of his own pop. To wit: the absent dad of *E.T.*, Henry Jones in *Indiana Jones and the Last Crusade*, or Ray Ferrier in *War of the Worlds*.

Harried Blondes
Perhaps based on his mother's fragile temperament, there are a host of wronged wives and struggling heroines – all notably blonde. To wit: Teri Garr's Ronnie Neary in *Close Encounters*, Caroline Goodall as Emilie Schindler in *Schindler's List*.

God Lights
In different forms, Spielberg returns again and again to these beams of holy light. To wit: pouring out of the Mother Ship in *Close Encounters*, the camp spotlights in *Schindler's List*, or the moonlight in *The BFG*.

Shooting Stars
Inspired by the night his father took him to see a meteor shower, look out for the shooting stars as a wish, a charm, or a touch of magic. To wit: the 'fortune and glory'[1] scene in *Indiana Jones and the Temple of Doom*.

Rear-View Mirror Shots
Going all the way back to *Amblin'*, the use of a car mirror to picture what is behind getting closer, or getting left behind, is a beloved device. To wit: at every turn of *Duel*, the T. rex pursuit in *Jurassic Park*.

Silhouettes
Spielberg loves to describe a character by shape and shadow, the most famous being Indy. To wit: the troop cresting the hill in *Saving Private Ryan*, or the looming figures of the approaching gangs in *West Side Story*.

Flight
Correspondingly, he all but fetishizes aircraft. To wit: the Zero bathed in sparks in *Empire of the Sun*, or the U-2 being readied for take-off in *Bridge of Spies*.

Beaches
Beginning with *Amblin'*, the beach, that liminal space between land and sea, fascinates the director (see also: islands). To wit: the treacherous shore of Amity in *Jaws*, the overwhelming D-Day landing in *Saving Private Ryan*.

FOREVER YOUNG

The BFG (2016), *The Post* (2017), *Ready Player One* (2018),
West Side Story (2021), *The Fabelmans* (2022)

On the first day of *Bridge of Spies*, before a frame had been shot, Steven Spielberg turned to his leading man and asked if he would like to star in his next film. It was a tall story, indeed a tale of giants, light years and genres away from Cold War Manhattan. The pliable pixels of motion capture would turn Mark Rylance, a Shakespearean great, into a 24-foot street caricature of himself, with a face like an unmade bed and ears like giant (even for a giant) sea shells.

The BFG bore the hallmarks of *The Adventures of Tintin*, another rare marriage of the director's hallowed brand with an equivalent cultural voice. In this instance, Roald Dahl was arguably the bigger sell. The British author's books were beloved for transporting lonely children to dark and whimsical pockets of the universe like absurdist variations on the young Spielberg.

For the older variation, after three historical dramas, this was consciously a film *about* childhood. An attempt to generate something similar to the fairy-tale traumas of *Bambi, Fantasia,* and *Snow White and the Seven Dwarfs.* Symbolically, Disney were backing *The BFG* with a budget of $140 million. He was also reminded of that visit to the Lincoln Memorial as a small child. 'There was just something about bigness that scared me when I was a kid,'[1] he confessed. He had set his eyes on a giant resting in a chair. Yet he felt a warmth emanating from that long face. It was that old mix of wonder and fear.

Kathleen Kennedy had optioned the book in 1993 and struggled to find a taker. Both Peter Jackson and John Madden had passed. Years later, Spielberg picked up a draft written by Melissa Mathison and began to get that 'Old Familiar Feeling.'[2] Dahl's story told of the 'big friendly giant'[3] who kidnaps the orphan girl Sophie (Ruby Barnhill – Spielberg's first female protagonist since *The Color Purple*), after she spots him skulking beneath London streetlamps at the witching hour.

The giant's child-like, malapropping Dahlisms – talk of 'hippodumplings' and 'snozzcumbers'[4] – are charmingly delivered in that melancholy, singsong Rylance manner. This was three films in a row exploring language, a taste for locution-as-character that can be traced back to Quint's gothic rumblings and E.T.'s burbled phrasebook.

That *E.T. the Extra-Terrestrial* was also written by Mathison is pertinent.

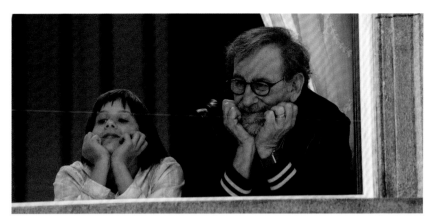

Left: For his adaptation of *The BFG*, Steven Spielberg would reignite his gift for drawing great performances out of children, with Ruby Barnhill starring as the orphan Sophie.

Below: The oddest couple – even by Spielberg's standards, the friendship between Sophie and the BFG (Mark Rylance, enlarged and exaggerated via motion-capture) is a wacky bond.

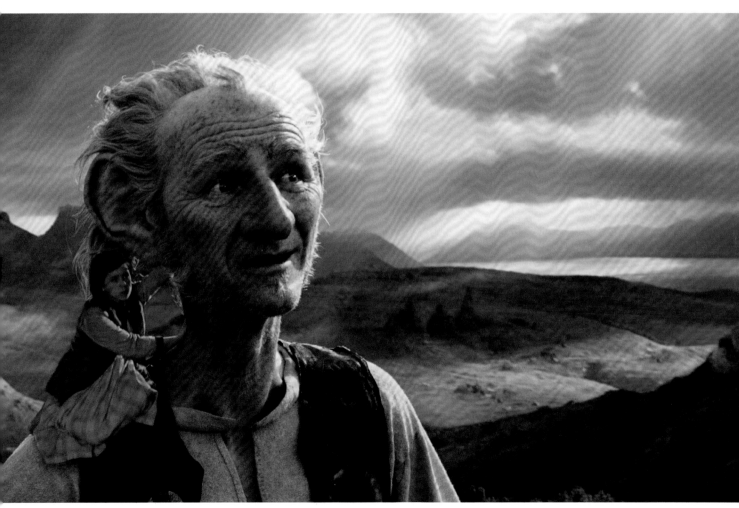

THE BFG
Director/Producer

No one was missing the fact that this was another saga about a lost child befriended by a wise yet innocent oddball. Another 'pure love story,'[5] boasted Spielberg. Was he amused that the initials of the title completed a trilogy of abbreviated childhood fables with *E.T.* and *A.I. Artificial Intelligence*? As he entered his sixth decade as a filmmaker, Spielberg had turned explicitly toward the subject of Spielberg. An older man in search of the Holy Grail that might make sense of his monumental career.

Like *Tintin*, it was also a sweetshop-bright blend of motion capture and real life, or at least a Dahli fabrication of life. It's like gazing into a beautiful aquarium, a bottled universe generated by Weta Digital, both endearing and cloying. For every 'extremely likeable'[6] (*Observer*), the critics chided a 'prescribed dose of poetry'[7] (*New Yorker*). The biggest shock was its failure, making only $195 million.

In a sliver of a self-portrait, the BFG is revealed as a collector of dreams, bursts of firefly-bright energy like the UFO heralds of *Close Encounters of the Third Kind*, awaiting delivery to slumbering children. We are left craving the ruffled dreams of suburbia.

Such were the demands of rendering the fake worlds of *Ready Player One* that the opportunity – and challenge – arose of shooting and releasing an entire film between filming and finishing the ready-made blockbuster to come. It would have to be a more technically conservative endeavour – just the usual actors, cameras, locations, and the state of the nation. For there was also, to Spielberg's mind, a sudden imperative in fast-tracking *The Post*.

This terrific drama looks like an outlier in this late phase of Spielberg's career. The one outwardly grown-up film. While set in 1971, it converses

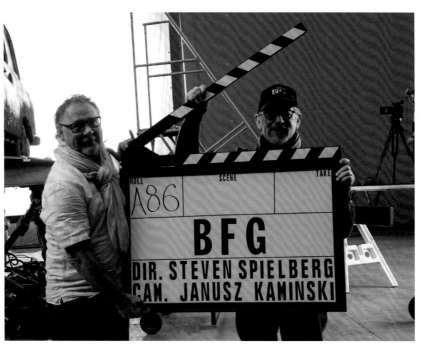

Top: Steven Spielberg plans his shot (presumably a wide) beside longtime producer Kathleen Kennedy, who had spent years trying to get *The BFG* made, until finally her closest collaborator came round to the idea.

Above: Thinking big – cinematographer Janusz Kamiński and Spielberg pose with the film's giant-sized clapperboard, but creating the film's world would rely heavily on blue screens.

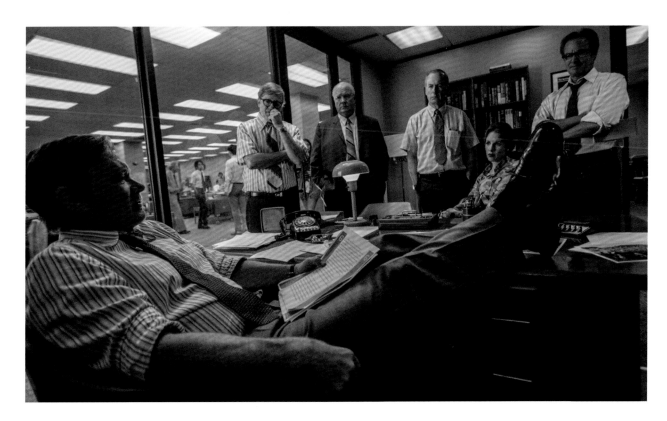

Above: Tom Hanks, as fabled *Washington Post* editor Ben Bradlee, confers with his inner circle – from the left: David Cross, John Rue, Bob Odenkirk, Jessie Mueller, and Philip Casnoff – in *The Post*.

directly with the here and now. *The Post* is his inflamed reaction to the post-truth turbulence of the Trump era.

'The level of urgency to make the movie was because of the current climate of this administration, bombarding the press and labelling the truth as fake as it suited them,'[8] he readily admitted. What the *New York Times* called the film's 'shiver of topicality.'[9]

An encomium to journalism, *The Post* serves as a prequel to Alan J. Pakula's era-defining portrait of the Watergate scandal *All the President's Men*. 'Arguably, the greatest newspaper movie ever made,'[10] Spielberg iterated again and again in interview. It says something for his love of the medium that he would consciously set a film within the shadow of another. *The Post* is less of a seventies movie. Pakula

takes the icebox approach, and his talky film is an edifice of municipal greys and shadow-drenched parking lots. Spielberg fires up warmer myths, unable to shake his liberal optimism – the belief, despite everything, that America is an idea worth fighting for. On a $50 million budget, it made a decent $193 million.

The script by first-time screenwriter Liz Hannah had come to him in 2017 via producer Amy Pascal. He was struck by the timeliness of the story. *West Wing* veteran Josh Singer added some of that walk-and-talk staple.

In the sub-genre of newspaper films, plots are complex. Over one fraught week in 1971, the *Washington Post* battles to publish excerpts from the Pentagon Papers, the covert government report that exposed the futility of Vietnam. Facing

THE POST 2017 Director/Producer

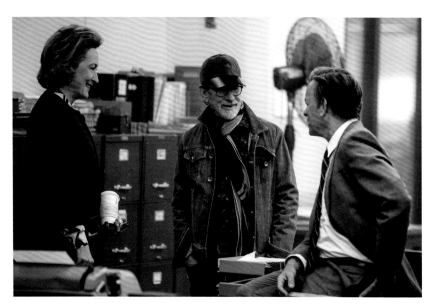

irascible, determined editor Ben Bradlee (Tom Hanks) are the massed ranks of rival papers, the *Post's* conservative board, and a Nixon-soured White House ready to smother the First Amendment. Stuck in the middle is *Washington Post* publisher Katharine Graham (Meryl Streep), fighting for the paper's survival.

This is the school of *Lincoln*, and to an extent *Minority Report*, another Washington movie charged with conspiracy. Another depiction of the currents of American power. There are echoes of Brody confronting a mayor's demands for capitalist good sense in *Jaws*.

The Post is a timely reminder of the quality of Spielberg's craft. Correspondingly, it is an appreciation of great craft, with the sprawling yet cluttered editorial office, the *Washington Post's* nerve centre, recreated right down to the overflowing waste-paper bins. The director almost fetishizes what he called the 'analogue era of hard copy,'[11] as he pores over the titanic presses, like great temples Indy might scale; the

clacking typewriters; the scurrying pencil of the copy editor. With sets built in an abandoned AT&T building in White Plains, New York, Spielberg's nervous energy drives the film. All the fervid, fast-talking editorial gatherings (the cynical snap of movie newspaper talk recalls *His Girl Friday* and *Ace in the Hole*), feet flying down corridors, boxes of documents unsealed with the bated breath of prising open the Ark. He even manages to make photocopying fraught.

Above all, it is a story syncopated to the shrill insistence of phone calls. In the hands of the maestro, this most uncinematic of actions becomes symphonic. Crack reporter Bob Odenkirk scattering quarters as he hustles his way to a source from a grubby payphone, his hungry face distorted in the dial. The heart of the drama is an operatic five-way call as Graham finally makes her decision to back Bradlee, risking the future of the paper, even jail time. The argument dances back and forth between Bakelite handsets and intent male faces in close-

up. Only with Graham, in mid-shot, does the camera take to the air to gaze down on the momentous moment. We are not only witnessing history, but a character finding her voice.

Hanks is having a ball as Bradlee, the swaggering newspaperman, thrilling to the chase, growling at petulant underlings (Odenkirk, Carrie Coon, David Cross, Zach Woods), a bear among the social climbers. He clearly loves the dare of taking on Jason Robards' Oscar-winning Bradlee in *All the President's Men*.

What a quintet of performances Hanks has gifted Spielberg: decent men in extraordinary moments, armoured in exasperated humour. He's a trickster too, Bradlee, essentially stealing a scoop from the *New York Times* (stymied by a government injunction), which lends an ironic slant to the paper's heroism.

Nevertheless, as the drama grows, and John Williams' score swells to meet it, it is Streep who takes centre stage. In her second Spielberg (having voiced the Blue Fairy in *A.I.*), she enacts a metamorphosis

from fluttering society hostess – still mourning the suicide of a celebrated husband, still entombed in tradition – into the steely publishing doyenne who shook the establishment. Spielberg frames Graham in a succession of boardrooms where disdainful, besuited men swoop around her like crows.

As Manohla Dargis effused in the *New York Times*, 'Streep creates an acutely moving portrait of a woman who in liberating herself helps instigate a revolution.'[12] Female empowerment is another theme that calls so clearly to modern times.

There isn't quite the third act to lift it into the upper echelons of the Spielberg canon. Once the papers (literally) hit the street, he magnanimously hands on the baton to Pakula's masterpiece with news of a break-in at the Watergate building. Nevertheless, *The Post* has made its point with great flair – the Fourth Estate in all their scruffy, inspired glory, a pack of terriers gnawing for the truth, remain a vital check on power. Spielberg was hoping film could do the same.

Ready Player One is another case of Spielberg attempting to make a Spielberg film. A *Star Wars*-Spielberg nut since childhood, former computer technician Ernest Cline had poured a motherlode of geek touchstones into his novel about a dystopian America of 2045 (filmed on the streets of Britain's Birmingham) where kids spend

Below: And there are times when it is all about special effects. In dystopian thrill ride *Ready Player One*, Tye Sheridan steps into the virtual-reality universe of OASIS.

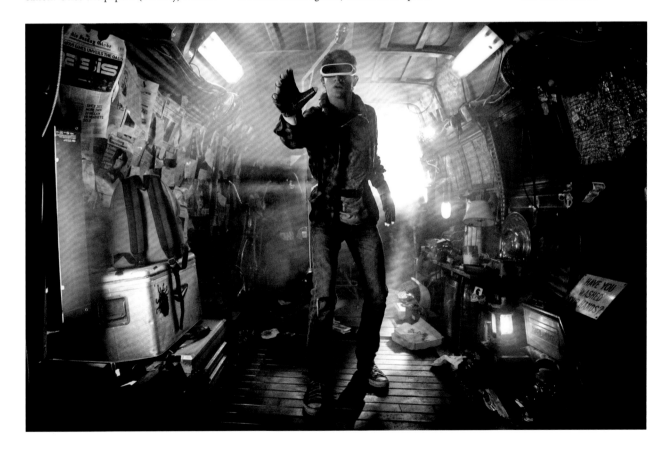

READY PLAYER ONE
Director/Producer

> **"This film was my great escape. This was a film, for me, that fulfilled all of my fantasies of places I go, in my imagination… It was really an out-of-body experience."**
>
> Steven Spielberg

their time in a virtual universe called OASIS, a repository of Cline's eighties obsessions: films, books, music, and the overriding aesthetic of video games.

'For me, this film was my great escape,' explained Spielberg. 'This was a film, for me, that fulfilled all of my fantasies of places I go, in my imagination, when I get out of town.'[13] It is a study of Spielberg at leisure – the billionaire Cline, dream deliverer, nerding out on video games and genre movies, the reclusive wizard at the heart of the maze.

The plot is structured as a *Charlie and the Chocolate Factory*-style challenge, posthumously laid down by the online world's billionaire creator Halliday (Rylance again), to overcome three challenges within the digital labyrinth of OASIS. The prize is the keys to the kingdom. Hidden beneath their stylized avatars, gamers Tye Sheridan and Olivia Cooke rise to the occasion. Out in downcast reality, corporate goon Ben Mendelsohn is on their tail.

There are hints of the meta-entanglements of the Arnold Schwarzenegger vehicle *Last Action Hero*, which, of course, gets referenced. Irony runs rife. The very making of the film was a version of what it depicted. Spielberg could literally don an HTC Vive headset and enter the chambers of OASIS as if it were a real location. 'It was really an out-of-body experience,'[14] he claimed.

Ready Player One is a science-fiction story about nostalgia for science fiction, gorging on the multiplicity of its references: *The Iron Giant, The Lord of the Rings, Akira, Aliens, Tomb Raider,* the list goes on and on. For the middle challenge of the film, Spielberg requested a simulacrum of the Overlook Hotel from *The Shining* – he was back channelling Kubrick again.

Such gleeful postmodernism presents a problem. When Spielberg took the reins, wary of repeating the indulgences of *Hook*, any reference to his own work was removed, with the exception of *Back to the Future*. This love song to Spielberg

Opposite: Inside the game inside *Ready Player One* – a film that would ironically require Industrial Light & Magic to create computer effects that resembled computer effects.

Below left: They like to be in America! Steven Spielberg realized his lifelong dream of making a full-blown musical with his new adaptation of the stage-show *West Side Story*.

Below right: Despite stellar reviews, released at a time when audiences were still sceptical about going to the movies after the Pandemic, *West Side Story* would be a box-office disappointment.

should have been sung by someone else. One of the next generation of acolytes and fanboys – a J.J. Abrams or Edgar Wright, those raised like Cline to cherish his boyish dreams. Spielberg is the ghost at his own banquet.

It was a hit ($607 million) almost by default. But unmemorable, even wearying. 'It's a film about having come too far and being at the end of something,' mused Jonathan Romney in *Film Comment*, 'where extraordinary things no longer mean much.'[15] It is aswirl with dazzling things – as was *1941!* – but the aesthetic is ersatz-ersatz, CGI faking CGI. The concluding moral to get real is the heaviest irony of all.

The urge to make a musical can be sourced to the jitterbugging of *1941*. He had tried out some song and dance in *Indiana Jones and the Temple of Doom* and *The Color Purple,* and chickened out of making *Hook* a musical. Naturally, *West Side Story* also bears the imprimatur of childhood, where the soundtrack from

the 1957 Broadway production, with its iconic score by Leonard Bernstein and lyrics by Stephen Sondheim – the only non-classical LP Leah would countenance in the house – was on repeat-play, care of her son. He would receive a serious reprimand for crooning the lyrics to *Gee, Officer Krupke* at the dinner table. When he saw the Oscar-adorned 1961 version of this New York-set musical spin on *Romeo and Juliet*, it was love at first sight.

He was seventy-five, he was Spielberg, so why not face his fears and remake it? Or as he styled it, *readapt* the original show. 'I never would have dared go near it had it only been a film.'[16] Not since *Always* had he been so old-school. Written by Tony Kushner (his go-to guy for steeper challenges), and shooting from 20 March 2019, this was a trial to match any action film. Over a gruelling five months, songs would stretch across the production – the exuberant daylight ballet of *America* took ten days to complete in stifling, summer heat.

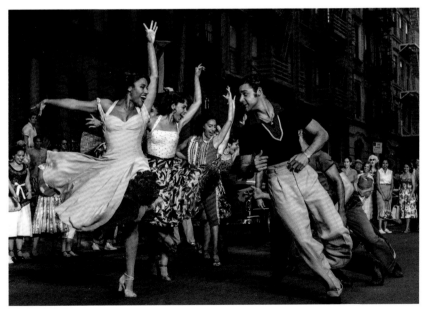

WEST SIDE STORY
2021 Director/Producer

MARCUS MUMFORD: CANNIBAL (MUSIC VIDEO)
2022 Director

Spielberg stays faithful to that soundtrack. This is the fifties. Rachel Zegler (discovered from 30,000 auditionees) and Ansel Elgort are Maria and Tony, the lovebirds from rival Upper West Side gangs, the Jets and the Sharks, white and Puerto Rican. The director consciously cast ethnically, with a stand-out Ariana DeBose as Maria's feisty best friend Anita.

The director pushed to be as 'street-real as humanly possible,'[17] finding locations in Harlem, Washington Heights, Queens, and New Jersey. The famous tenement façade, with its maze of fire escapes, location for the couple's declaration of love (*Tonight*), was built at Brooklyn's Steiner Studios. Yet he is liberated by the genre's essential pact with the fantastic. The glinting fifties New York of *Bridge of Spies* is elevated into a rapturous, dream Manhattan where even the rubble is fetching. Spielberg's camera

glides among the ravishing dancers as if he and his crew couldn't resist joining in.

The reviews were positive. Though some wondered why he had retreated to another nostalgia-strewn virtual reality. Sondheim (who loathed the 1961 version) had the chance to see the film before his death in 2021, and offered his approval. But with cinema going flattened by the Pandemic, it was a wounding flop for Spielberg (it had cost Disney $100 million, and made only $76 million).

And so the career comes full circle, back to where it began: the precocious childhood. With all the many disguises biography has taken in his films – the Elliotts and Jims, Hoopers and Hanrattys – he was finally emboldened to tell his own story. Like the trickiest of mirror shots, *The Fabelmans* is Spielberg on Spielberg becoming Spielberg, a way to outpace the biographers by turning (mythologizing?) his own life into a Spielberg movie.

Filmed in Arizona and California, with Mateo Zoryan and Gabriel LaBelle as somewhat idealized versions of the younger Spielberg né Sammy Fabelman, this is an episodic biopic of the formative years: New Jersey to the teenage plateau of Arizona, the dissolving marriage of his parents (embodied by Michelle Williams and Paul Dano), the struggles with his Jewish identity, his first fumblings in love, and the young filmmaker making sense of it all. Essentially, chapter one of this book.

It was a very un-Spielberg-like project, admitted Spielberg. 'There's no grand historical context for it. It's this very naked film. There are no aliens, no dinosaurs.'[18] Significantly, this is his life cast in the dream-glow of his films. Spielberg given the Spielberg touch. 'Storytelling is my therapy,'[19] he said.

He had wrestled with the idea for years. Why was every film he made in some way a conversation with himself?

Right: Spielberg frames a low angle on gang members Mike Faist and Ansel Elgort amid some of the most elaborate set-ups of his career in *West Side Story*.

THE FABELMANS
Director/Producer/Writer

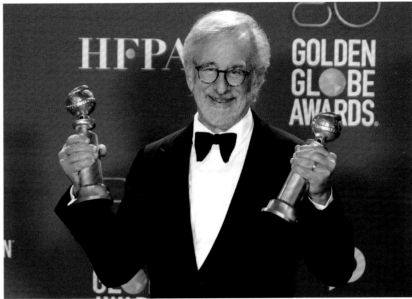

Above left: Auto-fiction
- *The Fabelmans* was
Spielberg's attempt to beat
the biographers at their own
game, by making a Spielberg
movie out of his own life.

Above right: Spielberg
clutches two Golden Globes
for his most personal film in
2023. Meanwhile, the Oscars
were back keeping their
distances.

His mother had seen through him. That he 'always felt safer using metaphor.'[20] *The Fabelmans* was a film he made for no one but himself. Yet it is a celebration of the thing he has known from the very beginning – that films are truly a collective experience. Beneath the flickering light the unreal becomes real.

What is Spielberg like at endings? Often marvellous, of course. The haunting departures of *Close Encounters* and *E.T.* The throbbing crate at the close of *Raiders of the Lost Ark*. But they are always left open in some significant way, as if he never wants the film to finish.

The Fabelmans ends just as the career begins, with the stern words of John Ford (the wonderful David Lynch, that anti-Spielberg) – keep your eye on that horizon and never be boring. He's lived up to that. It's his smallest picture (making an underwhelming $45 million), wise yet innocent. 'At 76, he's still the boy cradling an entire medium in his hands,'[21] wrote an enchanted Robbie Collin in the *Telegraph*.

The era-defining career is far from done. There are projects circling, anticipating the tipping point when his imagination unfurls and the dreaming begins. We await him in the dark, the best friend with the magical touch. The man with the universal touch.

'When I grow up,' he once laughed, 'I still want to be a director.'[22]

FRANK BULLITT PROJECT
Director

NAPOLEON (TV MINISERIES)
Director

UNTITLED UFO PROJECT
Director

Sources

BIBLIOGRAPHY

Awalt, Steven, *Steven Spielberg and Duel: The Making of a Film Career,* Rowman & Littlefield Publishers, 2014

Biskind, Peter, Easy Riders, Raging Bulls, Simon & Schuster, 1998

Bousquet, Olivier, Devillard, Arnaud, and Schaller, Nicolas, *Steven Spielberg All The Films: The Story Behind Every Movie, Episode, and Short,* Black Dog & Leventhal Publishers, 2023

Bouzereau, Laurent, and Rinzler, J.W., *The Complete Making of Indiana Jones,* Ebury Press, 2008

Freer, Ian, *The Complete Spielberg,* Virgin Publishing Ltd, 2001

Friedman, Lester D. and Notbohm, Brent, *Steven Spielberg Interviews,* University Press of Mississippi, 2000

Gaines, Caseen, *E.T. the Extra-Terrestrial: The Ultimate Visual History,* Titan Books, 2022

Gottlieb, Carl, The Jaws Log (Expanded Edition), HarperCollins, 2001

Haskell, Molly, *Steven Spielberg: A Life in Films,* Yale University Press, 2017

McBride, Joseph, *Steven Spielberg: A Biography (Third Edition),* Faber & Faber, 2010

Quirke, Antonia, *Jaws – BFI Modern Classics,* British Film Institute, 2002

Schickel, Richard, *Steven Spielberg: A Retrospective,* Palazzo Editions, 2022

Schwartz, Sanford (editor), *The Age of Movies: Selected Writings of Pauline Kael,* The Library of America, 2011

Shone, Tom, *Blockbuster: How Hollywood Learned to Stop Worrying and Love the Summer,* Simon & Schuster UK Ltd, 2004

Thomson, David, *Have You Seen...? A Personal Introduction to 1000 Films,* Penguin, 2008

DOCUMENTARIES

Duel: A Conversation with Director Steven Spielberg, Universal Home Video, 2001

Spielberg, HBO, 2017

The Making of Jaws, Universal Home Entertainment, 1995

The Making of Lincoln, 20th Century Fox Home Entertainment, 2013

War of the Worlds Unscripted: Steven Spielberg, Tom Cruise, MovieFone, 17 September 2012

THE OPENING

1. McBride, Joseph, *Steven Spielberg: A Biography (Third Edition),* Faber & Faber, 2010

THE NATURAL

1. *War of the Worlds Unscripted: Steven Spielberg, Tom Cruise, MovieFone,* 17 September 2012
2. Ibid
3. Ibid
4. Ibid
5. McBride, Joseph, *Steven Spielberg: A Biography (Third Edition),* Faber & Faber, 2010
6. Haskell, Molly, *Steven Spielberg: A Life in Films,* Yale University Press, 2017
7. Ibid
8. McBride, op. cit.
9. Haskell, op. cit.
10. McBride, op. cit.
11. Rainer, Peter, *Student Films of Welles, Scorsese, and Spielberg Offer Lessons in Ambition,* Los Angeles Herald, 24 February 1984
12. Haskell, op. cit.
13. Lincoln, Ross A., *Sidney Sheinberg, Universal Exec Credited With Discovering Steven Spielberg, Dies at 84, The Wrap,* 7 March 2019
14. McBride, op. cit.
15. Crawley, Tony, *The Stephen Spielberg Story: The Man Behind the Movies,* Quill Press, 1983
16. Awalt, Steven, *Steven Spielberg and Duel: The Making of a Film Career,* Rowman & Littlefield Publishers, 2014
17. McBride, op. cit.
18. Buddery, Sarah, *The Untold Truth of Steven Spielberg's Duel, Looper,* 14 December 2021
19. *Duel: A Conversation with Director Steven Spielberg,* Universal Home Video, 2001
20. Awalt, op. cit.
21. Ibid
22. *Duel: A Conversation with Director Steven Spielberg,* Universal Home Video, 2001
23. Kael, Pauline, *Sugarland and Badlands,* New Yorker, 18 March 1974

THE BIG FISH

1. Riger, Robert, *Hunting the Shark,* Newsweek, 24 June 1974
2. Gottlieb, Carl, *The Jaws Log (Expanded Edition),* HarperCollins, 2001
3. McBride, Joseph, *Steven Spielberg: A Biography (Third Edition),* Faber & Faber, 2010
4. Biskind, Peter, *Easy Riders, Raging Bulls,* Simon & Schuster, 1998
5. Ibid
6. Helpern, David, *At Sea with Steven Spielberg, Take One,* March/April 1974
7. Freer, Ian, *The Complete Spielberg,* Virgin Publishing Ltd, 2001
8. Gottlieb, op. cit.
9. Ibid
10. Ibid
11. *The Making of Jaws,* Universal Home Entertainment, 1995
12. Griffin, Nancy, *In the Grip of Jaws,* Premiere, October 1995
13. Gottlieb, op. cit.
14. Ibid
15. Benchley, Peter and Gottlieb, Carl, *Jaws: The Complete Screenplay,* Write Path, 2024
16. McBride, op. cit.
17. Knight, Arthur, *Jaws: THR's 1975 Review,* Hollywood Reporter, June 1975
18. Schwartz, Sanford (editor), *The Age of Movies: Selected Writings of Pauline Kael,* The Library of America, 2011
19. Nigel Andrews, *Jaws: Bloomsbury Movie Guide No.5,* Bloomsbury, 1999
20. *The Making of Jaws,* Universal Home Entertainment, 1995
21. Ibid
22. Gottlieb, Carl, *The Jaws Log (Expanded Edition),* HarperCollins, 2001
23. Benchley, Peter and Gottlieb, Carl, *Jaws: The Complete Screenplay,* Write Path, 2024
24. Helpern, op. cit.
25. McBride, op. cit.
26. Schwartz, op. cit.
27. McBride, op. cit.
28. Quirke, Antonia, *Jaws – BFI Modern Classics,* British Film Institute, 2002
29. Benchley and Gottlieb, op. cit.
30. Malcolm, Derek, *Steven Spielberg's Jaws Review – Archive 1975,* Guardian, 22 December 1975

31. Thomson, David, *Have You Seen…? A Personal Introduction to 1000 Films,* Penguin, 2008
32. Tuchman, Mitch, *Close Encounter with Steven Spielberg,* Film Comment, January-February 1978
33. King, Stephen, *Danse Macabre,* Hodder & Stoughton, 2006
34. Bowen, Chuck and Smith, Derek, *Review: Steven Spielberg's Jaws Celebrates 45th Anniversary, Surfaces on 4k, Slant,* 28 May 2020

SHOCK AND AWE

1. McBride, Joseph, *Steven Spielberg: A Biography (Third Edition),* Faber & Faber, 2010
2. Breznican, Anthony, *Steven Spielberg Has Lost His Father, Vanity Fair,* 28 August 2020
3. McBride, op. cit.
4. Ibid
5. Hynek, Dr. J. Allen, *The UFO Experience: A Scientific Inquiry,* Regency, 1972
6. Jackson, Kevin (editor), *Schrader On Schrader* (Revised Edition), Faber & Faber, 2004
7. McBride, op. cit.
8. Ebert, Roger, *Top Secret: Steven Spielberg on the Brink of the 'Close Encounters' Premiere, Chicago Sun-Times,* 1 May 1977
9. Bradshaw, Peter, *Close Encounters of the Third Kind Review – a Must Watch Director's Cut, Guardian,* 26 May 2016
10. McBride, op. cit.
11. Haskell, Molly, *Steven Spielberg: A Life in Films,* Yale University Press, 2017
12. McBride, op. cit.
13. Lightman, Herb A. (editor), *The Making of Close Encounters of the Third Kind, American Cinematographer,* January 1978
14. Ibid
15. Ebert, Roger, *Close Encounters of the Third Kind, Chicago Sun-Times,* 1 January 1980
16. Canby, Vincent, *An Encounter That's Out of This World, New York Times,* 17 November 1977
17. Freer, Ian, *Steven Spielberg, Jaws and 'God Light', Empire Online,* 7 September 2012
18. Freer, Ian, *The Complete Spielberg,* Virgin Publishing Ltd, 2001
19. Thomson, David, *Have You Seen…? A Personal Introduction to 1000 Films,* Penguin, 2008
20. Royal, Susan, *Steven Spielberg in His Adventures on Earth, American Premiere,* July 1982
21. Hodenfield, Chris, 1941: *Bombs Away!, Rolling Stone,* 24 January 1980
22. *1941 Special Edition,* Universal Home Entertainment, 2020

23. Sragow, Michael, *1941: World War II, Animal House Style, Los Angeles Herald Examiner,* 14 December 1979
24. Champlin, Charles, *Spielberg's Pearl Harbor, Los Angeles Times,* 13 December 1979
25. Hodenfield, op. cit.
26. Bouzereau, Laurent, and Rinzler, J.W., *The Complete Making of Indiana Jones,* Ebury Press, 2008
27. Ibid
28. McBride, op. cit.
29. Canby, Vincent, *Raiders of the Lost Ark, New York Times,* 12 June 1981
30. Bouzereau and Rinzler, op. cit.
31. Bouzereau, Laurent, and Rinzler, op.cit
32. Kasdan, Lawrence, *Screenplay – Raiders of the Lost Ark,* Ballantine Books, 1981
33. Ibid
34. Shone, Tom, *Blockbuster: How Hollywood Learned to Stop Worrying and Love the Summer,* Simon & Schuster UK Ltd, 2004

THE INNER CIRCLE

1. McBride, Joseph, *Steven Spielberg: A Biography (Third Edition),* Faber & Faber, 2010
2. Feinberg, Scott, *Steven Spielberg and John Williams Reflect on 50-Year Collaboration – and Williams Walks Back Retirement Plans, Hollywood Reporter,* 12 January 2023
3. Tapley, Kristopher, *Editor Michael Kahn on 'Bridge of Spies' and Four Decades of Steven Spielberg Magic, Variety,* 8 December 2015
4. Pavlus, John, *Karma Chameleon: Catch Me If You Can, American Cinematographer,* 4 November 2022
5. Ebert, Roger, *Private Spielberg, Chicago Sun-Times,* 19 July 1998

PHENOMENON

1. Haskell, Molly, *Steven Spielberg: A Life in Films,* Yale University Press, 2017
2. Sragow, Michael, *A Conversation with Steven Spielberg, Rolling Stone,* 22 July 1982
3. McBride, Joseph, *Steven Spielberg: A Biography (Third Edition),* Faber & Faber, 2010
4. Sragow, op. cit.
5. *E.T. The Extra-Terrestrial Anniversary Edition,* Universal Home Entertainment, 2014
6. Sragow, op. cit.
7. Royal, Susan, *Steven Spielberg in His Adventures on Earth, American Premiere,* July 1982

8. McBride, op. cit.
9. Gaines, Caseen, *E.T. the Extra-Terrestrial: The Ultimate Visual History,* Titan Books, 2022
10. Royal, op. cit.
11. Taylor, Charles, *You Can Go Home Again, Salon,* 22 March 2002
12. McBride, op. cit.
13. Ibid
14. Sragow, op. cit.
15. Ibid
16. Taylor, op. cit.
17. Ibid
18. Sragow, op. cit.
19. Ibid
20. *E.T. The Extra-Terrestrial Anniversary Edition,* Universal Home Entertainment, 2014
21. McBride, op. cit.
22. Hartnell, Jane, *Creating a Creature, Time,* 31 May 1982
23. Gaines, op. cit.
24. *E.T. The Extra-Terrestrial Anniversary Edition,* Universal Home Entertainment, 2014
25. Thomson, David, *Have You Seen…? A Personal Introduction to 1000 Films,* Penguin, 2008
26. Schwartz, Sanford (editor), *The Age of Movies: Selected Writings of Pauline Kael,* The Library of America, 2011
27. *E.T. The Extra-Terrestrial Anniversary Edition,* Universal Home Entertainment, 2014
28. McBride, op. cit.
29. Amis, Martin, *The Moronic Inferno,* Jonathan Cape, 1986
30. Scragow, Michael, *Extra-Terrestrial Perception, Rolling Stone,* 8 July 1982
31. Ventura, Michael, *E.T. The Extra-Terrestrial, LA Weekly,* 19 August 1982
32. McKellar, Don, *His Life as a Dog, Village Voice,* 19 March 2002
33. Will, George F., *Well I Don't Love You, E.T., Newsweek,* July 19, 1982
34. Amis, op. cit.
35. *E.T. The Extra-Terrestrial Anniversary Edition,* Universal Home Entertainment, 2014
36. Gaines, op. cit.

LOST BOYS

1. Bousquet, Olivier, Devillard, Arnaud, and Schaller, Nicolas, *Steven Spielberg All The Films: The Story Behind Every Movie, Episode, and Short,* Black Dog & Leventhal Publishers, 2023
2. McBride, Joseph, *Steven Spielberg: A Biography (Third Edition),* Faber & Faber, 2010

3. *Steven Spielberg Interview, 60 Minutes,* 1982
4. Ibid
5. Haskell, Molly, *Steven Spielberg: A Life in Films,* Yale University Press, 2017
6. Hoberman J., *Zoned Again, Village Voice,* 5 July 1983
7. McBride, op. cit.
8. Collins, Glenn, *Spielberg Films – The Color Purple, New York Times,* 15 December 1985
9. Maslin, Janet, *The Color Purple, from Steven Spielberg, New York Times,* 18 December 1985
10. Benson, Sheila, *The Color Purple, Los Angeles Times,* 18 December 1985
11. McBride, op. cit.
12. Forsberg, Myra, *Spielberg at 40: The Man and the Child, New York Times,* 10 January 1988
13. McBride, op. cit.
14. Ballard, J.G., *Empire of the Sun, Harper Perennial,* 2006
15. Bahiana, Ana Maria, *Hook, Cinema Papers #87,* March/April 1992
16. Hinson, Hal, *Empire of the Sun, Washington Post,* 11 December 1987
17. Phipps, Keith, *Empire of the Sun (DVD), AV Club,* 19 April 2002
18. McBride, op. cit.
19. Bouzereau, Laurent, and Rinzler, J.W., *The Complete Making of Indiana Jones, Ebury Press,* 2008
20. McBride, op. cit.
21. Haskell, op. cit.
22. Hoberman, op. cit.
23. Ebert, Roger, *Hook, Chicago Sun-Times,* 11 December 1991
24. Canby, Vincent, *Peter as a Middle-Aged Master of the Universe, New York Times,* 11 December 1991

MAKING HISTORY

1. *Academy Awards Broadcast, Oscars.org,* 1994
2. Ibid
3. *The Making of Jurassic Park,* Universal Home Entertainment, 1995
4. Schiff, Stephen, *Seriously Spielberg, New Yorker,* 13 March 1994
5. McBride, Joseph, *Steven Spielberg: A Biography (Third Edition),* Faber & Faber, 2010
6. Mottram, James (editor), *Jurassic Park: The Official Script Book – Complete with Annotations and Illustrations,* Insight Editions, 2023
7. Salamon, Julie, *Watch Out There's Trouble in Dinosaurland!, Wall Street Journal,* 14 June 1993

8. McCarthy, Todd, *Jurassic Park, Variety,* 7 June 1993
9. Mottram, op. cit.
10. Shone, Tom, *Blockbuster: How Hollywood Learned to Stop Worrying and Love the Summer,* Simon & Schuster UK Ltd, 2004
11. Richardson, John H., *Steven's Choice, Premiere,* January 1994
12. Adorno, Theodor W., *Prisms (Reissue), MIT Press,* 1983
13. Couric, Katie, *Spielberg's 'List' Teaching Tolerance Ten Years On, Today,* 17 March 2004
14. Richardson, op. cit.
15. Ibid
16. McBride, op. cit.
17. Richardson, op. cit.
18. Ibid
19. Ibid
20. Erbach, Karen, *Schindler's List Finds Heroism Amidst Holocaust, American Cinematographer,* January 1994
21. Ibid
22. Richardson, op. cit.
23. Coyle, Jake, *In Emotional Reunion, Spielberg Revisits 'Schindler's List', AP,* 27 April 2018
24. Denby, David, *Unlikely Hero, New York,* 13 December 1993
25. Richardson, op. cit.
26. Ibid
27. *Schindler's List 25th Anniversary Bonus Edition,* Universal Home Entertainment, 2018
28. Keneally, Thomas, *Schindler's Ark,* Hodder & Stoughton, 1982
29. Yule, Andrew, *Steven Spielberg: Father to the Man,* Little, Brown, 1996
30. *Schindler's List 25 Years Later,* Universal Home Entertainment, 2018
31. Thomson, David, *Have You Seen…? A Personal Introduction to 1000 Films,* Penguin, 2008
32. Heymann, Danièle, *Schindler's List, Le Monde,* December 1993
33. Schiff, op. cit.
34. Ibid

TIME TRAVELLER

1. Haskell, Molly, *Steven Spielberg: A Life in Films,* Yale University Press, 2017
2. Biskind, Peter, *A 'World' Apart, Premiere,* May 1997
3. Ibid
4. Ibid

5. *The Lost World: Jurassic Park* (Reissue), Universal Home Entertainment, 2012
6. Andrew, Nigel, *Spielberg's Plotless Monster, Financial Times,* 17 July 1997
7. Biskind, op. cit.
8. McBride, Joseph, *Steven Spielberg: A Biography (Third Edition),* Faber & Faber, 2010
9. *Amistad (Reissue),* Paramount Pictures Home Entertainment, 2015
10. McBride, op. cit.
11. Ibid
12. Lane, Anthony, *Nobody's Perfect,* Vintage, 2002
13. Pizzello, Stephen, *Five-Star General, American Cinematographer,* August 1998
14. Ibid
15. *Saving Private Ryan Special Limited Edition,* Paramount Pictures Homes Entertainment, 1999
16. *Academy Awards Broadcast, Oscars.org,* 1999
17. Beevor, Anthony, *The greatest war movie ever – and the ones I can't bear, Guardian,* 29 May 2018
18. Ibid
19. Canby, Vincent, *Critic's Notebook: Saving a Nation's Pride of Being; The Horror and Honor of a Good War, New York Times,* 10 August 1998
20. Dubner, Stephen J., *Steven the Good, New York Times Magazine,* 14 February 1999
21. McBride, op. cit.
22. *A.I.: Artificial Intelligence (Reissue),* Paramount Pictures Home Entertainment, 2011
23. Leydon, Joe, *Steven Spielberg and Tom Cruise, Moving Picture Show,* 20 June 2002
24. Kermode, Mark, *AI Apology - Kermode Uncut, BBC Radio 5,* 22 January 2013
25. *Spielberg On Spielberg,* Turner Classic Movies, 2007

THE SUBURBAN MOGUL

1. Puckrik, Katie, *J.J. Abrams: 'I Called Spielberg and He Said Yes,' Guardian,* 1 August 2011

BETWEEN WORLDS

1. McBride, Joseph, *Steven Spielberg: A Biography (Third Edition),* Faber & Faber, 2010
2. Ibid
3. Cawthorne, Alec, *Steven Spielberg – Minority Report,* BBC Films, 28 October 2014
4. Dick, Philip K., *The Minority Report and Other Classic Stories (Reprint),* Citadel, 2016

5. *Minority Report Two-Disc Special Edition,* DreamWorks Video, 2002
6. Haskell, Molly, *Steven Spielberg: A Life in Films,* Yale University Press, 2017
7. Bousquet, Olivier, Devillard, Arnaud, and Schaller, Nicolas, *Steven Spielberg All The Films: The Story Behind Every Movie, Episode, and Short,* Black Dog & Leventhal Publishers, 2023
8. Mikulec, Sven, *Minority Report: Steven Spielberg's Proof That You Don't Need to Sacrifice Substance to Produce Spectacle, Cinephilia,* Undated
9. Lane, Anthony, *Whowillhavedunit,* New Yorker, 23 June 2002
10. Evangelista, Chris, *21st Century Spielberg Podcast: With Catch Me If You Can And The Terminal, Steven Spielberg Found Light in the Darkness, Slash Film,* 12 May 2020
11. Ebert, Roger, *Catching Up With Spielberg, Chicago Sun-Times,* 23 December 2002
12. Ibid
13. Ibid
14. Evangelista, op. cit.
15. French, Philip, *Hanks at the Point of No Return, Observer,* 5 September 2004
16. McBride, op. cit.
17. *War of the Worlds Unscripted: Steven Spielberg, Tom Cruise, MovieFone,* 17 September 2012
18. Schickel, Richard, *Steven Spielberg: A Retrospective,* Palazzo Editions, 2022
19. Ebert, Roger, *Creaking Havoc, Chicago Sun-Times,* 28 June 2005
20. *War of the Worlds,* Paramount Home Entertainment, 2013
21. *I Would Die for Israel,* unattributed interview with Steven Spielberg, Spiegel International, 26 January 2006
22. *Munich,* Universal Pictures Video, 2006
23. *I Would Die for Israel,* op. cit.
24. *Munich,* Universal Pictures Video, 2006
25. *I Would Die for Israel,* op. cit.
26. Dargis, Manohla, *An Action Film About the Need to Talk, New York Times,* 23 December 2005
27. *Munich,* Universal Pictures Video, 2006
28. Bouzereau, Laurent, and Rinzler, J.W., *The Complete Making of Indiana Jones,* Ebury Press, 2008
29. *Indiana Jones and the Kingdom of the Crystal Skull: Two-Disc Edition,* Paramount Home Entertainment, 2008
30. Bouzereau and Rinzler, op. cit.

STRANGE HEROES

1. Fleming Jr., Mike, *Mike Fleming's Q&A With Steven Spielberg: Why It Took 12 Years To Find Lincoln, Deadline,* 6 December 2012
2. Ibid
3. Ibid
4. Assouline, Pierre, *Hergé: The Man Who Created Tintin,* Academic, 21 November 2008
5. Amidi, Amid, *'Tintin' Ushers in a New Era of Photoreal Cartoons, Cartoon Brew,* 28 December 2011
6. Haskell, Molly, *Steven Spielberg: A Life in Films,* Yale University Press, 2017
7. Boucher, Geoff, *Tintin: Steven Spielberg Says 'The Medium isn't the Message,' Los Angeles Times,* 2 December 2011
8. Corliss, Richard, *Spielberg's 3-D Cartoon Adventure: It's Tintinastic!, Time,* 21 December 2011
9. Berlatsky, Noah, *How Spielberg Handles the Racial Problems of the 'Tintin' Books, The Atlantic,* 22 December 2011
10. Parker, Paula, *A Conversation with Spielberg, Kennedy, and Curtis, Christian Entertainment Examiner,* 15 December 2011
11. McCarthy, Todd, *War Horse: Film Review, Hollywood Reporter,* 15 December 2011
12. Galloway, Stephen, *The Making of Steven Spielberg's 'War Horse', The Hollywood Reporter,* 2 December 2011
13. Scott A.O., *Innocence is Trampled But a Bond Endures, New York Times,* 22 December 2011
14. Fleming, op. cit.
15. Ibid
16. McGrath, Charles, *Abe Lincoln as You've Never Heard Him, New York Times,* 31 October 2012
17. Bradshaw, Peter, *Lincoln – Review, Guardian,* 24 January 2013
18. Fleming, op. cit.
19. *The Making of Lincoln,* 20th Century Fox Home Entertainment, 2013
20. *Lincoln,* 20th Century Fox Home Entertainment, 2013
21. McGrath, op. cit.
22. O'Hehir, Andrew, *Pick of the Week: Spielberg's Magnificent 'Lincoln', Salon,* 9 November 2012
23. Author interview, 2015
24. Lane, Anthony, *Making the Case, New Yorker,* 19 October 2015

THAT SPIELBERG TOUCH

1. *Indiana Jones and the Temple of Doom* (Reissue), Paramount Home Entertainment, 2013

FOREVER YOUNG

1. Mooallem, Jon, *Inside the Mind of Steven Spielberg, Hollywood's Big Friendly Giant, Wired,* July 2016
2. Ibid
3. *The BFG,* Universal Pictures UK, 2016
4. Ibid
5. Mooallem, op. cit.
6. Kermode, Mark, *The BFG review – a scrumdiddlyumptious feast, Observer,* 24 July 2016
7. Brody, Richard, *Steven Spielberg's The BFG is a Forced March of Fun, New Yorker,* 1 July 2106
8. Freedland, Jonathan, Steven Spielberg: *The Urgency to Make The Post was Because of Trump's Administration, Guardian,* 19 January 2018
9. Dargis, Manohla, *Review: In The Post Democracy Survives in Darkness, New York Times,* 21 December 2017
10. Freedland, op. cit.
11. Ibid
12. Dargis, op. cit.
13. Radish, Christina, *Steven Spielberg on 'Ready Player One' and Why He'll Never Rework His Own Movies Again,* Collider, 29 March 2018
14. Ibid
15. Romney, Jonathan, *Film of the Week: Ready Player One, Film Comment,* 30 March 2018
16. Gilbey, Ryan, *Steven Spielberg on Making West Side Story with Stephen Sondheim: 'I called him SS1!,' Guardian,* 8 December 2021
17. Forestier, François, *Danse Avec Spielberg, L'Obs,* 2 December 2021
18. Zacharek, Stephanie, *Steven Spielberg Waited 60 Years to Tell This Story, Time,* 16 November 2022
19. Bousquet, Olivier, Devillard, Arnaud, and Schaller, Nicolas, *Steven Spielberg All The Films: The Story Behind Every Movie, Episode, and Short,* Black Dog & Leventhal Publishers, 2023
20. Zacharek, op. cit.
21. Collin, Robbie, *A Train Crash, David Lynch and a Glimpse Into Steven Spielberg's Broken Home, Telegraph,* 26 January 2023
22. Unattributed, *Steven Spielberg: 'When I grow up, I still want to be a director,' Khaleej Times,* 15 April 2024

ACKNOWLEDGEMENTS

I'll come clean – this has been a long and often difficult journey. Steven Spielberg has cast a light over my love of film since I first ventured into a cinema. *Close Encounters of the Third Kind* was that foremost experience of wonder, and thereafter I have never missed a single one of his films on the big screen. He has always been there. We've met twice. The first time was to record an acceptance speech for an award (for *Saving Private Ryan*), with George Lucas as presenter. It was Abbey Road. The director of *Jaws* strode into the room with a smile (Lucas looked harried), and offered his hand. 'Hi, I'm Steven Spielberg.' Of course, he was – it was like meeting a best friend decades after you had become acquainted. Among his copious gifts, he is adept at getting past the shock and awe of meeting him. He simply starts a conversation.

So to encompass him within the bounds of a book… Well, he's been my great white, shall we say. So I have first to thank my editor Jessica Axe and designer Sue Pressley at Stonecastle Graphics for their infinite patience – and for their encouragement. And, of course, for how wonderfully the book has turned out both in terms of words and pictures. With all that has been written about him over the years, I have endeavoured to get past the myth and to the conversation. This is a book about many things, but at heart, about what it's like to watch a Spielberg movie.

There are many more who have played their part. My copy editor Nick Freeth so determined to land those accents, wondering about my puns, but a master of the granular detail. He makes me look good. Friend and colleague Ian Freer, who is a peerless resource on anything Spielbergian. Also Simon Braund, Steve Hornby, Nick de Semlyen, Phil Thomas, Mark Dining, Colin Kennedy, Julian Alcantara, Lyndy Saville, and Katherine Willing.

Fittingly, gratitude goes to my parents, my companions for so many early Spielbergs. Especially my mother, who had to negotiate with an eleven-year-old who refused to speak until she took him to see *Raiders of the Lost Ark*. It's all their fault, really. Above all, my love and thanks go to Wai, who inspires me every single day.

PICTURE CREDITS